A BRIGHT COLD DAY

A BRIGHT COLD DAY

The Wonder of George Orwell

NATHAN WADDELL

A Oneworld Book

First published in the United Kingdom, Republic of Ireland and Australia
by Oneworld Publications Ltd, 2025

Copyright © Nathan Waddell, 2025

The moral right of Nathan Waddell to be identified as the
Author of this work has been asserted by him in accordance
with the Copyright, Designs and Patents Act 1988

All rights reserved
Copyright under Berne Convention
A CIP record for this title is available from the British Library

Special thanks to A. M. Heath and the estate of Sonia Brownell Orwell for
granting permission to reproduce George Orwell's unpublished writings.

ISBN 978-0-86154-976-4
eISBN 978-0-86154-977-1

Typeset by Tetragon, London
Printed and bound in Great Britain by Clays Ltd, Elcograf S.p.A.

No part of this publication may be reproduced, stored in a retrieval
system, or transmitted, in any form or by any means, electronic,
mechanical, photocopying, recording or otherwise, or used in any
manner for the purpose of training artificial intelligence technologies
or systems, without the prior permission of the publishers.

The authorised representative in the EEA is eucomply OÜ,
Pärnu mnt 139b-14, 11317 Tallinn, Estonia
(email: hello@eucompliancepartner.com / phone: +33757690241)

Oneworld Publications Ltd
10 Bloomsbury Street
London WC1B 3SR
England

Stay up to date with the latest books,
special offers, and exclusive content from
Oneworld with our newsletter

Sign up on our website
oneworld-publications.com

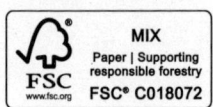

Contents

Timeline vii
Foreword xi

Morning

I	Rising	3
II	Washing	25
III	Breakfast	40

Daytime

IV	Work	59
V	Lunch	74
VI	Animals	90
VII	Walking	106
VIII	Greenery	123
IX	Hobbies	140
X	Walking (again)	158

Evening

| XI | Pubs | 175 |
| XII | Dinner | 191 |

Night

XIII	Sleep	211
XIV	Dreams	231
	Coda	255

Acknowledgements 261
Further Reading 265
Notes 269

Timeline

1903 Born Eric Arthur Blair on 25 June, in Motihari, Bengal, to Richard and Ida Blair (née Limouzin).
1911 Starts at St Cyprian's school, Eastbourne, East Sussex.
1914 Meets Jacintha Buddicom in Shiplake, Oxfordshire.
1917 Spends a term at Wellington College, Berkshire. Enters Eton College as a King's Scholar.
1921 Leaves Eton. Orwell's parents move to Southwold, Suffolk.
1922 Civil Service exams for joining the Indian Imperial Police. Sails to Rangoon, Burma, on the SS *Herefordshire*.
1927 Leaves Burma and resigns from the Indian Imperial Police.
1928 Moves to Paris. First journalism published in political and literary journal *Monde*, *Progrès Civique* and *G.K.'s Weekly*.
1929 'A Day in the Life of a Tramp' (essay). Admitted to hospital in Paris suffering from bronchitis. Works as a *plongeur* (dishwasher) at what is likely to have been the Hotel Lotti. Returns to England in time for Christmas.
1930 Works as a private tutor.
1931 Hop picking in Kent and tramping expeditions in London. 'A Hanging' (essay).
1932 Starts teaching at The Hawthorns School in Hayes, Middlesex.
1933 Pseudonymous publication of *Down and Out in Paris and London* (marketed initially as fiction; latterly as memoir or as a sociological account), by 'George Orwell'. In hospital with pneumonia.

1934 *Burmese Days* (novel). Employed part-time at Booklovers' Corner, London.
1935 *A Clergyman's Daughter* (novel). Lives with Rayner Heppenstall and Michael Sayers for a time in Kentish Town, London.
1936 *Keep the Aspidistra Flying* (novel). Goes north to Birmingham, Manchester, Wigan, Liverpool and Sheffield to research material for *The Road to Wigan Pier*, commissioned by Victor Gollancz. Starts renting The Stores in Wallington, Hertfordshire. Marries Eileen O'Shaughnessy. 'Shooting an Elephant', 'Bookshop Memories' (essays). Travels to Barcelona, where he enlists in the Partido Obrero de Unificación Marxista (POUM).
1937 *The Road to Wigan Pier* (book-length reportage). Fights on the front lines. Witnesses rioting in Barcelona in May. Shot in the throat by a fascist sniper and narrowly survives. Returns to England.
1938 *Homage to Catalonia* (book-length reportage). Spends six months at Preston Hall Sanatorium, Kent, with suspected tuberculosis. Travels to Morocco to spend the winter there.
1939 *Coming Up for Air* (novel). Back to England. Death of Orwell's father, Richard Blair.
1940 *Inside the Whale* (essay volume, containing 'Charles Dickens', 'Inside the Whale' and 'Boys' Weeklies'). Reviews Hitler's *Mein Kampf*. Joins British Home Guard.
1941 *The Lion and the Unicorn* (pamphlet). Joins the BBC as a talks assistant, later advancing to talks producer, in the Indian Section of the Eastern Service. 'Wells, Hitler and the World State' (essay).
1943 Death of Ida Blair. Leaves the BBC. Starts as literary editor for *Tribune*. Resigns from the Home Guard. Becomes member of National Union of Journalists.

TIMELINE

1944 Visits the Hebridean island of Jura for the first time. Eric and Eileen adopt their son, Richard.

1945 *Animal Farm* (novella). Resigns his position at *Tribune*. Death of Eileen from complications arising during a hysterectomy. Visits Jura again. 'Notes on Nationalism', 'Good Bad Books', 'Revenge is Sour' (essays).

1946 On Jura, works on what becomes *Nineteen Eighty-Four*. 'Pleasure Spots', 'The Moon Under Water', 'Politics and the English Language', 'Some Thoughts on the Common Toad', 'Why I Write' (essays). Unpublished booklet, 'British Cookery'.

1947 Moves between London and Jura. Sends 'Such, Such Were the Joys' to his publisher, Fredric Warburg. Often working in bed. Admitted to Hairmyres Hospital, Lanarkshire, where he stays for six months.

1948 Returns to Jura. Continues working on and finishes *Nineteen Eighty-Four*, typing it up himself and adding to his ill health. 'Writers and Leviathan' (essay).

1949 *Nineteen Eighty-Four* (novel). Spends nine months in Cranham Sanatorium, Gloucestershire. Re-establishes contact with Jacintha Buddicom. Transfers to University College Hospital, London. Marries Sonia Brownell.

1950 Dies of pulmonary tuberculosis. Buried in Sutton Courtenay, Oxfordshire.

Foreword

A man is asked by his neighbour to look at her blocked kitchen sink. He's annoyed by the intrusion but willing to help. It's not surprising the sink has failed, given the condition of the block of flats. Built in the 1930s, it's a relic from another time – a crumbling reminder of an age unlike theirs. Decaying buildings don't get much notice in their world. It would take years for a repair job to be funded by the committee that oversees things. Much easier to get on with it themselves. So the man enters his neighbour's apartment, and the first thing he notices is a reek of stale sweat. The smell of boiled cabbage, concentrated in the sink, hangs about the place. There's green water and filth. The dregs of a lacklustre dinner. The woman, a mother of two, would have cooked something else, but boiled cabbage is all she can afford. The man kneels and looks at the piping. Bending over elicits a cough, making the job harder than it needs to be. He fiddles with the pipes and quickly discovers the problem: a clump of human hair. Evidence of the times. Things break, things get clogged. Nothing works as it should or as it once did. Cleaning his hands removes the dirt, but it doesn't remove the feeling of having been dirtied.

This is a precis of a scene from *Nineteen Eighty-Four* (1949), arguably the twentieth century's most famous novel and certainly its most well-known fiction about the postwar surveillance state

and its brutalities. It is George Orwell's defining book and his most powerful account of the menace of authority, the lies told by governments, the consequences of all-seeing tech, and the fragility of truth in a world increasingly ensnared by falsehood. Orwell's publisher in the late 1930s and 1940s, Fredric Warburg, described it as 'a picture of man unmanned, of humanity without a heart, of a people without tolerance or civilization, of a government whose sole object is the maintenance of its power, of its absolute totalitarian power, by every contrivance of cruelty. Here is the Soviet Union to the nth degree, a Stalin who never dies, a secret police with every device of modern technology.' It's a text that always seems to be with us. In moments of crisis, *Nineteen Eighty-Four* is quoted by public figures of every stripe, with politicians invoking it as often as professors. It's a novel that has broken out of literary history and become part of the modern world's collective mind. To quote the historian Priya Satia, *Nineteen Eighty-Four* remains a book we turn to when we want to think about how 'oppressors vanquish and co-opt the concealed, bubbling hatred of the oppressed.'[1] It is a book for those who think something is wrong with the world – and who hope to change it.

Anyone even vaguely familiar with *Nineteen Eighty-Four* may find themselves nodding at this point. However, they may also raise an eyebrow at the idea that alongside its themes of 'the collision of industrialism and despair' and a form of politics 'utterly new to the human story', it is a book about everyday, domestic problems.[2] And there really is more of the ordinary in *Nineteen Eighty-Four* than you might think or recall. Help sought by Mrs Parsons, the dejected neighbour; help given by

FOREWORD

Winston Smith, the willing comrade. A clogged sink, a small favour – this is the stuff of countless humdrum encounters. Yes: *Nineteen Eighty-Four* is about the astonishing prospect of a world conquered by totalitarianism. But the everyday details make this extraordinary scenario plausible. In this novel, as in all his others, Orwell paid attention to mundaneness because he wrote with a narrative realism anchored in what he called the 'tiny details' of human behaviour. His expert handling of a lived-in reality is precisely what makes *Nineteen Eighty-Four* so effective. Sinks get clogged when sinks get worn, and they tend to smell when they get blocked. Anyone who's had to unclog a pipe will know that the stench can border on stupefying. Boiled cabbage, sweat and fetid hair: quite the aroma. But an ordinary, domestic pong even so. The odour roots Winston in a recognisable world, making the evils he experiences in it all the more visceral.

This book asks some simple questions: what happens if we tell the story of Orwell's life and work from *this* perspective – not from the tried-and-tested angle of big, serious questions about big, serious problems (power, truth, liberty, justice and so on), but from the perspective of the domestic and everyday? What sort of Orwell can we know, what sort of Orwell will we *discover*, if we approach him not as a writer with his eyes on the strange corruptions of politics in his time, but as a writer imaginatively fixed on daily ritual? And if we do all this, what insights into the nature of everydayness can we uncover in the process?

In short: what kind of Orwell is the daily Orwell?

As an academic, I spend a lot of time helping people read Orwell's work and figure out why it matters. Like so many

others – schoolchildren, undergraduate and postgraduate students and members of the wider reading public – I was introduced to Orwell by my English teachers, who inspired me to get my head around *Animal Farm* and then *Nineteen Eighty-Four*. Both texts seemed deeply important even if I couldn't always articulate why. One reason for this is that I thought, and still think, that there's a lot more to say about these texts, that there's even more hidden in Orwell's work than the usual ways of reading him have revealed. Seeing him as a political thinker who tackled the great questions of his time normalises the idea that these topics are the only subjects about which he had meaningful things to say. But what fascinates me about Orwell is that he paid so much attention to the small nuggets and grains of everyday life – to what Virginia Woolf called 'the fabric of things' – through which he posed sizeable questions about how we live and seek to change the world.

A Bright Cold Day is my attempt to show how and why Orwell spent so much time with the ordinary. This isn't yet another Orwell biography, though it draws on the many biographies of him that have been published. Instead, *A Bright Cold Day* approaches what Orwell thought, did and wrote mainly through his novels, blending fact and fiction into a kind of 'life in a day': a creative elaboration of those magazine features through which we learn about famous people by peeking behind the celebrity curtain, reading about a typical (though carefully stage-managed) twenty-four hours in their existence. The difference with this book is that this 'life in a day' is not about Orwell's life as such. I neither reconstruct a real, historical day from his lifespan nor try to show that any one day he lived

can somehow stand in for all the others. Using his fiction as its starting point, this book provides a subjective, associative and selective impression of how he imagined the happenings that structure so many people's lives across the rhythms of morning, daytime, evening and night.[3] *A Bright Cold Day* is thus a counter- or quasi-biography, an unconventional romp through Orwell's views of existence in its cycles of repetition, ritual and routine. It's an attempt to write about him in a fresh way by focusing on the everyday comings and goings in his life and books, and to enjoy the many moments of literary artistry this ordinariness inspired.

The shape of Orwell's life gave him the room to find interest in 'the trivial round and the common task' – a phrase from the hymn 'New Every Morning is the Love' that pays tribute to the satisfying regularity of everyday things, and a religious song he admired. He was never someone who stayed physically still for long, and he was always heading intellectually towards the next project. His was a dislocated life, untethered to the clock-on, clock-off routines of what he called 'a regular job', and rooted in the generative unevenness of constant intellectual and professional reinvention. It was this irregularity, in part, that gave him the large view needed to comprehend the grand forces affecting people's lives across the world and in many settings, modest and prestigious alike. Yet it also opened his eyes to the kaleidoscopic details of how people live in the daily grind and in necessary habit. Because he didn't work at the same job repetitively for decades, because he had such a varied set of careers, he was better able to stand back from the treadmill of regularity and to notice its complexities.

Orwell's discontinuous life, in which he moved across countries, between commitments and through intellectual traditions, helped him to appreciate the preciousness of ordinary things in a way that a more tied-down life might not have. Orwell's life had its monotonies, as does any life. But the frequent interruptions in his life and work helped him more than most to see monotony not only as a hardship but also as a small universe of captivations.

We usually imagine Orwell as a jacket-wearing, moustachioed sceptic with short back and sides who, between puffs on his cigarette, teaches us how to spot the gradual creep of injustice. Much less often do we think of him as a person caught up in the unelaborate business of getting on with life – in the world people bump into when they wake up, when they wash and get themselves ready for the day, when they eat breakfast, go to work, eat lunch, go home and sleep; in short, when people are getting on with being people. Reading Orwell means reading about regular events happening to regular people far more than about the exceptional happening to the exceptional. Even his most phantasmagorical text, *Nineteen Eighty-Four*, has its feet in familiar soil: in a blitzed London strewn with rubble, dirt, mess, broken windows and fragile flowers. But so do all of his books. His attention to the ordinary is his literary signature. He finds as much satisfaction describing the feel of a faint breeze as he does investigating the threat of nuclear war or the fate of democratic socialism. The great critic of totalitarian political systems was also the diarist who liked to count how many eggs his hens laid overnight, or the novelist who tried to reproduce the smell of a corridor and the greasy surfaces of

a canteen. Orwell never seems more himself than when he's jotting down details like the length of a snake caught in his garden, the quality of a good slab of butter or the best way to drill a hole in a piece of wood.

Orwell was engrossed by the trivial; or, more exactly, by the apparently trivial. The act of 'owning up to everyday facts and everyday emotions', as he put it in his essay 'Inside the Whale' (1940), never lost its interest for him. Obsessing over matters of waking, bathing, eating, working, thinking, drinking, moving, resting and dreaming, he repeatedly wrote about (his words) 'the persistent ordinariness of everyday life'. This is not to say he made space in his work for the ordinariness of all existences. He has his natural and preferred perspective, mostly the experiences of the middle-class, heterosexual white man. The critic Daphne Patai calls this Orwell's 'androcentrism', his tendency to think from a masculine point of view and, at times, in line with 'a traditional and damaging notion of manhood'.[4] We will come back to some of these objections to his work, but there remains all the same a tincture of the universal in how Orwell wrote about habit: about the intrigue-filled, wondrous routines that shape the seconds, minutes and hours in which so many people in the world live their lives.

A humble Orwell, then, rather than a grand one. He knew that the little contains the big – that a blocked pipe conjures up thoughts on political stoppage, and that a rancid clot of hair boils down to human scale a totalitarian society that stinks. But the ordinary details in his work aren't simply clues to or ciphers for extraordinary matters. If you take just one thing from *A Bright Cold Day*, I hope it's an appreciation of his frequently

poetic and shrewd descriptions of existence. These telling, delightful nuances that can so easily be missed are enthralling in their own right. And not only enthralling but important too. Orwell's fascination with or even his addiction to the everyday is meaningful, implying that day-to-day life isn't to be looked past in the search for grand structures of meaning and that it's a realm full of complexities, delights, fissures, nuisances and agonies. We tend to miss this or brush it off, individuals and societies alike, in our sprints towards consequence.

Morning

I

Rising

WE'LL NEVER KNOW EVERY WHICH WAY ORWELL WOKE up, or indeed how any long-dead writer got out of bed. We do know in some detail, though, how he liked to remember and to imagine the act of waking. A touching example is his memory of himself as a young boy deserted at St Cyprian's preparatory school in Eastbourne, which he entered as a boarder in 1911 aged eight. He tells of being woken by the summer light and reaching for a book – a volume by Ian Hay, or by W. M. Thackeray, Rudyard Kipling or H. G. Wells – on his bedside table while the other boys around him slept. He laid it all out in the posthumously published essay 'Such, Such Were the Joys' (1952), which needs to be handled carefully because it combines Orwell's broadly reliable memories of real events with what appear to be shrewd, late-in-life reimaginings of his childhood. The tonal ambiguity comes through in his recollections of early-morning reading: 'getting in an hour's undisturbed reading […] in the sunlit, sleeping dormitory' is offset by a memory of waking up to find that he'd wet the bed,

moist cotton adhering to his shamed body. An envelopment: by the dawn in one, by discomfort in the other. 'Oh, the despair,' he writes, 'the feeling of cruel injustice, after all my prayers and resolutions, at once again waking between the clammy sheets! There was no chance of hiding what I had done.' His account of the exposure combines traumatic memory with retrospective eloquence, detailing why the experience was, or why it later seemed to be, so painful. At the bottom of it all is the insight that there's nowhere to hide when the material that's meant to conceal you, a bed sheet, has turned stickily, stinkily translucent.

Here in a nutshell is the full range of Orwell's tales of waking: from sprightly leaps to traumatic revelations. There are also suggestions of anxieties to come, later in his writing, about unsympathetic worlds of spies and double-crossers. The strain of being deposited by his parents in a strange place had its consequences. Whereas decades later bed-wetting among boarding school pupils was taken for granted as a predictable response to abandonment, Orwell reflected later that around 1911 'it was looked on as a disgusting crime which the child committed on purpose and for which the proper cure was a beating.' He recalled feeling cleansed by the thrashing he duly received from his headmaster. When Orwell told his peers that he hadn't been hurt, and his nonchalance was discovered, he was sent in for another beating. This second encounter triggered 'a deeper grief which is peculiar to childhood and not easy to convey: a sense of desolate loneliness and helplessness, of being locked up not only in a hostile world but in a world of good and evil where the rules were such that it was actually not possible [...] to keep them'.

Orwell's time at St Cyprian's helped him to process his thoughts on being young, to better understand what it meant, in remembering, to be grown-up. The most melancholy aspect of the beatings he received may have been that they reminded him that his 'early childhood had not been altogether happy'. His bed-wetting eventually stopped because the habit was beaten away. A 'barbarous remedy', he observed, and one that succeeds 'at a heavy price'. But it did succeed. It exposed him to the realm of power, and to how often insecure people in powerful positions desire to be considered authoritative, expressing their self-disgust through cruelty. 'Look what you've made me do,' shouted the headmaster as the blows fell on Orwell's body. This was power asserting itself on a small platform, 'an expensive and snobbish school', on which he would one day avenge himself by writing one of the most profitable books of all time. *Nineteen Eighty-Four* is, among many other things, a book about receiving the wrong sort of education.[1]

When Orwell received *his* education he was still Eric Arthur Blair, the name he had been given at birth in 1903 in British India. He became 'George Orwell' some thirty years later. Before the publication of his first major work, *Down and Out in Paris and London*, his memoir about poverty across two cities, he settled on the pseudonym to spare his family the embarrassment of his experiences.[2] He had only just decided to become a full-time writer, having spent the five years between 1922 and 1927 in Burma serving in the Indian Imperial Police. His time in Burma eventually turned him into a full-throated critic of empire, giving him memories through which to reflect on the sometimes virtuous, often perverse mechanisms of authority

and to gauge his complicity with them. In empire, Orwell saw corruption, tyranny, censorship, manipulativeness and violence – topics with which he spent a great deal of time over the next twenty years as a novelist, poet, essayist, journalist, diarist and book reviewer. His two most famous texts, *Animal Farm* (1945) and *Nineteen Eighty-Four*, diagnose the horrors of revolutions gone wrong. Yet their shared preoccupation with power, and the ease with which power can be misdeployed, emerges in large part from his years as a police officer and from the regret and self-disgust this occupation generated in him.[3] Adopting the Orwell pseudonym not only meant putting on literary clothes but also meant coming to terms with the man he had once been, and preparing to become the writer he yet hoped to be.

In 1950, at the age of forty-six, Orwell died. By this point he'd published six major works of fiction, several important volumes of non-fiction, and numerous pieces for literary periodicals and newspapers. He'd spent time tramping and living rough, and his novel *Burmese Days* (1934), along with the essays 'A Hanging' (1931) and 'Shooting an Elephant' (1936), had imaginatively recreated his time in Burma. He'd gone to the north of England in 1936 to research the conditions of industrial communities, publishing his thoughts in *The Road to Wigan Pier* (1937). He had also been a soldier, fighting in the Spanish Civil War in 1937 as an international volunteer and writing about it all in *Homage to Catalonia* (1938), a masterpiece of political reportage. By the mid 1940s he'd made his name as a journalist, writing for outlets like *The Adelphi, Horizon, New English Weekly, Partisan Review* and *Tribune*,

among many others, and some of his best-known essays had appeared: 'Charles Dickens' (1940), 'Boys' Weeklies' (1940), 'Inside the Whale' (1940), 'Notes on Nationalism' (1945), 'Politics and the English Language' (1946) and 'Why I Write' (1946). By the time he died Orwell had had a varied career not only as a writer but also as a dishwasher, schoolteacher, private tutor, farm labourer, bookshop assistant, smallholder, village store owner and radio broadcaster. His novels of the 1930s – *Burmese Days*, *A Clergyman's Daughter* (1935), *Keep the Aspidistra Flying* (1936) and *Coming Up for Air* (1939) – had all been shaped by these experiences. He had served in the Home Guard during the Blitz and worked for the BBC as a talks producer, frequently enduring ill health throughout his life which never allowed him to forget his body's limits. In the end, he succumbed to tuberculosis.

Orwell's parents had sent him to St Cyprian's, aided by a scholarship, to give him a fighting chance of getting into the right kind of secondary school: Harrow, or maybe Eton (which he duly went to as a King's Scholar in 1917). Looking back, he portrayed the prep school as a proto-totalitarian state filled with 'overcrowded, underfed, underwashed' boys who were ruled over by the brutally capricious headmaster and headmistress, Sambo and Flip (code names for Vaughan and Cicely Wilkes). Orwell recalled that he was given an 'abrupt awakening' when he arrived there at the start of term:

> a feeling of: 'This is reality, this is what you are up against.' Your home might be far from perfect, but at least it was a place ruled by love rather than by fear, where you did not have to

be perpetually on your guard against the people surrounding you. At eight years old you were suddenly taken out of this warm nest and flung into a world of force and fraud and secrecy, like a goldfish into a tank full of pike.

Remembering St Cyprian's was evidently traumatic, but then so was the experience of attending it. Orwell recalled having hatred in his heart during his time there. But not everything was evil about the place. And some of the most evocative memories came from that recollection of the deceptively simple act of rising from sleep: the boy leaping out of bed into a sunlit dormitory; the boy waking up at night, cold, afraid and wet.

The apparent simplicity of waking up, of opening your eyes in the morning, haunts the main character of *Nineteen Eighty-Four*, Winston Smith, who lives in a radically changed England of the near future. This is Airstrip One, in Oceania, a single-Party society led by the elusive (and possibly imaginary) figure of Big Brother. Winston, who belongs to the Outer Party, works at the Ministry of Truth, where he labours day by day to rewrite the historical record and to bring the past into alignment with whatever the ruling caste, the Inner Party, announce Big Brother's priorities to be. Conformity is ensured through the controlled oversimplification of language into Newspeak, the state-approved dialect; through political populism, nationalism, antisemitism and xenophobia; through constant surveillance via the omnipresent telescreens, which allow the state simultaneously to broadcast propaganda and to spy on its citizens; and, behind it all, through the watchful operations of an enigmatic constabulary known as the Thought Police.

A permanent, endlessly mutable state of war with Oceania's neighbouring powers, Eurasia and Eastasia, means individuals can be stripped of their liberties with impunity. There are no laws in Oceania and so nothing is illegal – which is just another way of arranging matters so that everything is forbidden aside from what the ruling powers deem tolerable (which is little indeed). Winston falls in love with a mysterious girl from work, a fellow Outer Party member named Julia, and through their sexual intimacy defies the system. But not for long. O'Brien, a member of the Inner Party who at first seems on their side, turns out to be their captor and inquisitor. Winston and Julia resist but are eventually broken in Room 101, which is tailored to every person's worst fear. Confronted with the prospect of having his face devoured by rats, Winston surrenders. He gives up Julia, and in doing so gives up everything he is. Oceania's victory is total. There's nowhere to run, nowhere to hide. The system is designed to crush you.

By the end of *Nineteen Eighty-Four*, Winston has learned to love Big Brother, the Stalinesque dictator-deity whose face gazes at Oceania's citizens from the ubiquitous posters that carry his image. But Winston's learning is a forced conversion organised by agents of the state. As a member of Oceania's middle class, Winston feels that something is wrong with the world even though he can't articulate how it might be put right. There seems to be some hope in the proletarians, the large group of dispossessed citizens excluded from the Party who may have the collective power to overthrow the government if only they can become conscious of their sheer strength in numbers. O'Brien and Julia seem like people with whom to cultivate

saving relationships. Julia opens up Winston to unpermitted delights (sex, coffee, chocolate and perfume) in a society that has turned against all pleasures other than those offering hymns of praise to Big Brother. Apparently on their side, O'Brien recruits Winston and Julia into the mysterious Brotherhood, a secret organisation led by Big Brother's nemesis, Emmanuel Goldstein. Winston and Julia are eventually whisked away to the Ministry of Love, where O'Brien's purpose is revealed: he is to play the part of 'a teacher taking pains with a wayward but promising child' – the torturer-intellectual who will bring Winston, the student, into line. Curiosity kills the cat. Winston is undone by his desire to educate himself about the world. In Oceania, waking up to the truth is dangerous.

But let's not get ahead of ourselves. The awakenings depicted in *Nineteen Eighty-Four* were shaped by a lifetime's thinking about what waking up means, or what it can be made to mean. 'Such, Such Were the Joys', written alongside *Nineteen Eighty-Four* but published after it, shows that long after he'd left school, Orwell remained fascinated by the things to which the act of waking up can lead. The essay is an attack on what Richard Voorhees has called 'small-scale tyranny': the everyday authoritarianism of the powerful in situations with low stakes and high expectations.[4] As an attack, and like many memoirs, it has its exaggerations. Not everyone remembered being a student at St Cyprian's as Orwell did. Some, like his contemporary Henry Longhurst, had been happy there.[5] But the essay is arguably at its most interesting when read as a sign of Orwell's traumatic recollection of the boy he once was. The keynote of 'Such, Such Were the Joys' is remembering the frightened anticipation of

being chastised for bad behaviour. Orwell could freely jump to his books because his headteachers and matrons didn't know he was awake. His punishment for wetting the bed, by contrast, came about because he'd cried in the dark.

Waking up, and being woken up, came to have different meanings for Orwell in the years that followed. When he returned from British Burma, he quickly worked to abandon the privilege his education and overseas employment had given him. He recalled the task in *The Road to Wigan Pier*, in which he states that he was left 'with a bad conscience' following his time abroad, where he 'had been part of an oppressive system':

> Innumerable remembered faces – faces of prisoners in the dock, of men waiting in the condemned cells, of subordinates I had bullied and aged peasants I had snubbed, of servants and coolies I had hit with my fist in moments of rage (nearly everyone does these things in the East, at any rate occasionally: orientals can be very provoking) – haunted me intolerably. I was conscious of an immense weight of guilt that I had got to expiate. [...] I felt that I had got to escape not merely from imperialism but from every form of man's dominion over man. I wanted to submerge myself, to get right down among the oppressed, to be one of them and on their side against their tyrants. And, chiefly because I had had to think everything out in solitude, I had carried my hatred of oppression to extraordinary lengths. At that time failure seemed to me to be the only virtue. Every suspicion of self-advancement, even to 'succeed' in life to the extent

of making a few hundreds a year, seemed to me spiritually ugly, a species of bullying.

There are moral contortions, not to mention dated language, in this account, and the admitted shame of complicity does not cancel out the ploy of defensive reasoning either. Orwell's fury and intolerance is to be traced back, unpersuasively, to those who felt the smack of his hand. But there is also a genuine desire for atonement. He wanted to make up for having been part of a system he had come to despise. The way to do this was through abandoning one life, the life of the dominator, in order to embrace another, the life of the governed. Having been one of their masters, he could not submerge himself in the oppressed of Burma, so he sought out the oppressed back home.

Orwell's biographer D. J. Taylor remarks that, as with 'many an explanation of past events', this comes 'coated with retrospective certainty'.[6] Looking back, Orwell made his decision 'to get right down among the oppressed' seem more straightforward than it probably was. But he did decide to do something, however much the rationale for doing it may have been jostling in his mind. His first port of call was London's East End, where in 1928 he paid for a night's accommodation in a common lodging house. He had set his mind on 'tramping'. By the middle of that year he'd moved to Paris, where he sought out the rough experiences in the city's hotels and kitchens and on its streets and side alleys that enabled him to write a draft of *Down and Out in Paris and London*. By August 1931 he'd produced a revised version of this text that benefited from these experiences and from further tramping expeditions in the

British capital. Much of what he witnessed turned on the fact that destitute people don't often have a choice about whether or for how long they sleep.

One episode stands out. Writing to his friend Dennis Collings in August 1931, Orwell described a couple of nights spent camping in Trafalgar Square, an experience that stayed with him. The central chapter of his novel *A Clergyman's Daughter*, which portrays just such a night in Trafalgar Square, speaks to it. Part of what fascinated Orwell about the scenario was how London's police officers insisted on making those who were sitting on the floor stand up and on waking those who had fallen asleep. Sleep was possible in snatches, but only when permitted by the police. Between 9 p.m. and midnight it was impossible to sleep for more than five minutes before a booted officer appeared. After midnight you'd be lucky to get half an hour. Between 5 a.m. and 7 a.m. there was an opportunity to sleep with your head on a table in a nearby café before the proprietor kicked you out. He concludes the reminiscence with the thought: 'For all this no ostensible reason.' He was too astute an observer not to grasp that at one level the reason was control. The police woke him up not only because he was committing a crime (vagrancy) that made himself into what many passers-by would consider an inconvenience, but also because the police had power and he did not. Winston Smith gets the same treatment in the Ministry of Love, where he's forced to wait for his torture in a holding cell whose lights are never switched off. Sleep is impossible because they're so bright and a 'deafening roar' will sound from the telescreen at the first hint of tiredness. And if that fails, the kick of the booted

guards will get the job done. Being woken up in this way is what it feels like to be touched by a politics unsympathetic to the plight of the needy.

Orwell's commitment to being destitute, or to at least empathising with the disenfranchised, extended to a willingness to be arrested. In December 1931, he hatched a plan 'to get drunk and incapable' on the Mile End Road. Having been discovered by two officers, he was taken under arrest to Bethnal Green police station. He hoped to get himself jailed so he could gain experience of what it would be like as an inmate. Orwell recalled that he'd drunk so much that his time in the station was boring and that the next morning he was 'horribly sick', much sicker than he'd ever been before. The affair may also lie behind one of the most entertaining moments in his 1936 novel *Keep the Aspidistra Flying*. At one point its protagonist, the self-pitying poet Gordon Comstock, wakes up in a prison cell having been out on the razz. Opening his eyelids is a near-impossibility. He finds it hard to stand on his feet. His throbbing head is matched only by the pain of an electric light that seems 'like some scalding white liquid pouring into his brain through the sockets of his eyes'. Unable to deal with the situation, he turns his face away from the light and pulls a blanket over his head. As anyone who's ever had a hangover will attest, opening your eyes and getting out of bed can be all but impossible when you want to stay buried.

There are days, too, when waking is epiphanic, exuberant, the measure of rest well taken and often richly deserved. But waking can also be disorientating, brisk, painful or worry-laden, among so many other things. For these reasons, waking is never

merely waking. It's always a matter of waking up *to*, or finding yourself woken up *by*, a specific feeling or emotion. There's a paper-thin dividing line between waking (in the ordinary, daily sense of rising from sleep) and awakening (in the metaphorical sense of coming into existence or awareness), the one always at some level entailing the other. When we wake up in the morning, we don't just open our eyes: we come into consciousness of ourselves; we exist anew. And the breakdowns in this process are at least as interesting as the successes. When we say, or when we're told, that we've woken up on the wrong side of the bed, there's an implication that our best self is still asleep, that we haven't actually woken up. Just as waking up involves an awakening to ourselves, there may also be a disclosure in our inability properly to shake off slumber.

One context in which to understand Orwell's interest in the possibilities of waking and awakening is the influence of H. G. Wells, whose work Orwell devoured in his youth and whose opinions shaped so many of his own. His childhood friend Jacintha Buddicom recalled that the young Orwell (he seems to have been aged around twelve) coveted the copy of Wells's *A Modern Utopia* (1905) in her home. It was eventually given to Orwell, or Eric as he then was, who proclaimed that 'he might write that kind of book himself'.[7] His editor and biographer Peter Davison has written that Orwell's intention 'might, with only a little romantic exaggeration, be seen as the moment when *Nineteen Eighty-Four* was conceived'.[8] But whatever the young Eric may have thought, the adult Orwell certainly recognised that he and the other writers of his generation were in some sense 'Wells's own creation', as he put it in his essay 'Wells, Hitler

and the World State' (1941). He added: 'How much influence any mere writer has, and especially a "popular" writer whose work takes effect quickly, is questionable, but I doubt whether anyone who was writing books between 1900 and 1920, at any rate in the English language, influenced the young so much. The minds of all of us, and therefore the physical world, would be perceptibly different if Wells had never existed.'

A Modern Utopia, Wells's contribution to the genre of books written about ideal societies running back to Thomas More's *Utopia* (1516) and beyond, hinges on what it means, culturally and politically, to be awake. Having visited a modern version of More's ideal country, and finding himself back in the real world, the protagonist of *A Modern Utopia* says to a friend: 'You think this is real because you can't wake out of it [...]. It's all a dream, and there are people – I'm just one of the first of a multitude – between sleeping and waking – who will presently be rubbing it out of their eyes.'[9] The other major text here is Wells's *The Sleeper Awakes* (1910), a now rarely read dystopian novel that Orwell characterised as 'a vision of a glittering, sinister world in which society has hardened into a caste-system and the workers are permanently enslaved.' The society of Wells's text is 'a world without purpose, in which the upper castes for whom the workers toil are completely soft, cynical and faithless. There is no consciousness of any object in life, nothing corresponding to the fervour of the revolutionary or the religious martyr.' When Orwell wrote his version of the same story, the emphasis fell not on a man falling asleep in one era and waking up in another, but on the terrifying prospect of a man, Winston Smith, who knows he's awake in a world of

sleepers. Winston's 'moment of wakefulness', when it comes in the form of his subjection to the blinding lights of the Ministry of Love, is the dreadful prelude to a 'blissful dream' of love for Big Brother.

Orwell's books contain many scenes of waking that encapsulate these nuances and tensions, and that evoke the Wellsian origins for so much of what he wrote. *Animal Farm*, a fairy story, starts with the wise pig Old Major announcing to the gathered animals his dream for an Animalist future. After they first throw off the yoke of Mr Jones's tyranny, the animals sleep like they've never slept before. What follows is a tribute to the joy in the ecstatic stirrings of the well rested:

> They woke at dawn as usual, and suddenly remembering the glorious thing that had happened they all raced out into the pasture together. A little way down the pasture there was a knoll that commanded a view of most of the farm. The animals rushed to the top of it and gazed round them in the clear morning light. Yes, it was theirs – everything that they could see was theirs! In the ecstasy of that thought they gambolled round and round, they hurled themselves into the air in great leaps of excitement. They rolled in the dew, they cropped mouthfuls of the sweet summer grass, they kicked up clods of the black earth and sniffed its rich scent. Then they made a tour of inspection of the whole farm and surveyed with speechless admiration the ploughland, the hayfield, the orchard, the pool, the spinney. It was as though they had never seen these things before, and even now they could hardly believe that it was all their own.

Having taken the step out from and beyond their enslavement, the animals wake up in – and to – their utopia. Old Major calls it 'a dream of the earth as it will be when Man has vanished'. Only when it's too late do they realise that Man hasn't vanished but transformed his designs on their liberty, that the pigs have betrayed them, and that there's little difference between human masters and piggish overlords. As the book's concluding sentence runs: 'The creatures [...] looked from pig to man, and from man to pig, and from pig to man again: but already it was impossible to say which was which.'

Waking in *Animal Farm* can be a process of revelation. Yet we've already seen how Orwell could interpret waking as a form of torture. The morning after a night of revelry in the farmhouse, a deep silence hangs over the place. Not a pig stirs. At almost nine o'clock, the pig Squealer, the arch-propagandist to the Stalinesque pig, Napoleon, emerges from the building, 'walking slowly and dejectedly, his eyes dull, his tail hanging limply behind him, and with every appearance of being seriously ill'. *Awful news, Comrades. Napoleon is dying.* We know different. Napoleon has had too much to drink. The pig's hangover, itself a hangover of Mr Jones's rule, can't be hidden away, so it must be brought differently into view. An excuse is found to blame Napoleon's old enemy, the Trotsky-like pig Snowball, for the misdemeanour of having 'contrived to introduce poison into Napoleon's food'. Henceforth, drinking alcohol is to be a crime punishable by death, a decree meant to enforce the Fifth Commandment of Animalism, the animal's creed: 'No animal shall drink alcohol'. It doesn't take long for the animals to think that they never understood the commandment in

the first place. Now changed to read 'No animal shall drink alcohol *to excess*', the injunction enjoys the delicious ambiguity of a sanction – the status of something simultaneously allowed and forbidden. Napoleon's headachy efforts to open his eyes are not the eye-opener for the animals that they should have been.

On the evidence of *Animal Farm* alone, it seems that Orwell recognised that waking up can be a risky business. He wrote in September 1940, right at the outset of the Blitz, that it's 'always pleasant to awake from a nightmare, even when it is an air-raid siren that wakes you'. Being woken up from a nightmare by an air raid siren is relatively good, in the circumstances. It also points to his grasp of how waking up from a bad dream in the later months of 1940 could expose you, in London's ruined architecture, to corpses, falling bombs and devastated streets. Orwell wrote in a diary entry earlier that same year about how although it was 'natural to get up' at the sound of an air raid alert, sometimes you discovered that the alarm was false and you weren't in any danger after all. Such occasions could in their way be worse than actual bombardment, inducing feelings of shame at having been spared when others had died. He argued that the real point of air raids is not to drop bombs per se but to generate warnings that keep people awake. One of the Nazis' goals had been to create an exhausted England that would be easier to defeat: 'Hitler only needs to send his planes over half-a-dozen at a time to hold up work and rob people of sleep to an indefinite extent.'

Here is a statement about the impact of actual bombing runs on sleep. Yet Orwell had long since used the imagery of bombs

and explosions to describe startled wakefulness. When Dorothy Hare, right at the start of his novel *A Clergyman's Daughter*, is 'wrenched from the depths of some complex, troubling dream', she hardly leaps out of bed in grateful abandon. On the contrary, she gets up in a state of 'extreme exhaustion'. And Dorothy is certainly a tired young woman. *A Clergyman's Daughter* is a novel about how she's forced against her will into a sequence of gruelling scenarios. Dorothy lives at home in Knype Hill (loosely based on the seaside town of Southwold, in Suffolk, to where Orwell's parents retired) with her father, the Rector Charles Hare, who treats her as an inconvenience yet depends on her to run the household. After a long day of parish duties, Dorothy is cornered by the creepily overfamiliar Mr Warburton. Two years earlier he had made love to Dorothy – in the old sense of courting – 'violently, outrageously, even brutally'. The suggestion of sexual violence is echoed later when Warburton kisses Dorothy against her will. She then has some sort of episode, which the narrator does not describe, waking up in London with no memory of who she is or how she got there. A trauma has been inflicted. Falling in with a crew of itinerant youths, she goes to work in the Kentish countryside picking hops, later finds herself spending the night in Trafalgar Square amid beggars and tramps, works at a school and then makes the slow return to Knype Hill, all the while learning about who she is and what she wants from the world. There's a lot of Orwell's life in the book, which ends much as it begins, with Dorothy doing parish chores. Absorbed in the task of making costumes for the local school play, she forms an image that he would repeat: a worker lost in their work.

The alarm clock that rouses Dorothy at half past five in the morning, so she can get on with the day's main business of serving her father, explodes 'like a horrid little bomb of bell metal', carrying on with a 'nagging, feminine clamour' that can't be ignored. The line's dated gender politics may be obnoxious, but they're also finely tuned to the novel's focus on power imbalances between the sexes. Dorothy's father, the clergyman of the book's title, handles his daughter in these terms: as a nagging little warning voice he'd rather do without. His 'incurably soured' temper alienates his daughter along with 'every man, woman and child in the parish'. As a patriarchal symbol, the alarm clock can't be disregarded, because it exemplifies how Dorothy is positioned by the male-controlled environment in which she exists. A few self-admonitions put her on her way. Dorothy turns off the clock before it wakes her father. Waking can be a release, but it can also be an entrapment, and Dorothy proves the point. Emerging from sleep frees her from a nightmare, but the return to consciousness isn't exactly restorative.

If it's always pleasant to wake up from a nightmare, then the opposite seems equally true – that waking from a pleasant dream is rarely enjoyable. There's a curious incident early on in *Nineteen Eighty-Four* when Winston Smith wakes up from a dream with the word 'Shakespeare' on his lips. Winston has had an erotic vision of revolt. No doubt he would rather have stayed asleep. He dreams of Julia walking towards him across a utopian landscape, the Golden Country. She throws off her state-sanctioned clothes as she approaches. But it's not the sight of her naked body that titillates him; rather, it's *how* she throws off her clothes that is so erotic. 'With its grace

and carelessness,' Julia's gesture of defiant self-exposure seems 'to annihilate a whole culture, a whole system of thought, as though Big Brother and the Party and the Thought Police could all be swept into nothingness by a single splendid movement of the arm.' What follows is both symbolically appropriate and unintentionally comical. As a relic of an ancient time, Shakespeare seems to encapsulate all Winston holds dear against the tyrannies of Big Brother. Yet who wakes up from a naughty dream and utters the name of England's national poet? It's not entirely clear that Winston's ejaculation is strictly (or even solely) verbal.

The obvious implication of these scenes and sites of waking is that Orwell meant to connect waking up (opening your eyes, emerging from sleep) with the metaphor of waking from some limiting or liminal place or condition – a political arousal. Winston's arousal in this sense, even though it leads nowhere, is erotic before it's truly political. So many of Orwell's protagonists are 'wakeful' in this extended sense of the term: on the verge or in the throes of some new consciousness. And it just so happens that his interest in the idea goes right back to the start of his career. Orwell isn't known as a poet, and rightly so. The poems he wrote throughout his life aren't his best work. But some of his most striking images of waking appear in them. A good example is 'Awake! Young Men of England' (1914), which was written by the young Eric Blair when he was still at St Cyprian's. The poem closes by exhorting England's 'young men' to 'enlist by the thousand' in the fight against Germany, for fear of revealing themselves to be 'cowards indeed'. Two decades later, and faced with the prospect of another conflict,

the Spanish Civil War, making huge demands on the average citizen, Orwell was again minded to reflect in poetry on the spirit of the age. 'A Happy Vicar I Might Have Been' (1936) is Orwell's address to 'an evil time' on the brink of war. An allusion to Lewis Carroll precedes its rousing finish:

> I dreamed I dwelt in marble halls,
> And woke to find it true;
> I wasn't born for an age like this;
> Was Smith? Was Jones? Were you?

Smith, Jones – two names Orwell would use again. And an echo, too, of the concern found in his pamphlet *The Lion and the Unicorn* (1941) about England being a nation of sleepwalkers (an idea we'll come back to again in this book).

Orwell's fears were partly to be realised in the Blitz, which gave him plenty of opportunities to reflect on the connection between literal and symbolic awakenings. The first experience of the day – opening our eyes, returning to consciousness – isn't something we fuss over unless circumstances dictate otherwise. Up we get and on we go, unless we can't or won't. The Blitz turned this process into a constant fear of being woken up to be bombed, or of being bombed while asleep without the chance to wake: a challenge to a nation under fire. It had a dream logic: the Blitz was an awakening, but it was also an interruption that troubled distinctions between fantasy and reality. Orwell wrote in his essay 'New Words' (1940) that 'the waking mind is not so different from the dreaming mind', and *Animal Farm* and *Nineteen Eighty-Four* exploit this thin

divide between dreaming and waking to superb effect. There remains something fascinating, all the same, about Orwell's accounts of the ordinary act of waking as such – with getting up and getting on. He drew a line from waking up, and from being free to wake up, to the end of liberty; not in the sense of stirring 'one Monday morning […] to a world of slogans and rubber truncheons', although that fear was real enough, but in the sense of never quite knowing whether liberty is a dream.

II

Washing

ORWELL'S BAD MEMORIES OF ST CYPRIAN'S MIXED WITH good ones, which usually related to summertime: carefree jaunts to nearby villages or swimming in local bathing spots, wandering about the grounds as twilight approached, keeping caterpillars and finding newts in the neighbouring woodlands. In a telling set of recollections he focuses on what he called 'memories of disgust' associated with bad food and repellent tableware: the pewter bowls in which sour porridge was served at breakfast, the rims of which were caked with ancient grime, the porridge a stomach-churning mix of 'lumps, hairs and unexplained black things'. And then there was the whole-school plunge bath, a ghastly affair filled with oily water that was rarely changed. He may have been most sickened by the 'cheesy smell' of the towels. Matters were hardly much better when the pupils washed themselves in the 'murky seawater' of the local baths. Orwell recalled having once seen a 'turd' float past him there. 'It is not easy for me to think of my schooldays,' he wrote, 'without seeming to breathe in a whiff of something cold and evil-smelling – a sort of

compound of sweaty stockings, dirty towels, faecal smells blowing along corridors, forks with old food between the prongs, neck-of-mutton stew, and the banging doors of the lavatories and the echoing of chamber-pots in the dormitories.'

He was a student of the sordid and repellent. Personal hygiene was central to the many life experiences which found their way into his books, and especially into *Nineteen Eighty-Four*, including his horror at the sound of grimly reverberating toilets. The thought of Comrade Parsons, Winston Smith's neighbour, using a lavatory 'loudly and abundantly' in a waiting room in the prison-like Ministry of Love proves the point, its surreal foulness puncturing the trauma of incarceration inside Oceania's master-dungeon. The scene is the occasion for various perverse self-cleansings. Before being taken away to who-knows-what punishments, Parsons clears his bowels in a flustered parody of early-morning routine. A woman who may or may not be Winston's mother is brought into the chamber, roaring drunk. In a different world this would have been the contrite morning after the gaudy night before; either way, she isn't herself. She vomits 'copiously on the floor', forcing Winston to smell the bitter tang of alcohol on her breath. An evacuation from the body before the body, her body, is evacuated to some unknown place elsewhere in the building. Winston's thoughts take him to the memory of razor blades – not for shaving, but for ending his life. This smuggled blade, which he hopes to receive from the mysterious Brotherhood, the unlocatable enemies of Big Brother, will never arrive.

Orwell's novels bear the mark of a lifelong fascination with 'squalor and neglect'. He found both in abundance at St

Cyprian's and couldn't stop seeing them everywhere he looked in the years that followed. He left the school in December 1916 and spent a brief term at Wellington College, in Berkshire, before starting at Eton in May 1917. Though he had already secured a scholarship, he'd had to wait for a place to become available. Life at Eton was in some ways similar to life at St Cyprian's: comparably hierarchical, similarly full of opportunities for disgust and pain. Christopher Hollis, a contemporary of Orwell's at Eton, remembered its 'régime of fairly rough justice'.[1] In other respects, Eton opened up Orwell's world. He looked back on his time there as 'relatively happy'. Jacintha Buddicom wrote: 'The atmosphere of Eton was entirely different from that of Wellington,' which was run on more Spartan lines, 'and Eric, good at swimming, took to it as a duck to water.'[2] Another Eton contemporary, Denys King-Farlow, recalled the swimming in particular: 'Blair loved swimming (as appears often in his writing) but never bothered about swimming or diving with any style.'[3] How well or with what agility he swam was less important than the fact that he was keen to swim. It may, in some roundabout way, have been a compensation for all the childhood grubbiness he'd endured.

After Eton, Orwell sought to join the Indian Imperial Police. He was appointed as a probationary assistant superintendent in October 1922, having passed the exams with average grades. He sailed for Rangoon on a little bit of England going east, the *Herefordshire* (a cargo ship built in 1905 by Harland & Wolff, Belfast, the same firm that constructed the RMS *Titanic*), arriving in Burma in November. He was to spend five years there, training to become a small but important part of Britain's

imperial machinery and having experiences that gave him the ideas for some of his most celebrated prose. Orwell clearly wanted to serve. He wouldn't have applied if he hadn't. His biographer Jeffrey Meyers puts it well when he says that 'Eric Blair thought his career in Burma would be a great adventure.'[4] This was to be a test, a way to grow up. When Orwell wrote about it all later on in his life he'd become a different person with a different agenda: a professional writer. In retrospect, the experience of empire looked to him a decidedly filthy business. The writer in him needed the adventure to have failed, or at least to have been different from what the school leaver had once imagined it might be like.

Where Orwell's reminiscences and stories are to be trusted is in the fact that Burma gave him enough content for a career's worth of books. Whether he experienced all that he writes about in them is another matter. His novel *Burmese Days* and his essays 'A Hanging' and 'Shooting an Elephant' imply that in Burma he witnessed criminals executed and animals killed; that there he was exposed to the irrational behaviour of crowds and to the self-serving actions of the privileged; that he saw something of the world's beauty, but that he also encountered corruption, inefficiency, stupidity, wastefulness and decadence; that he came to a new understanding of himself. He was prepared to admit in 1929 that the colonial power in Burma had its 'good and bad sides', but it was the bad sides that came to dominate what he thought about the 'despotic', 'self-interested' character of British imperial control. He later wrote that his five years of police service left him with a hatred of the imperialism he served, a 'bitterness' he couldn't fully convey. 'In order to

hate imperialism,' Orwell insisted, 'you have got to be part of it.' *Burmese Days*, a veiled reminiscence of certain aspects of his time abroad, picks up that bitterness and runs with it. Yet whether the novel accurately reflects his feelings about Burma when he was there, serving the Empire in its territories, is the wrong question to ask. Colonial Burma as he came to feel about it years later, and as the novel's protagonist John Flory terms it, was 'a stifling, stultifying world in which to live' – a world of censorship, debauchery, boredom, vassalage and lies. Begun in 1931, *Burmese Days* is a novel about what empire meant to Orwell in the early 1930s, not how he'd experienced it in the mid 1920s.

The novel begins with the crocodilian Burmese villain U Po Kyin, sub-divisional magistrate of Kyauktada, scheming about how to destroy the reputation of Dr Veraswami, an Indian civil surgeon and superintendent of Kyauktada's jail. Veraswami is Flory's friend and confidante, a person to whom he can confess his hatred of all that the British Empire represents. A timber merchant by trade, Flory tries to make Veraswami understand his point of view, but with no success; the doctor idolises everything about the British and will not be shaken from his convictions, even when Flory spills the beans on the racist chatter that regularly takes place between his compatriots in the nearby European Club. U Po Kyin hopes to discredit Veraswami in his efforts to join the Club so he can take his position and acquire the 'prestige' he feels he's due. Flory, another self-hating Orwell protagonist, wants to share his life in Burma with someone who will understand him. For a time it seems that this person might be Elizabeth Lackersteen, an

English woman who has recently arrived in the country and who contrasts starkly with the local woman Flory has taken as his concubine, Ma Hla May, whom he despises. All too quickly, Flory is upstaged by a young cavalry officer, Verrall, and before long he's ousted from Elizabeth's affections. Flory and Elizabeth reconcile when Verrall departs, only to be split again through U Po Kyin's scheming: he has tutored Ma Hla May to cause a scene in front of Flory during a church service, and to make Elizabeth disgusted with him. The plan works. Abandoned and without any hope of the future he craves, Flory kills his dog and then shoots himself. Victorious, U Po Kyin ascends to membership of the Club, only to die from apoplexy shortly after his retirement.

A man of about thirty-five (so many of Orwell's characters are 'about' a certain age), Flory is a version of Orwell as he might have been had he gone to Burma and stayed there. One of the first details we learn about Flory is that he often forgets, or neglects, to shave. And no wonder, given that he doesn't make the effort to shave unless he has 'a few drinks inside him'. We can forgive him that. A stiff drink for a stiff upper lip, or at least for the appearance of one. A mirror reveals more of Flory to himself than he'd like: 'He felt his scrubby chin and lounged across to the mirror to examine it, but then turned away. He did not want to see the yellow, sunken face that would look back at him.' There is a disgust here that recalls how Burma's natural spaces have been ravaged: landscapes eviscerated, 'forests shaved flat – chewed into wood-pulp for the *News of the World*, or sawn up into gramophone cases.'[5] Flory hesitates to shave because a smooth chin binds his morning routine

to the economics of colonial industry, and not least because 'every particle of his body [is] compounded of Burmese soil'. The point is worsened by the fact that Flory's stubble grows quickly enough to warrant two shaves a day. One shave is a tragedy; two, a farce.

Flory's mirror is a giveaway. He can't bear to look at himself in the mirror because he's ashamed of the 'hideous birthmark' that runs down the left side of his face. Other characters reject his birthmark's supposedly 'dishonouring' and 'unforgivable' implications.[6] The mirror, though, tells Flory a different story about himself. Mirrors show us as we are, rather than as we would like ourselves to be. While he's a fine critic of the failings he sees everywhere about him, Flory struggles to acknowledge his own inadequacy – not the alleged inadequacy of a birthmark, which is a part of who he is, but the deeper inadequacy of his questionable temperament. When Flory's friend, the well-meaning Dr Veraswami, declares that he stands in Flory's reflected glory, we know the good doctor is being naive. The truth is that Flory is a resentful man who is childish and easily conned. Rebuffed by the woman he craves, Elizabeth, he kills himself not because he's cowardly (that would be a cruel trick by any standard), but because Orwell needed him to serve a symbolic purpose: to show the misery to which the 'stifling' atmosphere of imperialism can lead.

The mirror here reminds us that there's something disturbing about our morning rituals of cleansing, because morning is when we're least ideally ourselves, least 'made-up'. Those who put on make-up in the morning start the day by making themselves, by creating their disposition. Elsewhere in his

work Orwell makes a number of references to women 'caked' in make-up. These come partially from his stores of misogyny, but they also express his interest in how cosmetics disguise their wearers and in how the enhanced face becomes a mask. Washing away dirt and oil from our skins exposes us, in being washed, to our own glances and assessments. Very often we don't like what we see. As a dirt and filth obsessive, Orwell might have said that washing away dirt reveals the soiled self beneath. Our rituals of preparedness are pantomimes, and ablutions don't necessarily entail abolitions. There's pleasure in the ritual, but no amount of ritual can smooth away those thoughts, when they come, that somehow what we do when we get ourselves washed and ready for the day is ridiculous. These rich ambiguities are right there in the word *ablution*, whose 'ab-' prefix signals the ditching of something, unwashedness, that will shortly return in the need to wash oneself once more. The etymology of the term highlights its ceremonial origins (washing the body as a religious rite), whereas its history of use evokes its association with pomposity. Perhaps this is why, in *Keep the Aspidistra Flying*, Gordon Comstock eventually starts only to wash 'the parts that show' – meaning less work, less ritual and less exposure to self-scrutiny.

Orwell's first-person novel *Coming Up for Air*, the title of which alludes to an act of immersion in water, begins with a washing scene, and a bit of shaving. Stately, plump George Bowling reaches for a 'bluntish razor-blade', slyly echoing the start of James Joyce's Ulysses (1922).[7] Unlike Flory, Bowling can bear to look at himself in the mirror. There's a touch of narcissism about the man:

> I haven't such a bad face, really. It's one of those bricky-red faces that go with butter-coloured hair and pale-blue eyes. I've never gone grey or bald, thank God, and when I've got my teeth in I probably don't look my age, which is forty-five.

When he washes, Bowling makes sure, as Orwell makes sure through him, that we know he's fat. In context, Bowling's portly proportions are meant to suggest his middling qualities, just as his surname might make some readers think of bowling balls.[8] The idea motivating the story, George's decision to do a bit of sightseeing back home in Binfield, comes to him the day he gets his new false teeth: a new falsity to go with the faux-antique interiors of Binfield's suburban homes and with the spurious forms of nostalgia the novel will spend so much time investigating.

Like 'teeth in a skull', Bowling's dentures are a memento mori, a reminder that everything decays, and that nostalgia, in 1939, is no defence against the loss of the past or the arrival of the future, with its threats of bombs and rubber truncheons. As substitutes for some prior, now-lost original, Bowling's teeth match what happens when he starts to get dressed. After he's washed himself, he sits in the bath. He doesn't know that he hasn't washed off all the soap on his neckline. Stickiness unsettles him, as it so often did Orwell; it puts him 'into a demoralised kind of mood', taking all the 'bounce' out of him, 'like when you suddenly discover in a public place that the sole of one of your shoes is coming off'. It's an example of what the critic David Trotter has described as the bloom slipping away

from fantasy, a subtle corrosion of 'the idea of yourself' you have prepared for the world's inspection:

> The treacly blob which suddenly materializes on the hem of a dress, just as you are about to go out for the evening, or the black mark etched with the force of acid into a shirt-collar, are worse than irritating. [...] You can change your clothes, but you cannot restore that feeling of absolute readiness; you cannot restore the anticipation.[9]

Bowling observes how the 'queer thing is that, however carefully you sponge it away, when you've once discovered that your neck is soapy you feel sticky for the rest of the day'. The mess puts him in a bad mood; he can't recover the feeling of being ready to get up and go that he once had, and his family is forced to suffer his irritations. And when he leaves the house, a gust of wind makes him aware of his body and of how his clothes don't seem to fit him. The ritual hasn't worked. Getting ready for the day has made him sticky, and stickiness, for Bowling, puts everything at risk of coming unstuck.

The mirrors that evoke such different responses in Flory and Bowling have a perverse counterpart in that passage in *Nineteen Eighty-Four* when Winston is forced to look at his reflection by O'Brien, after a long spell of torture in the Ministry of Love. Winston is frightened by what he beholds, which seems alien and unnatural. Another memento mori: he knows he's looking at himself, a 'bowed, grey-coloured, skeleton-like thing'. That knowledge makes it worse. He can't pretend the reflection is of someone else's body. The mirror forces him to take himself

as he is, magically providing an exterior perspective on the degradation he's felt in his bones but not yet witnessed with his eyes. The crueller act may be that O'Brien gives Winston some respite from this slow hollowing-out of his body by feeding him up and letting him bathe before he's turned over to the horrors of Room 101. Like George Bowling, Winston is given a new set of dentures. He's permitted 'to wash himself fairly frequently in a tin basin', and with warm water too. But the good fortune doesn't last. Before long, Winston is back in O'Brien's sights. Winston is the sacrificial victim having experienced a lustration or ritualistic purging. All traitors in Oceania are 'washed clean', we're told. Winston must be made pristine so his conversion to a total love for Big Brother can be all the purer.

Orwell wrote a great deal about bathing, and about its paraphernalia. In an early letter to his mother sent from St Cyprian's, for example, he points out that he was held back in a race by the tightness of the 'bathing dress' he was wearing. Months later he asks to be sent one with a better fit, not one of the beastly garments that 'come all over [the] body'. It's tempting to read into this a discomfort at being trapped, and see it as an echo of the authoritarian school environment from where he was sending his letters home. Looking back on this same period in 'Such, Such Were the Joys', he offers many other tributes to the ambiguous pleasures of bathing, from the disgust of the plunge pool to the rarity of a hot bath. No wonder the boys at St Cyprian's tried to avoid the experience. 'One was supposed to go into the plunge bath every morning, but some boys shirked it for days on end, simply making themselves scarce when the bell sounded, or else slipping along the edge of the bath among

the crowd, and then wetting their hair with a little dirty water off the floor.' Given how commonly 'Such, Such Were the Joys' is taken to echo the atmosphere of *Nineteen Eighty-Four*, it's no surprise that dipping and dunking in Orwell's imagined future is similarly ambiguous. Although baths offer some respite from the weary labours of life under Big Brother, bath time is also an occasion for surveillance, a time of recuperation in which you're observed while you try to relax in tepid water: 'Asleep or awake, working or eating, indoors or out of doors, in the bath or in bed – no escape.'

Washing engaged Orwell's social conscience. He recognised that how often people are able to wash, and how well, is the signature of class, and more precisely the sign of class difference. When he returned from Burma and set himself the task of learning what it's like to be among the destitute people of England, one of the things that caught his attention is how having a bath can be a vector for power. *Down and Out in Paris and London*, his first major work, is largely a study of 'disgusting filth', and of how those in need are forced to live in it. He pointedly accentuates the repulsive environments of London's lodging houses, for example, with their 'leprous' walls that echo the similarly 'leprous' houses in Parisian streets. Such houses offer the pretence of being able to wash oneself, even as their mucky basins make it impossible, just as the casual wards of workhouses force their visitors to wash in water already used to clean smelly feet and the 'greasy little clouts known as toe-rags'. *Down and Out in Paris and London* is also a fine account of what people can get away with, or what they think they can get away with, in what we would now call the service industry:

table butter that's been touched by filthy fingers; toast anointed in beads of sweat dropped from a kitchen worker's forehead; used sheets put back onto the beds in hotel rooms without being cleaned; a roast chicken recovered from a lift shaft, into which it had been casually dropped, and then served to paying customers; a waiter washing 'his face in the water in which clean crockery was rinsing'.

Orwell noticed a different version of grime in the industrial north of England when he went there early in 1936 to research the book that became *The Road to Wigan Pier*. Having been underground with a group of miners, briefly enduring the hellish conditions they had to put up with every day of their lives, he describes how they got themselves clean. Gargling water to remove coal dust from their throats came before a basin-wash, at the end of which it was often necessary to repeat the procedure. He pauses over the fact that the dust clings to the miners' navels. He also indulges in racist analogy – miners emerge from the pit as 'black as a Negro' – and in comparisons that point to now-intolerable forms of cultural mimicry: 'It is the normal thing to see a miner sitting down to his tea with a Christy-minstrel face, completely black except for very red lips which become clean by eating.' There's a sense here in which Orwell imagines cleanliness as the patrolling of racial identity. The larger note of *The Road to Wigan Pier* is its focus on how being or becoming clean comes at a cost:

> Probably a large majority of miners are completely black from the waist down for at least six days a week. It is almost impossible for them to wash all over in their own homes.

> Every drop of water has got to be heated up, and in a tiny living-room which contains, apart from the kitchen range and a quantity of furniture, a wife, some children and probably a dog, there is simply not room to have a proper bath. Even with a basin one is bound to splash the furniture.

Worked half to death in the mines, the miners are then denied the basic right of keeping their bodies dirt-free. Powdered with coal dust, their best (and easiest) bet is to stay dirty. Yet wash they do, to the surprise of those bourgeois observers who insist that the miners wouldn't wash themselves even if they could.

Running through so much of Orwell's work is the thought that to have the luxury of choosing to bathe when you like, how you like and for how long you like is a sign of privilege. Being forced to bathe, even when it might be good for you, is the mark of opportunity asserting itself over those less fortunate. Writing about England's itinerant beggars in 'A Day in the Life of a Tramp' (1929), he highlighted the rituals of cleaning that occurred in the country's hostel wards, or 'spikes'. Upon entering these prison-like spaces, the 'tramp's name and trade are written in a register. Then he is made to have a bath, and his clothes and personal possessions are taken away. Then he is given a coarse cotton workhouse shirt for the night.' Writing about a similar occasion in 'The Spike' (1931), in which he describes a group of homeless men washing themselves in a malodorous bathroom, the ghost of St Cyprian's returns:

> It was a disgusting sight, that bathroom. All the indecent secrets of our underwear were exposed; the grime, the rents

and patches, the bits of string doing duty for buttons, the layers upon layers of fragmentary garments, some of them mere collections of holes held together by dirt. The room became a press of steaming nudity, the sweaty odours of the tramps competing with the sickly, sub-faecal stench native to the spike. Some of the men refused the bath, and washed only their 'toe rags', the horrid, greasy little clouts which tramps bind round their feet. Each of us had three minutes in which to bathe himself. Six greasy, slippery roller towels had to serve for the lot of us.

It seems that Orwell, however far he roamed from the stuffy environments of his schooldays, couldn't help but find himself back in different versions of the toilet cubicles and plunge pools that loomed so large in his recollections. In memory, they were one and the same. Hence his assessment of St Cyprian's, expressed in his essay 'Inside the Whale': 'five years in a lukewarm bath of snobbery'.

III

Breakfast

IF *BURMESE DAYS* IS ANYTHING TO GO BY, ORWELL'S time in Burma was spent enduring punishing heat and humidity. The novel examines the 'long stifling midday hours' of a country whose occupation by the British came, in his eyes, to symbolise everything wrong with empire; a tale of mismanaged offices, sticky heat, the sluttish and decaying airs of officialdom. The climate differed sharply from that of Suffolk, where he had spent months at his parents' home before sailing across the world. For a budding sceptic, the fug of the Burmese climate pointed to the decay and claustrophobia at the heart of the imperial project. And nowhere in *Burmese Days* is this more evident than in the rotting European Club, a citadel of privilege for the Westerners in the novel's setting, Kyauktada. At around ten o'clock in the morning, everyone in the Club has sweaty faces and exposed forearms. Patches of damp form on silk coats as their wearers press their backs against unventilated chairs. Eyes and heads ache from the stuffiness. Making matters worse is the 'malaise' of food eaten earlier in the day,

specifically the 'stodgy breakfast' every Englishman in the club will have consumed and only just started to digest.

Orwell no doubt once sat in a similar club, a little dyspeptic, a little too satiated, getting ready for a day's work, having eaten a breakfast that for the Burmese climate was on the wrong side of generous. Would his police work have been affected by indigestion? Or was it more that he didn't know how to stomach the work in the first place? He'd arrived in Burma as a nineteen-year-old – 'young [with] no sense', as he puts it in his poem 'Romance' – and the country was to be an education in sense-making. It would have been common for boys in Orwell's position to go from Eton to either Oxford or Cambridge. Instead, he applied for a job on what he and many other young men of his generation considered the imperial frontier. Once in Burma he went by train to Mandalay, where he began the nine-month police training course. By the end of his probation, Orwell had worked in various districts across Burma, and with varying levels of responsibility. He looked after ammunition stores, trained locally recruited constables, organised patrols, managed police stations, oversaw investigations of minor crimes and stood in for his absent superiors.[1] It was time spent learning the internal workings of a system he would come to despise.

'Shooting an Elephant' – Orwell's essay about a police officer who disgraces himself by shooting an escaped elephant to avoid looking foolish – exposes empire as an organisation marked by petty bureaucratic meddling and callous materialism, whose most self-aware representatives are tortured by self-loathing. *Burmese Days* makes the same points as the essay, but on a

larger scale. It all begins with breakfast. Having announced his unsavoury plans in the novel's opening chapter, U Po Kyin sits down to a 'huge bowl of rice and a dozen plates containing curries, dried prawns and sliced green mangoes', stuffing down the food 'with swift greasy fingers, breathing fast'. His meals, we're told, are 'swift, passionate and enormous'; less meals and more 'orgies, debauches of curry and rice'. It's not as if the British are any better. Where U Po Kyin's breakfasts are all self-indulgence, theirs are as likely to be an afterthought – the thing you have after a morning's bout of drinking. Empire, Orwell stresses, runs on whisky and gin before it runs on food.

U Po Kyin's decadent breakfasting echoes his political greed. Just as he devours an enormous breakfast, so too will he chomp his way through the revolutionary scene. The breakfasts eaten by the British are similarly emblematic; the heaviness makes them as bilious as the empire they serve. Yet this wasn't the only manner in which Orwell understood the importance of breakfast in social and political terms. And in this context, stodginess wasn't always a problem. If we can know a people by their national character, then surely everyone agrees (and Orwell certainly did) that we can know the English by the enormity of their breakfasts. This is one of the claims of *The Lion and the Unicorn*, which begins by trying to identify what makes the English what they are. Is it their beer? Is it the weight of their coins? The greenness of their landscapes? Their ostentatious advertisements? Their urban crowds? Their bad teeth? Their placidity? Thinking about such questions for too long can make them seem unanswerable:

You lose for a while your feeling that the whole nation has a single identifiable character. Are there really such things as nations? Are we not 46 million individuals, all different? And the diversity of it, the chaos! The clatter of clogs in the Lancashire mill towns, the to-and-fro of the lorries on the Great North Road, the queues outside the Labour Exchanges, the rattle of pin-tables in the Soho pubs, the old maids biking to Holy Communion through the mists of the autumn mornings – all these are not only fragments, but *characteristic* fragments, of the English scene. How can one make a pattern out of this muddle?

A typically Orwellian list for a characteristically Orwellian problem: the question of what makes the English *English*. He answers it by emphasising the muddle rather than the pattern. Englishness is a matter of social tensions and hypocrisies: these give England's national character its familiar shapes. But if there *is* something distinctive and recognisable in English civilisation, it begins with something 'somehow bound up with solid breakfasts and gloomy Sundays, smoky towns and winding roads, green fields and red pillar-boxes'. A decently sized morning meal, and probably a stodgy one: *this* is what takes prime position in Orwell's list of English characteristics.

He has in mind here the kind of substantial breakfast George Bowling has at one point in *Coming Up for Air*: haddock, grilled kidneys, toast and marmalade, all washed down with coffee. The breakfast makes Bowling feel better after one too many drinks the night before. A seriously sized meal for a serious job: the hangover cure. For Orwell, breakfasts aren't

snacks. A good breakfast means a lot of grub. But they can be taken too far. He remarks in *The Lion and the Unicorn* that English culture is 'a culture as individual as that of Spain', and nowhere is this clearer to him than in the excess of a Spanish breakfast. In his 1938 book of front-line reportage, *Homage to Catalonia*, he recalls an occasion at six in the morning in a hospital ward when he was served a meal that 'consisted of soup, an omelette, stew, bread, white wine, and coffee', and with an even larger lunch to follow. 'Spaniards,' he adds, 'seem not to recognize such a thing as a light diet.' The meal troubled him first because it was so outlandish and second because so many people in the country at that time were on the brink of starvation. It roused him to strong culinary opinion: 'They give the same food to sick people as to well ones – always the same rich, greasy cookery, with everything sodden in olive oil.'

Remarks like these disclose Orwell's social conscience. Even in breakfast there's injustice. If the distinctiveness of English civilisation is a matter of solid breakfasts, the England of his imagined future in *Nineteen Eighty-Four*, now rebranded as Airstrip One, is an England that's forgotten what it stands for. No decent breakfasts in this future of pain and suffering, because decency has been annihilated. At the start of the novel, Winston Smith forgoes lunch at work for a jaunt home. Standing in his kitchen, he discovers that there's nothing to eat except 'a hunk of dark-coloured bread'. This won't do, because he needs to save the bread for breakfast the next day. So instead he has a gin and a cigarette. The gin, with its acidic tang, burns his throat. The cigarette falls apart before he can light it. He still

doesn't eat the bread. And no wonder, given that its 'strange evil taste' won't satisfy him anyway. The bread that his lover, Julia, secures on the black market, 'proper white bread', is the sort of food he wants. He only gets to enjoy it for a short time. When he finds himself imprisoned in the Ministry of Love, all he wants is bread: any bread, even the dark-coloured bread that stands as a symbol of his 'ancestral memory that things had once been different'. In *Nineteen Eighty-Four* stale bread for breakfast isn't simply unsatisfying; in its meagreness it points to a glimmer of possibility, to the hope that change might come, however distant the prospect.

Breakfast could bring out Orwell's lighter side too. Greasiness upset him, but he could also get agitated about apparently innocuous matters like the comparative merits of crumpets and muffins. He wrote about the humble crumpet as a 'particularly delicious kind of tea cake' that's 'made to be toasted and buttered' and 'eaten with salt'; maybe for the same reason Mrs Wayne, a vagabond in Trafalgar Square, drools over the thought of crumpets in *A Clergyman's Daughter*, character and creator coinciding. Orwell also seems to have had a thing for kippers. A comical excess of kippery yearning features in this same novel, in which the smell of 'sausages, kippers, coffee and hot bread' streaming out from a café at five in the morning makes the assembled onlookers grumble as some of them get kippers for breakfast and some of them don't. Kippers even play a role in his futurological imagination. In *The Road to Wigan Pier* he suggests that the picture of 'a working-class family sitting round the coal fire after kippers and strong tea' couldn't be evoked in a distant future of rubber, glass and steel.

No smoked fish enjoyed like this in the utopian hereafter. But then again, he hopes, no poverty either.

Orwell was clearly what we would now call a breakfast person. He also thought the English could be understood by working out why they, too, were breakfast people, why they invested so much emotion in their bacon and eggs, or in their porridge. This is the concern of another account of national character, this time from 1946. In January of that year, he was in talks with the British Council about writing a booklet on food in Britain. He had already published 'In Defence of English Cooking' (1945) and 'A Nice Cup of Tea' (1946), his tribute to 'one of the mainstays of civilisation' in Britain. With these pieces he seems to have caught the attention of the right sort of foodies. Orwell, always reliable for copy, duly wrote the booklet. Yet in early May he received a letter from the Council's publications department advising him that there were doubts about 'such a treatment of the painful subject of Food in these times', with the revelation that the booklet, 'excellent' though it was, would not be published.[2] Given the impact of the war on food supplies in Europe, there were sensitivities around the health of continental readers. He pointed out in his article 'The Politics of Starvation' (1946) that 'a good part of Europe' was lapsing into 'brute' hunger, so no doubt he would have understood why. The booklet was dropped, with Orwell receiving thirty guineas for his trouble.

'British Cookery', as the unpublished booklet was posthumously titled, strives to be an objective synopsis of the nation's gastronomic preferences. Yet as with any impressionistic account it reveals a lot about its author's tastes too. According

to Orwell, the British diet contains wonders as well as barbarities: the best food isn't found in hotels and restaurants but in homes; marmalade at breakfast must be orange-flavoured, or else it's not a British breakfast; soups are rarely good; potato cakes are delicious; stews are unimaginative; fish deep-fried in oil is nasty; vegetables are delicious raw, but often spoiled in the cooking; pastry is okay; rice pudding should be ignored; clotted cream tends to be more delicious in the western parts of England; plum cake is glorious; the best apples are the Cox's orange pippin, the Blenheim Orange, the Charles Ross, the James Grieve and the Russett; cider good, beer better. Orwell is alert, as ever, to class difference: in how middle- and upper-class people prefer unsweetened over sugary tea, for example; or in how the richer classes call their midday meal 'luncheon' and their evening meal 'dinner', whereas those from humbler backgrounds call the former 'dinner' and the latter 'tea'. When Orwell writes that 'most people would *like* to have breakfast at nine o'clock', you can just about hear the strains of a man without time to be leisurely. But what comes across clearly is the sense that of all the meals it's breakfast that matters most – and matters not only because there are gastronomic possibilities in breakfast that seem somehow to outstrip all other fares, but also because a missed or sub-par breakfast, for him, made for a rotten start to the day.

This is what happens in *Keep the Aspidistra Flying* to Gordon Comstock, who hurries off one morning 'without a proper breakfast' and ends up being miserable until well after the sun goes down. Orwell himself occasionally had bad mornings that made for bad days too. Researching *The Road to Wigan Pier*, he

began his diary for 1 February 1936 by stating that he'd had a 'lousy breakfast' with a 'Yorkshire commercial traveller'. Was the breakfast lousy? Or was the commercial traveller the problem? It's possible that both were at fault. Later on he walked twelve miles to Birmingham and took a bus to the Bull Ring, arriving at 1 p.m.:

> Lunch in Birmingham and bus to Stourbridge. Walked 4–5 miles to Clent Youth Hostel. Red soil everywhere. Birds courting a little, cock chaffinches and bullfinches very bright and cock partridge making mating call. Except for village of Meridew, hardly a decent house between Coventry and Birmingham. West of Birmingham the usual villa-civilization creeping out over the hills. Raining all day, on and off.

He was on his way to Wigan, and you can tell he didn't like being held back by a crummy meal. The rain couldn't have helped. He found time for a little birdwatching (always a pleasure for him), but maybe he wouldn't have been so irked by the sight of a creeping 'villa-civilization' if he'd had something more substantial in his stomach from the outset.

Orwell described the spectacle of endless suburbia as the prelude to 'the real ugliness of industrialism', by which he meant the slag heaps, slums and wastelands on the fringes of places like interwar Sheffield and Wigan. *The Road to Wigan Pier* spends many pages accentuating the 'sinister magnificence' of these quasi-lunar topographies, which in his view had a sublime ugliness. They disgusted him, and he found in that disgust intriguing possibilities for journalistic description.

BREAKFAST

They were also the macrocosmic equivalents of what he saw and smelled in the blue-collar households that gave him much of the material for the first half of the book – 'a sterling example of campaigning journalism, eliciting the reader's empathy by interleaving hard data with a vivid sense of the sights, sounds, tastes and smells of working-class life.'[3] One such place, the tripe shop-cum-lodging house run by the Brookers ('the kind of people who run a business chiefly in order to have something to grumble about'), allowed him to indulge his imaginative obsession with mess, dirt and filth.[4] Beastly bedrooms, dust-covered chandeliers, squalid furniture, grimy fabric, dampness: these are the horror-laden emphases with which *The Road to Wigan Pier* begins. Worst of all, Orwell records, the sight of black thumbprints on buttered bread, or Mr Brooker carrying a full chamber pot up the stairs, his thumb 'well over the rim'. A shudder leaps off the page.

Breakfast, as provided by the Brookers, was a messy, sickening affair. The details on which Orwell focuses reveal how he was disgusted *and* fascinated by their establishment, a place haunted as much by the odour as by the idea of the piles of rotting tripe hidden away in the larder. He never sat at the kitchen table without noticing its stratum of Worcester Sauce-stained newspapers beneath layers of gluey cloth. He got to know each of the breakfast crumbs, almost naming them as he watched 'their progress up and down the table from day to day'. Mealtimes were loathsome. The Brookers would give you a decent breakfast – bacon, eggs, bread and butter – but any pleasure was diminished by grime marks on the bread and by the memory of fingers contaminated by sloshing excrement.

No one dared touch the marmalade jar, let alone extract its contents: 'an unspeakable mass of stickiness and dust'. Orwell was less disgusted by the dust than by the stickiness, a sensation associated in his work with a wide range of downbeat emotions: boredom, disgust, uneasiness, forbearance. The final straw was having to have breakfast in the knowledge that there was a full chamber pot beneath the kitchen table. He could put up with only so much 'stagnant meaningless decay'.

Just as *Down and Out in Paris and London* and *The Road to Wigan Pier* had done before it, 'British Cookery' makes it clear that Orwell understood what the cultural historian Kaori O'Connor called 'the politics of food'.[5] Food was political in that it marked cultural divisions and social differences between economic classes. Yet it could also be political 'at the table', as it were. Mealtimes in his work are occasions for all sorts of half-concealed antagonisms and latent hostilities. Consider *A Clergyman's Daughter*, which of all his novels is the one most centrally concerned with the politics of breakfast. Soon after the novel begins, its heroine, Dorothy, looks at her 'memo list'. There's a reminder to make bacon for breakfast. Having bathed in freezing water and returned from Holy Communion, she gets on with it. Her father points out that she's twelve minutes late in coming back. He concedes that 'bacon for breakfast is an English institution almost as old as parliamentary government', yet wonders if they might have a different option. Dorothy retorts by pointing out that bacon is cheap – they need to economise – and mentions that she saw 'some quite decent-looking bacon as low as threepence' a pound. 'Ah, Danish, I suppose?' the Rector complains. 'What a variety of Danish invasions we

BREAKFAST

have had in this country.' The joke's on him. He's probably been eating, and enjoying, Danish bacon all his life.[6]

A Clergyman's Daughter draws the domestic politics of breakfast, and the domestic politics of bacon more specifically, into its circular narrative form. The novel ends where it begins, with Dorothy back in the home she briefly abandons. She checks her 'memo list' at the novel's start, and she checks it again at its end. Almost identical reminders to cook bacon for breakfast appear in both instances. By the end of the book we've seen how the oppressive routine with her father is hard to break. On her parish rounds, Dorothy visits houses that smell 'peculiar in the extreme'. In nearly all of them there's 'a basic smell of old overcoats and dish-water' upon which other pongs are superimposed: 'the cesspool smell, the cabbage smell, the smell of children, the strong, bacon-like reek of corduroys impregnated with the sweat of a decade'. Bacon, bacon everywhere, no matter where Dorothy goes. When she's out hop picking in Kent with a vagabond called Nobby, she always cooks his breakfast as well as her own. And breakfast with Nobby is 'always the same – bacon, tea and bread fried in the grease of the bacon'. Breakfast with Nobby is hardly any different from breakfast with the Rector, who, having bullied his daughter so peevishly and petulantly in the mornings, turns aghast at the thought of having to cook for himself after Dorothy leaves home. (It may be anachronistic to say so, but the man who caused her to leave in the first place, Mr Warburton, has a surname that irresistibly evokes the brand of bread many readers no doubt would now associate with a decent bacon sandwich.[7]) The fact that Warburton twice behaves

'pseudo-paternally' around Dorothy, at the start and end of the novel, only further reinforces the patriarchal sameness she finds everywhere she goes.

In this novel, however, it's not bacon but marmalade that rules. *A Clergyman's Daughter* is a novel about sticky scenarios – about losing your memory, finding yourself out in the cold, having to submit to different types of servitude. Glue is the novel's symbol for these situations. Dorothy's 'journey' through the text is a matter of finding herself stuck back into short-lived safeties. True to form, then, *A Clergyman's Daughter* depicts marmalade as an anchor for passive-aggressive entrapment. Dorothy finds herself employed by the cruel Mrs Creevy at Ringwood House Academy for Girls, where, the morning after she arrives, she learns about her employer's unique brand of hostility. In a spirit of apparently impartial thriftiness, Mrs Creevy informs Dorothy that they'll have the same cooked breakfast as each other: two fried eggs, marmalade, bread and butter, a cup of tea. Yet Dorothy receives only two-thirds of an egg to Mrs Creevy's one and one-third, the act perfectly encapsulating the 'avarice' that leads her to underpay her staff, be mean to her neighbours and view copperplate handwriting tasks as a justifiable stand-in for emotionally literate pedagogy. Dorothy never gets to enjoy the marmalade that sits on the breakfast table until Mrs Creevy decides to sack her. Dorothy has her fill from the jar, never suspecting that she's about to be fired. It's a small detail that once again loops back to the constrictive, nostalgic airs of her home, the Rectory, whose 'silver-gilt marmalade spoon', a family heirloom, hints at her father's superficial lavishness (gilt silver being less expensive

to buy than solid gold), and subtly evidences his investment in the remnants of a long-since vanished golden past.

Orwell stressed the fact that marmalade rarely appears on the nation's tables at times of the day other than breakfast, which presumably is why, in *Down and Out in Paris and London*, he relishes hearing about Americans in Paris who know 'nothing whatever about good food', and who demonstrate their ignorance by eating 'marmalade at tea'. The passage in question also includes a deliciously contemptuous swipe at 'disgusting American "cereals"', which elicited a concerned letter from Orwell's aunt, Nellie Limouzin. She felt that his American readers might 'take umbrage' at the book's representation of cereals that 'are not really disgusting any more than porridge'. He could well have agreed, given that he described porridge in 'British Cookery' as a 'spongy mass'. Aunt Nellie wanted him to tone it down a bit. He refused. And what's more, he went on the warpath again in *Keep the Aspidistra Flying*, in which he describes 'the dry, drifted leaves' littering a London pavement as 'strewn, crinkly and golden, like the rustling flakes of some American breakfast cereal; as though the queen of Brobdingnag had upset her packet of Tru-weet Breakfast Crisps down the hillside'. The allusion to the giant Brobdingnagians in Jonathan Swift's *Gulliver's Travels* (1726) is a satirical excess, American cereal brands suffering by comparison with the loftier point of cultural reference.

Keep the Aspidistra Flying aligns the Tru-weet brand and the 'goofy optimism' of the advertisements used to promote it with the capitalist consumerism at which its protagonist rages. Towards the end of the novel, following Gordon Comstock's

reintegration into the bourgeois structures he's spent so long opposing, he imagines a future in which he'll 'cease to squirm at the ads' used to promote the brand. But by this point the novel has done its work. 'Tru-weet' means a dying civilisation marked by imbecility, emptiness and desolation; its advertising hoardings, with their 'monstrous doll-faces' looming over passers-by, are a sign of 'vacuous' materialism and commerce. Orwell clearly disliked this sort of thing. Similar ideas return in *Coming Up for Air* in the form, yet again, of marmalade – this time, the Golden Crown brand (an allusion to Robertson's Golden Shred, first sold in 1874). In this novel, as we've seen, George Bowling's day begins badly because he gets dressed without realising his neck is still soapy. This 'disgusting sticky feeling' leads to another one of George's hobbyhorses. Little irritates him more than the marmalade label's small print, which announces that, by law, the marmalade contains 'a certain proportion of neutral fruit juice'. He froths at a statement meant to make the marmalade sound respectable. Neutral fruit *juice* means neutral fruit *trees*, which don't exist. George's wife, Hilda, scolds him for making a poor joke. Yet the scene plays its part in affirming Orwell's sceptical attitude towards a market-driven culture that compromises even small pleasures in the privacy of our homes.

So there's a lot of humorous possibility in breakfast, even if the humour can sometimes be produced in the most disquieting circumstances. 'A Hanging', Orwell's famous essay about a condemned man in Burma sent to the gallows, provides a glimpse into a very different breakfast scenario. After the man is hanged, his bowels still digesting, Orwell and his

acquaintances leave the gallows yard, walking past the condemned in their cells:

> The convicts, under the command of warders armed with lathis, were already receiving their breakfast. They squatted in long rows, each man holding a tin pannikin, while two warders with buckets marched round ladling out rice; it seemed quite a homely, jolly scene, after the hanging. An enormous relief had come upon us now that the job was done.

Relief articulating shame: this is the remark of someone who knows, looking back, that he's been part of something terrible. Orwell remembers everybody laughing. The humour is a release valve. And the rice breakfast being ladled out makes it worse. Here is ordinariness as yet another prelude to capital punishment, the soon-to-die adopting the rituals of sustenance that won't, in the end, sustain them.

The contrast in the scene between the doomed breakfasters and the chuckling officials reflects the wider contrast Orwell detected in an imperialism that sustained itself less on moral decency than on alcohol, its spokespeople and administrators in Burma drowning their sorrows in whisky and gin. To be British means enjoying your bacon and eggs, or your porridge, as much as it means having 'a horror of abstract thought' or feeling 'no need for any philosophy or systematic "world-view"'. Less the 'thin vegetable soup with slimy hunks of bread floating about in it' of the kind he was served in a Parisian hospital, and more the sort of 'serious' breakfast he praised in 'British Cookery'. Yet there's always the sense in Orwell that the one problematically

implies the other: the full breakfast on one plate means an empty belly somewhere else. And this, he insisted, was one of the best arguments in favour of socialism. For Orwell, being full at the start of the day meant being fully prepared to right some wrongs, to *write about* wrongs as a way of doing so. It also meant being on the better side of lack, and this gave him an obligation – both moral and literary – to make breakfast count.

Daytime

IV

Work

ORWELL VALUED WORK FOR THE OPPORTUNITIES IT gave to observe. His essay 'Bookshop Memories' (1936) – written in tribute to his time as a second-hand bookshop assistant, at Booklovers' Corner on the South End Road, near Hampstead Heath – opens by announcing 'the rarity of really bookish people' and the frequency of customers with different designs on the stock: first-edition snobs, book hunters who can remember no details about the text they want to purchase, the customer who tries to sell the bookshop their worthless home library, the time-waster who puts in large orders and never pays. He worked part-time at Booklovers' Corner from 1934 to 1936, and part of what tickled him about the experience was the fact that bookshops are 'places where you can hang about for a long time without spending any money'. He was also troubled by how they're places where you can hang about for a long time without actually liking books. Working in a bookshop brought Orwell into an intimate relation with textual particulates: 'books give off more and nastier dust than any other class of objects

yet invented, and the top of a book is the place where every bluebottle prefers to die.' Not a good thing for a man with significant respiratory ailments. What might seem like the ideal occupation for a writer in fact threatened to turn him off for good. 'Seen in the mass,' he wrote, 'five or ten thousand at a time, books were boring and even slightly sickening.'

Already as a two-year-old there were signs that Orwell tended towards illness. His mother Ida recorded in her diary for 6 February 1905 that little Eric had been diagnosed with bronchitis. He would have recurrent bouts of the ailment for years, including when he was at St Cyprian's. He got little sympathy there when coughing and hacking. He often suffered from influenza and caught pneumonia several times in his late teens, twenties and thirties, but it was a case of dengue fever that gave him an immediate reason to come back home from Burma. On holiday in Cornwall with his parents after he returned to England, he found himself ill in bed and being nursed by his mother. His friend Ruth Pitter reminisced that he was 'far from well, even then'.[1] His smoking habit can't have helped, but then again neither can the dusty books. (The dust especially became an obsession. His novels are strewn with references to dusty surfaces and dust-coated skin.) The spectre of tuberculosis started to make itself known around this time, too, and never departed. He was never fully fit and fine, always a bit congested and phlegmy, and was finally diagnosed with TB at the relatively late age of thirty-five. Increasingly poorly throughout the late 1930s and into the 1940s, 'the progression of his illness coincided with the flowering of his talent.'[2] Being ill kept him occupied even as it gave him some of the

impetus needed to transform himself into the writer he hoped to become.

For a man who worked tirelessly, and is celebrated for having done so much in his short life, it can be surprising to learn how suspicious Orwell was of what he called the 'business of going to work'. The phrase comes from *Keep the Aspidistra Flying*, which is his most characteristic novel of work (and of its avoidance). It has one foot in the world he recalls in 'Bookshop Memories' and another in the fantasies of narcissism and paranoia the essay scrutinises. Would-be bohemian poet Gordon Comstock yearns to leave the world of work, which to him means the shackles of wage-capitalism, so he can enter another: the world of literature. He fancies himself a poet, imagining this as an escape from slavery into fortune. The problem is that he's neither particularly committed to his day job as a bookshop assistant nor particularly effortful when it comes to writing poetry. When Gordon sits down one evening to work on the epic poem he can't bring himself to finish, *London Pleasures*, he can't help but procrastinate. For Comstock, the business of going to work cuts both ways. It's an enterprise, but it's also a form of being busy – and he hates both equally.

Gordon starts working in a bookshop after he decides to leave a socially 'approved' job at the New Albion, a publicity firm that designs hoarding posters and cosmetics advertisements. He leaves because at the New Albion he's surrounded by 'little bowler-hatted worms who never turned' and 'go-getters, the American business-college gutter-crawlers' who remind him of what he sees as the advertising sector's emptiness. He leaves because he can't bear the thought that he's a man starting to

turn into a pig, 'sliding down, down, into the money-sty'. He wants out before it becomes impossible to say whether he's *of* this world rather than merely *in* it. The angst is long-standing. And Gordon has form here, as an earlier refusal demonstrates:

> Pen-pushing in some filthy office – God! His uncles and aunts were already talking dismally about 'getting Gordon settled in life'. They saw everything in terms of 'good' jobs. Young Smith had got such a 'good' job in a bank, and young Jones had got such a 'good' job in an insurance office. It made him sick to hear them. They seemed to want to see every young man in England nailed down in the coffin of a 'good' job.

Gordon wants to avoid the promise of his surname (Comstock, 'become stuck') because he dreads getting bogged down in the respectability of a specific form of labour; having a job that, as Orwell put it in *Coming Up for Air*, also 'has' you. Gordon wants to get out of the 'money-sty', not to be 'stuck in it for life'. He doesn't want to make a name for himself, because this would mean becoming some generic stand-in for a respectable position in society: a Smith, a Jones. The irony is that Gordon can't ever get out of being placed somewhere. His fate is always to be anchored, tethered – to family, in the guise of his lover, Rosemary, and their unborn child, and in the form of an inevitable return to a 'good' job working for an advertising agency.

There's no escape for Gordon in the end, only different versions of not-quite-fitting-in. He dreams of finding a place 'down in the ghost-kingdom, *below* ambition', but he never

discovers it. Gordon's thought is that he might find such a place among the 'lost people, the underground people, tramps, beggars, criminals, prostitutes', and it was this idea that Orwell pursued after he returned from Burma in 1927. Following his arrival back in England in October of that year, he busied himself with work, and got to know what it was like to be worked to the bone. His resignation from the Indian Imperial Police was confirmed in January 1928, several months after which he moved to Paris. Living in the French capital, where he stayed until December 1929, gave Orwell what he needed to understand a different guise of deprivation: the kind made by being 'sweated' in swanky hotel kitchens. These activities gave him much of the material for *Down and Out in Paris and London*, a tribute to and a sort of disgusted fantasy about 'the lost people' whose ranks Gordon naively hopes to join. They also came before a stretch of time during which Orwell worked at several jobs in sequence: private tutor, essayist, hop picker and schoolteacher.

By the time Eric Blair became 'George Orwell', he'd acquired inside knowledge of many different forms of work, from being an agent of empire in Burma, to tramping his way through London, to cutting his hands on hop bines in Kent, to drudging it in public schools in the suburbs. He wanted to be a writer, and he launched himself onto the path by living a little bit of 'the radical bohemian, intellectual and literary life' of Paris.[3] Tantalisingly, alongside the articles in French that Orwell published in *Monde* and *Progrès Civique*, there are novels and short stories from this period which have not survived. Being a writer meant working hard, to some extent, but it also meant

writing about hard work, which is one reason *A Clergyman's Daughter* is a novel structured as a collage of working scenes. Orwell's other novels of the 1930s – *Burmese Days, Keep the Aspidistra Flying* and *Coming Up for Air* – group together around the fact of work not getting done: in *Burmese Days* we never see John Flory do any work as a timber merchant; in *Keep the Aspidistra Flying* Gordon Comstock can't bring himself to labour over anything other than his neuroses; and in *Coming Up for Air* the point of departure for George Bowling's story is a long-awaited holiday in the countryside.

There is a closeness between Orwell and Gordon. Orwell too found it difficult to keep 'at' a given line of work – not because he was a refusenik, but because he seems to have been temperamentally restive, keen to get from here to there, always searching for the next venture. The historian Robert Colls insists that Orwell is a 'difficult subject' to write about because there's no 'trajectory' in his life: 'It is more a series of intense reactions to peoples and places as he came upon them,' an unpredictability that 'led him into all sorts of awkward and angry corners which fed the contrariness in his nature'.[4] But his moves from job to job also show that he simply needed to work, and that he was going where the work was. Unlike Comstock, he had plans both to start and finish writing texts of all kinds. The variety of his employments gave him what he needed to write about work's ordinariness, its monotony and grind, the gelatinousness induced by its exhaustions, and, importantly, about its capacity to induce joy as much as boredom in the worker.

Dorothy Hare, in *A Clergyman's Daughter*, is Orwell's most nuanced depiction of a person caught in the doubleness of

work. Like Winston Smith after her, who can lose himself in the 'tedious routine' of rewriting history 'as in the depths of a mathematical problem', Dorothy takes satisfaction from plunging into tasks that she also loathes. She clearly excels at serving her father, Charles, just as she excels at serving the symbolic Father behind him through the good works she does for the community of Knype Hill. Dorothy's morning routine – waking up at half past five, getting the kitchen ready for the day, a freezing cold bath followed by an inspection of her daily 'to do' list – gets her in something like the right mood for visiting her father's congregation:

> Every day of her life, except on Sundays, she made from half a dozen to a dozen visits at parishioners' cottages. She penetrated into cramped interiors and sat on lumpy, dust-diffusing chairs gossiping with overworked, blowsy housewives; she spent hurried half-hours giving a hand with the mending and the ironing, and read chapters from the Gospels, and re-adjusted bandages on 'bad legs' and condoled with sufferers from morning-sickness; she played ride a cock-horse with sour-smelling children who grimed the bosom of her dress with their sticky little fingers; she gave advice about ailing aspidistras, and suggested names for babies, and drank 'nice cups of tea' innumerable – for the working women always wanted her to have a 'nice cup of tea', out of the teapot endlessly stewing.

These visits are a collage of grimy encounters, from the sticky-fingered children to Mrs Pither's 'large, grey-veined, flaccid legs',

which Dorothy duly anoints with an analgesic salve. Often they take place on sunny days that are 'called "glorious" by people who don't have to work', by those who can sit back and enjoy the sunshine rather than labour in its stifling heat.

Dorothy's morning round brings her into contact with Mr Warburton, the local businessman who, in the original version of the novel, is said to have once tried to rape her. In the published version, Dorothy loses her memory after an encounter with Warburton when he kisses her without her consent. This provokes the first 'break' in the text, where Dorothy wakes up on the New Kent Road without knowing how she got there. The trauma is felt in the form of an unexplained time shift. Her adventures after this point in the book take her to a job picking hops in the countryside; to a freezing night in Trafalgar Square; to a job at Mrs Creevy's school; then back home again, to Knype Hill, in a loop that brings to mind the coiling shapes of 'mangrove roots in some tropical swamp'. Dorothy newly understands herself in ending up back where she started, though to pin her realisations on the after-effects of non-consensual intimacy might reasonably be criticised as a degrading plot device, one that makes a woman's fuller inhabitation of herself dependent on first having to suffer through sexual violence. All the same, her realisations make her one of Orwell's most intriguing protagonists. *A Clergyman's Daughter* ends with Dorothy absorbed in the ostensibly tedious work of making costumes for the local school play. The devil in the detail is that she's absorbed in the 'pious concentration' the work demands. This is *good* work, as Orwell sees it: work that benefits the children destined to wear the costumes, and

work that allows Dorothy to define her own relationship to a communal task.

Orwell is often at his most fascinating when writing about drudgery and toil. He was almost certainly influenced in this, as with so much else in his output, by Charles Dickens, from whom he learned how to write about huge inequalities of wealth and the forms of labour they generate. Like Dickens, he maintained a steady interest in 'submerged populations' and particularly in the 'non-criminal poor', as he put it in his long 1940 essay on the earlier writer, 'the ordinary, decent, labouring poor'. His concern at 'privation' and at 'brute labour' led him to argue that economic inequality must be 'abolished before the real problems of humanity can be tackled'. So many of the major problems of his time, he claimed, simply could not be addressed 'while the average human being is either drudging like an ox or shivering in fear of the secret police'. This is the condition of the proles and the members of the Outer Party in *Nineteen Eighty-Four* – the one animalistic, the other kept in a constant state of paranoia. It's also the condition of the animals in *Animal Farm*: toiling for freedom's sake yet watched all the while by Napoleon's dogs. Working towards freedom on Animal Farm is not a matter of freely working; it's a case, as so often in Orwell's thinking, of enforced labour.

Animal Farm is at one level a book about the difference between work and labour, the one jubilant and full of satisfaction, the other tiresome, demotivating and fruitless. The story is simple. Inspired to recover the lost produce of their labour from the humans who have enslaved them, the animals on Manor Farm stage a mutiny only to lose the little freedom

they thereby gain to the conniving, treacherous pigs. It's a book about how revolutions can be turned back into something very much like the status quo. Few animals on the regained farm shirk their responsibilities, but not everyone works in the same way. The pigs are only too happy to do the 'work of teaching and organising' the other animals because it gives them the clearest opportunity to exploit them. At the centre of the novel is Boxer the horse, who is 'universally respected for his steadiness of character and tremendous powers of work'. Orwell admired Boxer because in his 'strength' and in his 'never-failing cry of "I will work harder!"' he shows up the doublespeak of Squealer the pig's 'excellent speeches on the joy of service and the dignity of labour'. Yet Boxer's commitment to the cause doesn't save him. In the end, he's discarded: sold off in old age to be boiled down into glue. The fear haunting the pigs, and the reason Boxer must be sent to his death, is not that he will rise up against his porcine masters, but that the other animals will wonder why he hasn't risen up already and rise up themselves.

If Boxer is the most noble worker in Orwell's works of fiction, then the miners in *The Road to Wigan Pier* are the most virtuous labourers in his works of journalistic reportage. It might be more accurate to say that in the book Orwell gave himself the leeway to see a particular sort of worker as honourable. I put the point in this clumsy way because *The Road to Wigan Pier* has been questioned for how it depicts men as virtuous workers, in contrast to, and at the expense of, the women who support them. 'Orwell makes miners the core of his chronicle,' writes Beatrix Campbell: 'they are the essential man and the essential worker, but the equation between work

and masculinity depends on an exclusion – women.'[5] His miners are superhuman. They're noble. They look like they're made of iron. They seem, misleadingly, to stand alone: the women who support them do their share of work, too, in the home. Orwell's biographer Peter Davison's riposte to Campbell centres on how contextual factors such as the General Strike of 1926 and interwar documentary films encouraged onlookers to idealise miners as 'heroes of industry'.[6] The author may in this limited sense have gone with the flow, allowing himself to indulge in convention.

As idealisations, Orwell's miners are at once reductive and excessive: misleading in their apparent typicality and romantic in their superhuman resilience. With their 'noble bodies', their 'wide shoulders tapering to slender supple waists, and small pronounced buttocks and sinewy thighs, with not an ounce of waste flesh anywhere', they are as much objects of desire as they are targets of respect. There is what the critic Frank Kermode calls a 'pastoral note of envy' in how the author 'speaks of the physical beauty of the miners' and in how he recognises in them 'with amazement and with some humility an otherness, an exploited strength'.[7] The fact that the miners are idealised in the first place indicates their significance: to establish a contrast with the suspect business of going to work that Orwell rails against in a novel like *Keep the Aspidistra Flying*. He idealised the miners because he was committed to establishing a resonant alternative to the bourgeois counter-ideal of 'getting on', of seeking to *be* somebody.[8]

Orwell journeyed to the north of England having been commissioned by the publisher Victor Gollancz to write about the

deprived economic infrastructures in such 'industrial towns' as Leeds, Wigan and Sheffield. His experiences in 'these barbarous regions', as he put it in a flippant letter to the socialist writer Jack Common, made him 'pine to be back in the languorous South and also to start doing some work again'. Watching others work harder than he ever could made him yearn to put down the experience on paper. Part of this involved tracing connections between mining and empire, between the coal extracted from a Yorkshire mine and 'the metabolism of the Western world'. Enabling the dirty work of empire was the dirt-laden work of the miner, 'a sort of grimy caryatid upon whose shoulders nearly everything that is *not* grimy is supported'. In a faint echo of H. G. Wells's *The Time Machine* (1895), in which the subterranean Morlocks endure the darkness so the privileged Eloi can enjoy the sunshine, Orwell aligned those who worked in England's mines with those elsewhere who were subject to the colonial expansionism that their mining braced up: 'Here in England, down under one's feet, were the submerged working class, suffering miseries which in their different way were as bad as any an oriental ever knows.'

The Road to Wigan Pier offers an account of degrading and dehumanising manual labour, with miners toiling in the 'heat, noise, confusion, darkness, foul air, and, above all, unbearably cramped space' of England's collieries. It also presents, in the second half of the text, an Orwell looking back on his role in the 'empire-racket'. Empire gave him work in his employment as a police officer, and it gave him work to do in seeking to write about injustice. His time in the Indian Imperial Police was an education in power: who has it, who suffers it, who envies it,

who hates it. He was one of many faces and instruments of British authority, part of the 'uprush of modern progress' that took so many young men out and away from home. Orwell's early biographers, Peter Stansky and William Abrahams, have suggested that his reasons for seeking employment in Burma 'were romantic and deeply coloured by fantasy', and that he 'seems to have had no understanding or premonition of what it meant to become an officer in the Indian Imperial Police, what the job would demand of him. His entire interest was directed to going out, going back, to a dreamscape of India', to the land of his birth as he had come to imagine it in childhood in reading figures like Kipling.[9] The work of his reminiscences – in such texts as his novel *Burmese Days*, in essays like 'A Hanging' and 'Shooting an Elephant', and in the second half of *The Road to Wigan Pier* – is the unpicking of fantasy. And not only the unpicking of fantasy, but also a lifting of the veil. These are texts written to undercut the proudly mythical view many readers in England had of their empire.

'A Hanging', as we've seen, describes the execution of a prisoner, watched by Indian and British officials. The first-person narrator of the piece, the 'I', is Orwell, or more precisely Eric A. Blair, who signed it. Does this make 'A Hanging' autobiographical? Opinions are split. Whoever the narrator is meant to be, he stands back and looks. A sign of things to come, in Orwell's case, in a career of observation. The text examines the hideous discrepancies that exist between those executing and those killed, between those wearily supervising just another job to be done on an average day and those whose weary days are about to end. The claims of those in power are announced in

the essay's opening line: 'It was in Burma, a sodden morning of the rains.' This is an average execution in an unremarkable jail yard, the indefinite article in the essay's opening line deepening the sense of the commonplace already figured by the indefinite article in its title. The claims of the powerless, a Hindu man condemned to die, are spoken by the style of the piece, which lingers on the details of the condemned prisoner (his frail physique, his shaven head, his 'vague liquid eyes') and on startling moments of disruption. Before the man can be hanged, a dog bounds into the jail yard and licks his face. Shortly after the dog is removed, the man carries on walking towards the gallows, only to step aside to avoid a puddle.

The Hindu man's actions signal what it means to snuff out a life. And not just to do that, but to do it because it's part of a job description, because it's *work*. Seeing the Hindu man as a being fully alive in the moment, 'bowels digesting food, skin renewing itself, nails growing, tissues forming', we recognise the awful ordinariness of the short distance from life to death in the steps taken from a jail cell to a hanging rope; in the time needed for a neck to snap. An awakening, of sorts. The casual death of the Hindu man invites us, and maybe forced Orwell, to notice – or at least made him want to prove through public confession that he had noticed, years after his time in Burma – how work doesn't lead necessarily to joy (as it does at times with Dorothy Hare) or indeed only to anti-capitalist disgruntlement (as it does most of the time with Gordon Comstock). 'A Hanging' evokes the idea that an observing, working imperial functionary can be transformed by his work into an instrument of policies formulated elsewhere by other

people, into an operation of laws codified for supposedly noble purposes. Orwell appears to claim through his narrator that he did his job, which had been to look on while another human being was discarded like a stone.

V

Lunch

WRITING IN FEBRUARY 1935 TO HIS FRIEND BRENDA Salkeld (someone we'll return to in later chapters), Orwell noted that his life had become rather busy. At this point in time he was living in Hampstead and working at Booklovers' Corner. The sense of busyness came from a consuming routine:

> My time-table is as follows: 7am get up, dress etc, cook & eat breakfast. 8.45 go down & open the shop, & I am usually kept there till about 9.45. Then come home, do out my room, light the fire etc. 10.30am – 1pm I do some writing. 1pm get lunch & eat it. 2pm – 6.30pm I am at the shop. Then I come home, get my supper, do the washing up & after that sometimes do about an hour's work.

Not just a sequence of activity: a 'time-table'. This is a man who hopes to persuade his correspondent of the professionalism of his day. He doesn't work. He is 'kept' at work, or kept *by* it. The 'etc.' is a calculated aside meant to suggest an impressive

additional toil beyond what's mentioned. The washing-up gets done. The most amusing detail, though, is the fact that Orwell felt obliged to point out that lunch entailed not only getting food but also eating it – as if Brenda wouldn't have known that the eating formed part of his day. As a detail it points to a fastidiousness in description, a commitment to mundane albeit necessary process. It also indicates how seriously he took lunch *as* lunch, as a thing to enjoy and by which to be preoccupied.

Orwell's seriousness about lunch is visible in the fact that he was willing to risk his health to have a *good* lunch. To feel the force of this we need to turn to Spain, and to Barcelona. When he was fighting in May 1937 with the Partido Obrero de Unificación Marxista, the POUM, he was shot in the throat by a fascist sniper. In the days that followed, he was reintroduced to the agony that, in the instant of being shot, had somehow deserted him. He found himself hospitalised and often 'dopey from morphia but still in great pain, practically unable to move and swallowing blood constantly'. Despite being in such a dire physical condition he was still expected to eat, the Spanish nurses forcing him to consume 'the regulation hospital meal – a huge meal of soup, eggs, greasy stew and so forth' even though he clearly couldn't manage it. He would much rather have had the better lunch of a cigarette. He didn't get his way, though not because cigarettes were forbidden but because, due to a period of tobacco famine, they were in short supply. And he would much rather have had a decent meal, too, not the sloppy, oily stuff he was getting in hospital.

The man under whom Orwell served in Spain, Georges Kopp, reported that when he visited the author in hospital

at Tarragona, he sounded like a rattling automobile when he spoke, his speech 'inaudible outside a range of two yards'. Orwell was subsequently moved to a sanatorium in Barcelona where, having arrived in a high fever with no appetite, he quickly regained his voice, a normal temperature and renewed hunger. The next day, he took matters into his own hands (as Kopp reported):

> Today, 30th. Eric travelled by tram and tube, on his own initiative, down to the Centre of Barcelona, where I met him at 11.45 a.m. He explained his escapade by the want of cocktails and decent lunch, which were duly produced by [Orwell's wife] Eileen's tender care (with help of a barman and several waiters).

Orwell wasn't going to be denied a midday pleasure simply because he'd had a close call with death. No chance. His little insurrection made up for having to forgo in recovery the luxuries he'd sought out when he arrived in Barcelona from the front lines. As he recalled in *Homage to Catalonia*: 'After several months of discomfort I had a ravenous desire for decent food and wine, cocktails, American cigarettes, and so forth, and I admit to having wallowed in every luxury that I had money to buy.'

The idea of a lunch sought out as an interruption of some other activity sits behind one of the most unforgettable sequences in Orwell's work, which occurs in his novel *Coming Up for Air*. The book is not at all coincidentally also a novel about eating and about being consumed, usually with worry. It's a mode of

disquiet imagined through the prospect of desperately keeping up with one's mortgage instalments: 'we aren't householders, [...] we're all in the middle of paying for our houses and eaten up with the ghastly fear that something might happen before we've made the last payment.' As the critic Martha C. Carpentier has pointed out, *Coming Up for Air* is a novel governed by metaphors 'cast in images of orality', an idea nodded to in its title (the thought of someone gasping for breath).[1] The novel's protagonist, George Bowling, likes his grub, just as he likes to imagine the world being eaten by flames. He daydreams about bombing runs and about the emptiness of modern civilisation: 'All this rushing to and fro! Everlasting scramble for a bit of cash. Everlasting din of buses, bombs, radios, telephone bells. Nerves worn all to bits, empty places in our bones where the marrow ought to be.' Fear, he notes, is the element in which most modern people swim: fear of unemployment, war, fascism, communism. Those who live in fear 'spend their time eating aspirins'. For Bowling, the modern is destructively analgesic.

Near the start of the novel, Bowling slips into an American milk bar for lunch after going into London. We know there's a problem already – he usually avoids milk bars, not least because their hyper-modern interiors disgust him:

> Everything slick and shiny and streamlined, mirrors, enamel and chromium-plate whichever direction you look in. Everything spent on the decorations and nothing on the food. No real food at all. Just lists of stuff with American names, sort of phantom stuff that you can't taste and can hardly believe in the existence of. Everything comes out of a carton or a tin,

or it's hauled out of a refrigerator or squirted out of a tap or squeezed out of a tube. No comfort, no privacy. Tall stools to sit on, a kind of narrow ledge to eat off, mirrors all around you. A sort of propaganda floating round, mixed up with the noise of the radio, to the effect that food doesn't matter, comfort doesn't matter, nothing matters except slickness and shininess and streamlining. Everything's streamlined nowadays, even the bullet Hitler's keeping for you.

Bowling protests too much because he's satisfied (satiated, even) by complaint. But he can't resist. Against his better judgement he orders a coffee and frankfurters, and goes in for a bite.

He expects the sausage to have as little taste as the bread roll encasing it. The surprise is that it tastes of fish. 'Christ!' he exclaims. The shock of the unexpected gives him, as it gives Orwell, a chance to indulge in disgust. An explosion. The frankfurter doesn't only taste unexpectedly of fish, it also bursts in the mouth 'like a rotten pear', a 'sort of horrible soft stuff' oozing all over Bowling's tongue, on which he rolls the vile discharge while reflecting on how the modern world seems to be characterised by interminable substitutions: 'Everything slick and streamlined, everything made out of something else.' It's a perfectly chosen image for a novel so repeatedly concerned with images of fakeness, beginning with Bowling's false teeth and extending to 'fake-picturesque' houses and sham-Tudor architecture; modern interiors with medieval fittings; supposedly meaningful jobs that turn out to be pointless; a bombing run that seems to announce the start of another world war but is actually a hideous accident. The fishy frankfurter is a bomb,

too: an industrial product announcing its synthetic innards through an explosion of repellent incongruity – fish where there should be meat. It's all too much for Bowling, for whom fakeness is constitutive of the modern world: 'when you come down to brass tacks and get your teeth into something solid, a sausage for instance, that's what you get. Rotten fish in a rubber skin. Bombs of filth bursting inside your mouth.'

This scene is brilliantly disagreeable. The critic Lynette Hunter has described it as one of the most disgusting sequences Orwell ever wrote.[2] It's also a superb account of the hurried lunch slotted in during the workday, which is the worst sort of lunch to have ruined precisely because it needs to be hurried. When we eat lunch at pace, in between commitments, we don't want that briefly snatched period of respite to be interrupted by the unforeseen. We want it to be predictable, soothingly samey. When Bowling has his hurried lunch, the problem is not that the food is substitution and no substance but that the hotel in which it's served reminds him of the milk bar's soullessness. The hotel dining room is all mock-medieval furnishings – a ceiling beam that holds nothing up, oak panelling that isn't oak, a slick young waiter who gives the game away – and the hotel lounge is no different: 'fake-medieval again, [with] streamlined leather armchairs and glass-topped tables'. Everything pretends to be something else. The hotel lunch, against expectations, is nice: minted lamb and wine that makes Bowling belch contentedly.

Bowling's meal is straight out of the norm, or at least straight out of the norm as Orwell imagined it. He writes in 'British Cookery' about how 'every British person's *idea* of the midday meal is approximately the same' – that it 'consists essentially

of meat, preferably roast meat, a heavy pudding, and cheese'. Bowling's meal may be authentic in comparison with the superficial decoration of the hotel in which he eats it, but as a particular version of lunch it's entirely in keeping with tradition: 'With mutton or lamb there usually goes mint sauce,' Orwell reminds us. Bowling's contentment reflects the degree to which he can't imagine himself out of a particular heritage. Yet it also gives the author an opportunity to peek into Bowling's vulgarity. A predictably 'national' lunch fills him up and makes him leer. Having burped his fill, Bowling notices 'a woman of about thirty with fair hair'. Vague plans 'to get off with her' enter his mind, and before long he's running an eye over her and mentally taking off her clothes. The scene depends on a deliberately uncomfortable alignment between lasciviousness and consumption, with Orwell encouraging us to view Bowling's thoughts about the woman as thoughts about what else, besides the lamb, he can devour.[3]

Lunch scenes in Orwell's novels are case studies in awkwardness. At the top of the pile is the episode in *Keep the Aspidistra Flying* in which Gordon and his girlfriend Rosemary (a gastronomic name) stop for lunch at a place called the Ravenscroft Hotel – 'one of those hotels,' the narrator tells us, 'which have overcharging and bad service written on every brick.' Immediately they discover that they won't get away merely with ordering bread and cheese, as they plan to. They can't have *lunch* in a place like this. It's *luncheon* or nothing. Gordon, opposed to capitalism in all its forms, sees the occasion as little more than an opportunity to be fleeced. One reason for this is that, yet again, fakeness is the order of the day. The

hotel's splendour is skin-deep, just as the food it provides is 'corpse-cold', barely resembling anything digestible: the beef and salad 'taste like water'; the wine has the flavour of mud. Gordon's and Rosemary's waiter is at pains to offend. All that's real is the size of the bill, which swallows up everything in Gordon's wallet. Rosemary wants to pay her share, but Gordon is too proud to let her.

Not all of Orwell's lunches had the potential to collapse into revulsion. In an April 1943 letter to E. M. Forster, he sought out the older writer's company because he wanted to discuss making a pamphlet of the radio scripts Forster had delivered on the BBC throughout the preceding decade. He noted that they'd lunched before, at the Ariston Café, and advised that it was to be a routine yet reassuring discussion: 'I don't want to press you into this against your will,' Orwell wrote. 'Perhaps we could talk it over?' Lunches of this kind were a common diversion for him in the early 1940s, when he worked as a talks producer for the Indian Section of the BBC Eastern Service. He held this role from August 1941 until November 1943 (the month in which he began to write *Animal Farm*), using the opportunity to create what has been called 'a "university of the air" for students of the Punjab and other Indian universities, coupled with weekly news broadcasts that enabled educated Indians generally to follow the progress of the war around the world'.[4] Forster's contribution to this effort came in the form of an experimental broadcast. In November 1942, Orwell organised five authors to write a collective serial story in five parts, each author continuing and developing the story as they wished from the previous instalment. He was joined in this by

L. A. G. Strong, Inez Holden, Martin Armstrong and Forster, and he regarded it all as a failure. But clearly it didn't turn him off from collaborating with Forster; the April 1943 lunch wasn't just lunch. It was the consolidation of a partnership.

Those whose job it is to get other people to do things for them often find lunch a useful lubricant. It nourishes a budding professional acquaintance, or reinforces the value of an existing one. Orwell was no different. He knew that lunch can make a contract, that food, consumed at leisure in the early afternoon, can smooth an arrangement. It didn't always work, though. Shortly after he became the literary editor of *Tribune* magazine in 1943, following his resignation from the BBC, he wrote to the modernist poet T. S. Eliot asking him for copy. He thought lunch might swing it. He had the same thought half a year later, when he wrote to Eliot in June 1944 apologising for the delay in sending a manuscript and for its 'slightly crumpled condition'. The manuscript in question was *Animal Farm*. It had been damaged in the Blitz and Orwell hoped Eliot might publish it at Faber: 'Could you have lunch with me one of the days when you are in town?' Viewed in hindsight, it's hard not to notice a divination in the plaintive register of the appeal. He wasn't in luck. Eliot wrote back a month later with the unwelcome news that Faber would be turning down *Animal Farm* on the grounds that the firm had 'no conviction' the story presented 'the right point of view from which to criticise the political situation' of the time. Among the possible objections to Orwell's handling of the Russian 'problem', Eliot pointed out, was his presentation of the pigs: 'there couldn't have been an *Animal Farm* at all without them: so that what was needed, (someone might

argue), was not more communism but more public-spirited pigs.' *Animal Farm* was duly picked up by Secker & Warburg, who had previously published *Homage to Catalonia* and whose anti-authoritarian stance made it a fitting home for the story.

The experience didn't turn Orwell off Eliot, or from lunch with him, for that matter: another request for lunch comes through in September 1944, followed by another that October. It may have confirmed a sense, evident in Orwell's fiction, that a lot can ride on a midday meal, or at least on the prospect of one. It depends to an extent on the lunch in question. The only animals who eat lunch in *Animal Farm* are the pigs. The other animals eat, but the pigs 'take their meals', in the manner of their erstwhile human oppressors. Some of the other animals recognise this for the double standard it is. And no wonder, given that as the power of the pigs increases it also becomes more and more clandestine. With the animals reeling from the destruction of their windmill, and facing the prospect of a strength-sapping effort to rebuild it at even greater effort, a rumour does the rounds that Napoleon the pig has secluded himself in 'separate apartments' from his fellow oinkers. He takes his meals alone, dogs serving him as he eats 'from the Crown Derby dinner service which had been in the glass cupboard in the drawing-room'. A poem is written in his honour, with lines praising him as 'the giver of / All that thy creatures love, / Full belly twice a day'. It is, of course, a deception. The animals work 'longer hours' and feed 'no better than they had done' when they were ruled by men.

Had the animals existed in the world of *Nineteen Eighty-Four*, the Newspeak word given to their displeasure would have

been 'unbellyfeel' – the exact opposite of 'a blind, enthusiastic acceptance' of the ruling ideology. The animals are supposed to consent to their subjugation willingly, relishing it in the interests of the greater good and accepting their hunger pangs as part of the hard-won liberty they now enjoy. The only thing that brings them some relief is enforced celebration in the form of the so-called Spontaneous Demonstrations, weekly jamborees mandated by Napoleon as a way to commemorate 'the struggles and triumphs of Animal Farm'. Timed like clockwork, the Spontaneous Demonstrations show up the lie in the false freedom the animals appear to have won for themselves. Theirs is a spontaneity commanded to occur, and thus a mirage. Yet the animals enjoy it, or at least most of them do:

> At the appointed time the animals would leave their work and march round the precincts of the farm in military formation, with the pigs leading, then the horses, then the cows, then the sheep, and then the poultry. The dogs flanked the procession and at the head of all marched Napoleon's black cockerel. Boxer and Clover always carried between them a green banner marked with the hoof and the horn and the caption, 'Long live Comrade Napoleon!' Afterwards there were recitations of poems composed in Napoleon's honour, and a speech by Squealer giving particulars of the latest increases in the production of foodstuffs, and on occasion a shot was fired from the gun. The sheep were the greatest devotees of the Spontaneous Demonstrations, and if anyone complained (as a few animals sometimes did, when no pigs or dogs were near) that they wasted time and meant a lot of

standing about in the cold, the sheep were sure to silence him with a tremendous bleating of 'Four legs good, two legs bad!' But by and large the animals enjoyed these celebrations. They found it comforting to be reminded that, after all, they were truly their own masters and that the work they did was for their own benefit.

The Spontaneous Demonstrations recover the excess energy that might otherwise take shape as resistance and repurpose it as a performed, observed loyalty. Sufficiently distracted from the reality of their situation, the animals are 'able to forget their bellies were empty, at least part of the time'.

This politicisation of hunger reappears in *Nineteen Eighty-Four*, at the centre of which is the image of a famished child, the young Winston, snatching chocolate from his mother and sister and condemning them to starve. What a member of the Outer Party can't do, however, is go hungry. Or at least Winston can't go hungry, not as an employee of the Ministry of Truth, whose canteen keeps its workers' bellies full and their minds bellyfeeling. That's the plan, at any rate. Descending into the canteen on his lunch break, Winston is hit by a metallic stench of stew and the state-approved tipple, Victory Gin. He's joined by his co-worker Syme, an expert linguist working on the famed Eleventh Edition of the Newspeak Dictionary. They shuffle forwards in the canteen queue, collecting greasy trays with which to carry their lunch: 'a metal pannikin of pinkish-grey stew, a hunk of bread, a cube of cheese, a mug of milkless Victory Coffee, and one saccharine tablet'. Making matters worse is the fact that the stew looks like vomit – more like food turned

inside out and upside down. It's not the first time Winston and Syme have had to hold their noses and get on with this mucky business of eating: they start swallowing the 'filthy liquid mess' in the knowledge that if they don't, questions will be asked. The meat in the stew is sloppy and spongy and also 'probably' synthetic. The uncertainty in that adverb encompasses the strain of a society in which things suspected or known to be false have to be accepted as real, on pain of torture and death.

Workplace conversations over lunch can be harrowing in their way. Winston doesn't choose to sit with Syme; Syme chooses to sit with him. Winston's lack of say in the matter shows in how he 'indifferently' replies to one of Syme's opening conversational gambits and smiles 'sympathetically' at his remarks about the size of the Newspeak dictionary. Syme is one of Winston's putative or so-called friends, a comrade whose company is 'pleasanter than that of others', but he's still a nuisance whose 'mocking eyes' make Winston feel uncomfortable in his presence. Drawn into a rapturous disquisition on the nature and future of Newspeak, Syme speaks dreamily about the end of language – the destruction of words. All Winston can do in reply is paste an expression of bland enthusiasm across his face. Syme goes on and on, jabbering away in a vain effort to convince Winston that Newspeak is the future and he the past. Syme borders on being just another noise in the raucous canteen, just another hum in a room full of the gabbling faithful. One such person, a man with a 'strident voice', is especially noticeable, not least because he's talking gibberish. Ideologically compliant gibberish, sure, but gibberish all the same. They reduce to the same thing: 'Whatever it was, you

could be certain that every word of it was pure orthodoxy [...]. It was not the man's brain that was speaking, it was his larynx. The stuff that was coming out of him consisted of words, but it was not speech in the true sense: it was a noise uttered in unconsciousness, like the quacking of a duck.' Winston wants to eat his lunch in peace. But the canteen, like everything in his life, isn't about to make life easy for him.

Comrade Parsons turns up. (*Yawn.*) Fat, froggy and encased by a thin film of sweat, he's designed to make Winston uncomfortable – and Orwell too, it seems, given the frequent pejorative references to fat people in his fiction. Neither character nor author miss an opportunity to mock the so-called oversized, but Winston seems to fear the Billy Bunteresque Parsons in particular because, in his fatness, he suggests the greedy, chocolate-stealing boy that Winston once was and may still be: 'His whole appearance was that of a little boy grown large [...]. In visualising him one saw always a picture of dimpled knees and sleeves rolled back from pudgy forearms.' A differently difficult realisation for Winston is the fact that Parsons hasn't joined him for lunch because he wants to eat in his company. No: he's joined him for lunch because Winston owes him money, a 'voluntary' subscription to the fund underwriting the preparations for the orgy of xenophobia held annually in Oceania – Hate Week – which serves the same function as the Spontaneous Demonstrations in *Animal Farm*: to compel citizens into merry obedience to the political structures by which they're subjugated. Winston finds the two dollars he owes to Parsons and hands them over. But the damage has been done: this lunch is an extension of the workplace, not a respite from

it. It's a prison space, everyone there playing the role of inmate and guard simultaneously. When the whistle blows, signalling it's time to get on with his work, Winston stands up, ready to enjoy his well-earned cigarette. Before he can smoke, the tobacco falls out.

Canteens are ripe for satire because they're places in which human interactions can be mechanised. No matter how they're dressed up, canteens remain a kind of uncanny factory space, reproducing the workings of machine-like environments. Workers are moved through them like cars on a conveyor belt, everything is standardised by design, industrial exertions make for sweat and clamour. The canteen in the Ministry of Truth is 'deafeningly noisy', filled with strident chatter, the clanking of utensils and the incessant babble of the telescreen behind it all. Regulated workers are ferried into the canteen as if they're on a production line, before receiving their uniform, 'regulation' lunches. Winston and Syme are served food by unseen labourers whose humanity isn't visible: the meal is handed to them through an opening beneath a grille, separating eater from server. There's a long-standing class dynamic here, those lower in the socio-economic hierarchy labouring on behalf of those higher up it, and there's also an insight into what mechanical effort does to the human body. The proles serving Winston and Syme their lunch are hidden away, robotic in their activity. Well-chosen verbs reinforce the impression. Their lunch is 'dumped' onto their trays, just as the Victory Gin they're forced to drink is 'served out to them in handleless china mugs'.

Orwell recalled in his 'As I Please' column for 31 December 1943 that two years earlier he had 'filed past the menu board' in

the BBC canteen and predicted that soon it would be 'Rat Soup' for lunch, followed by 'Mock Rat Soup' shortly afterwards. It's not entirely clear which option was more unsettling, though the act of 'filing' through the space would probably have irked him, the same as it irks Winston and Syme. Part of the irritation is that canteens deliberately stop their patrons from lingering in them: the idea is that you get your food, eat quickly and leave, the queue at the servery reminding everyone that it's always time to move along. There is a smidgen of this frustration in a message Orwell sent to V. S. Pritchett in June 1943: 'This is to follow up our hurried conversation in the canteen.' The speed of the conversation needs to be mentioned and recalled, because its hurriedness is taxing – just one part of the everyday grind that makes things less enjoyable than they could be. It's for these reasons that Gill Plain is hardly exaggerating the point when she writes that *Nineteen Eighty-Four* is 'fashioned from the horrific realities of fascism, communism and the BBC canteen'.[5] The horror of totalitarian politics is hard to miss, the terror of a canteen counter-intuitively linked to it. Orwell seems to have thought that canteens are not spaces for feeding but places always on the brink of giving less and taking more: sites of lack in an 'age of austerity', to use Plain's phrase, and in this sense part of the logic that moves increasingly towards denying others their right to be satisfied.[6]

VI

Animals

IN APRIL 1936, ORWELL MOVED TO THE VILLAGE OF Wallington in Hertfordshire. There he leased a cottage, The Stores, previously occupied by his Aunt Nellie. It had once been the village shop. He quickly set about reopening it, corresponding with fellow writer Jack Common the day after he moved in about 'sending out feelers', trying to make sure his landlord didn't 'double the rent', and 'making enquiries among the villagers to see whether they would like to have a shop [there] again'. A week or two later, the reopened shop a certainty, he declared:

> I intend, at first at any rate, to stock nothing perishable except children's sweets. Later on I might start butter and marg. but it would mean getting a cooler. I am not going to stock tobacco because the pubs here (two to about 75 inhabitants!) stock it and I don't want to make enemies, especially as one pub is next door to me.

Orwell penned a similar letter around this time to the writer Cyril Connolly:

> As you see by the address this used to be the village shop. There is now no shop, only vans from Baldock, so I am going to reopen it when I have got the place in order & arranged what wholesalers to deal with. I shan't make much out of it but I ought to make my rent & a little over. Of course I shall have to rationalise it so that it doesn't interfere with my work.

Country life and work: a conjunction to which Orwell would return. The name of nearby Manor Farm would come in useful later on, too, and he put it on record that one of the key inspirations for *Animal Farm*, the sight of a little boy whipping a 'huge cart-horse' while driving it along a narrow path, came to him in Wallington. He added to Connolly that although he was welcome to visit, The Stores had 'absolutely no conveniences'. At the time of writing, the garden was 'a pigsty'.

Orwell never stopped associating pigsties with bad messes, but it wasn't as if the untidiness was a problem per se. It gave him a project to work on. Soon the garden had been turned from 'a wilderness of tin cans' into something much more practicable, and before long he'd acquired another patch of land over the road, giving him the option to grow vegetables in one and flowers in the other. Hens followed, as did a goat, Muriel, who would be immortalised in *Animal Farm*. There's a lovely sign of how country life and work overlapped for him in a letter to his fellow novelist Henry Miller where, midway through, he breaks off to say that he has 'to go and milk the

goat' and that he'll continue the letter when he comes back. By October 1936 we find him once more writing to Common, advising that the goat is 'giving a quart of milk a day' and that 'some of the hens [have] begun laying'. Orwell's diaries are fastidious in giving details of how many eggs were laid – a practical consideration, because the eggs could be sold, and a small sign of his interest in nature, whose ancient workings fascinated him. These little things were among the 'joys' prone to being 'dissembled' (concealed) in the modern age, as he put it in his poem 'A Happy Vicar I Might Have Been' (1936), a text about feeling out of place in modern life and a tribute to nature's innocent pleasures: greenfinches on apple boughs, roaches in shaded streams, horses galloping, ducks in flight at dawn.

By the end of 1936 Orwell was in Spain to fight fascists. Life went on in the meanwhile. He'd proposed to his first wife Eileen O'Shaughnessy, unsuccessfully, the previous October, but they married in June 1936 in the village church. Shortly before the wedding he remarked of his domestic arrangements: 'I expect we shall rub along all right – as to money I mean – but it will always be hand to mouth as I don't see myself ever writing a best-seller.' The Stores gave him thirty to thirty-five shillings a week, the profit from which was just enough to pay the rent. Book reviews came out of him at regular intervals, and in August he lectured alongside the art historian and philosopher Herbert Read at *The Adelphi*'s summer school in Langham, near Colchester. Orwell's friend Rayner Heppenstall later wrote in wry humour that 'George Orwell', whom he'd known until then as Eric Blair, had come down 'to give one of

the morning lectures (using this name for *serious things* now, it seemed, not merely for his pot-boiling novels)'. Heppenstall added the detail that after the lecture he and Orwell retired to a nearby pub, the Shepherd and Dog.[1]

I've no idea whether animals were on Orwell's mind in Langham, but they were certainly on his mind in Wallington, where he lived in a perfect little slice of pastoral Englishness. Yet here his thoughts turned not to cows, horses or sheep but to elephants and Burma. The result was his essay 'Shooting an Elephant'. At one point in the piece, the narrator, who may or may not be Orwell, insists on the awfulness of killing the creature:

> I did not want to shoot the elephant. I watched him beating his bunch of grass against his knees, with that preoccupied grandmotherly air that elephants have. It seemed to me that it would be murder to shoot him. At that age I was not squeamish about killing animals, but I had never shot an elephant and never wanted to. (Somehow it always seems worse to kill a *large* animal.)

A debate about this essay has centred on whether or not Orwell did shoot an elephant. Less often mentioned is the fact that, true or not, *autobiographical* or not, the events of the essay point to his familiarity with animals large and small, and to how unsqueamishly he dealt with them. Skip ahead ten years and he is matter-of-factly shooting rabbits on Jura. As the novelist Margaret Drabble notes, 'Orwell was fond of animals,' yes, 'and he was also, like a true Englishman, fond of *killing* [them]. He

killed many snakes on Jura [too], and if witnesses are to be believed, he seemed to kill them with excessive brutality and some pleasure in that brutality.'[2]

Burma had its fair share of brutality, but it was also one long experience of what would have seemed to Orwell like exotic fauna – elephants, snakes, tigers, parrots. Part of the joy in writing about such creatures lay in working out the right words with which to convey their strangeness. There's a beautiful example in *Burmese Days*: a 'bird, a little bigger than a thrush, with grey wings and body of blazing scarlet, [breaking] from the trees [...] with a dipping flight'. It's right that 'Shooting an Elephant' is celebrated for its subtle rendering of an escaped working animal's violent execution, yet it should also be valued, I think, for the tender melancholy with which it portrays the elephant's dying efforts to resist its mortality. Fatally wounded by multiple bullets, the elephant is jolted by 'agony', the 'last remnant of strength' knocked from its legs: 'But in falling he seemed for a moment to rise, for as his hind legs collapsed beneath him he seemed to tower upward like a huge rock toppling, his trunk reaching skyward like a tree.' Orwell's similes grapple for distinctive images; the grappling is all part of an effort to capture the spectacle's impact. They reveal how seriously he worked to register the magnificence of a beautiful animal in death, and to discover a tragic beauty in the violence too.

Orwell's writing about animals often reads more like prose poetry, like haikus, or the condensed poetry favoured by the imagist poets in the 1910s. His diaries are full of wonderful vignettes devoted to the animal life that so often gathered around him, and which he so often gathered around himself.

ANIMALS

Here's an entry from 25 August 1938, written when he was in Suffolk:

> A bedstraw hawk-moth found in our back garden [...]. Evidently a straggler from the continent. Said to be the first seen in that locality for 50 years.
> Little owl very common round here. Brown owl does not seem to exist.

Or consider the following, written a week or two later, which describes a scene in the Bay of Biscay as Orwell and Eileen were travelling aboard the SS *Stratheden* towards Morocco, where they stayed until March 1939:

> Should sight land again tomorrow night. Sea at present calm. Once or twice small shoal of fish, pilchards or sardines, leaping out of the water as though something was after them. Small land-bird, bunting or some such thing, came on board this morning when out of sight of land. Also pigeons perching on rigging.

It had been suggested to Orwell that he should winter in a warm climate to ease the symptoms of what his doctors thought was tuberculosis. When he and Eileen reached Gibraltar, they found a strange place full of strange creatures: describing one animal in terms of another, he logs the fact that the Barbary ape, a large 'doglike' primate 'with only a short stump of tail', comes down from the rock and steals food from the Gibraltan residents. The local breed of goat is the Maltese; the donkeys

are small, like their English counterparts; there aren't any cows, and hardly any hens. There are cats and muzzled dogs.

At Tangier, Orwell notices the dazzling variety of fish in the harbour and how the donkeys are overburdened, carrying heavy loads without much complaint. There are two kinds of swallow or martin. There are camels, sheep, goats, horses, mules, cows, oxen, all of them 'almost without exception in wretched condition'. Journeying to Marrakesh, his eyes are drawn to birds in the sky: ibis, kestrels, hawks, kites, crows, partridges and goldfinches, but no storks. Once there, he witnesses a man carrying a hare. In Casablanca he discovers that the marine life is curiously similar to England's. There are winkles, limpets, barnacles, land crabs and mackerel, but no gulls. He catches a water tortoise ('smelt abominably'), adding that there are no 'ordinary sparrows' about the place, although there is 'a small bird of the finch family' – and large ants too, along with irritating flies and innumerable mosquitoes, but no 'plagues of flying insects'. Marrakesh has blackbirds, little owls and large bats. There are nightjars, horses of different colours. The goats are tiny, but the sheep are large and fat: 'When buying a sheep a man carries it across his shoulders, where it lies completely docile like a large slug.' Another animal comparison to describe another animal. And yet another, from Villa Simont, Route de Casablanca: 'Footmarks of tortoises in the mud could easily be mistaken for those of a rabbit.' On and on it goes, in entry after entry: animal sighting upon animal sighting, the thoughts and jottings of an amateur naturalist.

We get a clear sense from Orwell's seemingly inexhaustible drive to record the Moroccan fauna of how often he saw the

animal first and the human second. He appears to have seen the human through the animal, in fact, as the ubiquity of animal–human comparisons in his writing implies. Everywhere you look in his work there are human actions and characteristics explained in terms of animalistic and bestial semblance: a large group of men who behave like sheep; lizardesque scoundrels; a postmistress with a face like a dachshund; the beehive condition of the world; fascists, far away, that seem as tiny as ants; functionaries who resemble beetles – the examples are innumerable. And in that innumerability is a clue to how easily such comparisons came to his mind. They were often automatic, an essential, unthinking part of how he imagined things. *Animal Farm* adjusts the habit. In this text, animals are seen first only because they are humans in disguise. When we're told that the animals worked 'like slaves', the strategy is revealed, if the allegorical subtext of the novella hasn't already disclosed it. But even here we can sense the strains of his tendency to imagine character animalistically. Boxer the horse's superhuman (superanimal?) exploits as a labourer can only be explained by comparing him to *more animals*: 'He had been a hard worker even in Jones's time, but now he seemed more like three horses than one; there were days when the entire work of the farm seemed to rest upon his mighty shoulders.' For Orwell, comparing things to animals, seeing the animal before seeing the human, was as easy as breathing.

He did see the human, nevertheless. An 'immense development of mendicancy' – not many 'actual beggars but countless touts for curio-shops, brothels etc' – caught his eye in Tangier, and the poverty in Marrakesh was unignorable (13 September):

Children beg for bread and when given it eat it greedily. In the bazaar quarter great numbers of people sleeping in the street, literally a family in every doorway. Blindness extremely common, some ringworm and a certain number of deformities. Large number of refugees camping outside the town. Said to be some of the people who fled north from the famine districts further south. It is said here to be punishable by law to grow tobacco plants in the garden.

Orwell reiterated these observations a fortnight later (27 September), describing the prospect of unemployed women 'flocking' into Marrakesh, which was full of 'swarm[s]' of beggars too. The critic Sarah Gibbs has written of how in these diary entries he can come across more like 'a biologist than a tourist', and nowhere are the possible pitfalls of a scientistic mindset more evident than in his idiomatic yet still degrading descriptions of human groups as animalesque masses: crow-like old women, Burmese children laughing like hyenas, proletarians as herds.[3] Still, he tried to pay attention to injustice, however much we now might want to recoil from his language. Donkeys were overworked, but so were young children, who could be found making wooden ploughs and spoons, brass and copper utensils, 'and even some classes of blacksmithing'. Flies encrusted children's eyes, putting them at constant risk of blindness from infection. Animals and humans overlapped in description, but they also overlapped in the crowded, unsanitary spaces through which Orwell and Eileen moved.

When he and Eileen returned from Morocco in March 1939, Orwell's animal-fixated mind switched away from the

sight of toiling animals, harnessed and bound, in unfamiliar landscapes to the comings and goings of creatures in the more familiar English countryside. When they returned to Wallington in April 1939, he noticed how many bats seemed to flit about the place and how many pigeons, too. His diary entries across that spring offer a compendium of creaturely sightings and demonstrate his absorption in the animals whose goings-on framed each and every day. Visiting the pond up by Wallington church, Orwell discovered that it had become stagnant and full of 'scummy green stuff', yet he nevertheless paused long enough to notice 'a few newts in it'. Orwell's jottings also show him in a tender mode, as per his entry for 27 April: 'Starlings very busy obtaining straw for nests. Mrs. Anderson [a neighbour] heard a cuckoo at 5.45. Caught a thrush in the kitchen, unhurt; a full-grown bird, very yellow inside beak.' And he carried on counting the number of eggs laid by his hens: four one day, ten another, then eight, eight, ten, ten, five, nine, ten and thirteen, and so on – all of them saleable and an anchor for his mind amid an increasingly unstable world.

Late one night in October of that year, Orwell found something glimmering in the grass. He'd spent the day doing what he so often did: gardening – planting cabbage rows and making space for some gooseberry bushes. He had also tried his hand at making coal briquettes to be used in a fireplace. He doesn't seem to have expected to find a creature emitting its own light:

> Tonight found a kind of phosphorescent worm or millipede, a thing I have never seen or heard of before. Going out on the lawn I noticed some phosphorescence, & noticed that this

made a streak which constantly grew larger. I thought it must be a glowworm, except that I had never seen a glowworm which left its phosphorescence behind. After searching with an electric torch found it was a long very slender worm-like creature with many thin legs down each side & two sort of antennae on the head. The whole length about 1¼". Managed to catch him in a test-tube & bring him in, but his phosphorescence soon faded.

Briefly, Orwell became a biologist, studying the creature in detail, noting its shape and structure. The collector in him couldn't resist picking it up, thereby altering its behaviour. He was caught in the collector's paradox: the changing or even the undoing of a thing in the very act of treasuring it. Phosphorescence became dullness. You can almost hear him tut as he finishes the diary entry. What stands out from his reflections is his interest in the creature as something to be studied for its own sake: as an entity to be examined with curiosity, yes, and examined forensically; something precious to be admired.

Noting the measurements of the glow-worm was Orwell's way of paying tribute to its vulnerability. He could easily have stepped on it in the dark. Jotting down its length and counting its legs and antennae fixed it in his diary, a fragile archive of sorts, and placed it in his memory, another kind of safehold. He didn't give the insect a name, but it wouldn't have been out of character if he had. Late in life, he emphasised that his good memories of childhood, 'and up to the age of about twenty', were in some way 'connected with animals'. Years earlier, near the end of his time at St Cyprian's, he wrote a letter to his mother

in which he told her that he'd acquired '3 caterpillars', and that he'd named them 'Savonarola, Paul, and Barnabas'. Naming the insects turned them into personalities, and in that sense gathered them for safekeeping. Here you can grasp how nature *mattered* to him, and how what his biographer D. J. Taylor calls his 'career as a student of the natural world', one which saw him fixate 'on the flora and fauna of early twentieth-century England', took root.[4] Orwell didn't simply want to learn about the natural world and the animals that live in it. He wanted to exist in nature and to hold its creatures in his hands. Against the glitter of the modern, with its steel architecture, concrete facades and chromium plating, which turned horses into tanks, he treasured the blossom of the organic.

He makes a version of this point in his wonderful essay 'Some Thoughts on the Common Toad' (1946), which begins with a tribute to toads heralding the arrival of spring by emerging from their wintry holes in the ground and crawling 'as rapidly as possible towards the nearest suitable patch of water'. Noting the magnificence of the toad's eye – 'like gold', or more exactly 'like the golden-coloured semi-precious stone which one sometimes sees in signet rings, and which I think is called a chrysoberyl' – Orwell notes his joy at seeing toadspawn and tadpoles, a springtime pleasure that in his view 'has never had much of a boost from poets'. (Seamus Heaney would make up for that.) And then a surprise. Loving nature can be a bulwark against authoritarianism:

> I think that by retaining one's childhood love of such things as trees, fishes, butterflies and [...] toads, one makes a peaceful

and decent future a little more probable, and that by preaching the doctrine that nothing is to be admired except steel and concrete, one merely makes it a little surer that human beings will have no outlet for their surplus energy except in hatred and leader worship.

Orwell certainly held on to this childhood love of nature well into adulthood, as the episode with the glow-worm bears out. It was in valuing the small aspects of creation that the large ones could be safeguarded. Naming a caterpillar *mattered*.

Which is not to say that he, or indeed Eileen, didn't have a sense of humour about all this. For example, Orwell nicknamed one of his chickens 'Henry Ford' in tribute to the American industrialist, because the animal 'had such a brisk businesslike way of going about his job', copulating with his first hen 'within 5 seconds' of being put into his enclosure. Making her way into *Animal Farm*, name intact, the goat Muriel appears as one of the more literate animals, reading out the commandments to the other creatures on the farm and even questioning the abolition of the revolutionary song 'Beasts of England' when it's outlawed by the pigs. And the couple appear teasingly to have named their black poodle Marx as a reminder that neither Orwell nor Eileen had read the work of the dog's famous German namesake, and as a teasing joke about size, the poodle ironically at odds with the philosopher's sociocultural enormity. Eileen once remarked that after they *had* read a 'little' Marx they took so strong a dislike to the man that they couldn't look the dog in the face when they spoke to him.

The best joke in Orwell's repertoire of animal writings, though, remains *Animal Farm*. Not because it's funny, although it clearly *is* funny in several respects, but because the joke is so often on the text's readers, who can be found scrambling to read it, bursting with competitive staidness, in the most earnest and sometimes the most humourless of terms. Some of the blame for this is no doubt down to how the novella is taught in schools and universities and tends to be written about in the media. Everyone knows that, despite its title, *Animal Farm* is about people rather than animals, that its cast of farmyard creatures is an allegorical mirroring of certain personalities and categories of individual from the Russian Revolution and the Soviet Union. Orwell himself sanctioned this view, writing to his friend Dwight Macdonald in December 1946 that the book was 'intended [...] primarily as a satire' on exactly these figures. So, Mr Jones is Tsar Nicholas II, Moses the raven a representation of the Russian Orthodox Church. Among the pigs, Old Major is a Marxy Lenin or Leninesque Marx; Napoleon is Stalin; Snowball is Trotsky; Squealer is a condensed representation of the Soviet propaganda machine. Boxer the horse, as the critic David Dwan explains, 'seems to stand for Russia's new worker-heroes – figures like Alexei Stakhanov who became an international name in 1935 for allegedly mining 250 tons of coal in one shift'.[5]

Yet what's less often mentioned is that, as its title suggests, *Animal Farm* is about *animals*, and not about any old animals, but animals with which Orwell had personal, everyday connections. When he lived in Wallington, he passed most of that time immersed in the ordinary, unglamorous business of

looking after livestock. When we learn that Napoleon is willing to sell the eggs from the hens on Manor Farm, we can just about hear Orwell's hens clucking in the background. When Napoleon tries to find traces of the traitor Snowball by snuffing the ground in the vegetable garden, we can hear Orwell's spade and hoe digging the earth. And when the animals take pride in the little patch of Eden they create in their farm's fields and pastures, what comes to mind is the author's 'A Happy Vicar I Might Have Been', a poem written in Wallington, in which the modest joys of the natural take animal shape. *Animal Farm* is never read in these over-literal terms, because its allegorical connotations are so deeply ingrained in our collective sense of what *Animal Farm* means and why it matters. But it's no surprise that *Animal Farm* got written in the way that it was, given how Orwell was so reliably fascinated by human–animal equivalence.

Orwell lived a life in and among nature's menagerie. He may have wanted to question the 'common' view that 'animals are wiser than men', but he certainly thought there was wisdom in looking into the nooks and crannies of human–animal similitude. Drabble reminds us that his first recorded word is said to have been 'beastly', and that his earliest poem, written when he was only four or five, is about a tiger with 'chair-like teeth'.[6] Orwell remembered the poem as plagiarising Blake's 'Tiger, Tiger', though it may well have been inspired by a toy or a picture book (or even by Kipling's Shere Khan). But these early instances of animal thinking are merely the first in a long sequence of comparisons, metaphors, depictions, allusions and echoes in which many creatures are lovingly put on the page.

As the critic Douglas Kerr has argued, the 'idea of writing itself seems to have been entangled for Orwell with the idea of human relations with the natural world'.[7] There was no getting away from animals, in other words, no getting away from the closeness in nature between animal and human behaviour. This closeness reminded Orwell, as it is meant to remind us, of how easily the one can collapse into the other – of the vulnerability of human achievements to creaturely disarray. The thriller writer John Buchan remarked that the division between civilisation and chaos amounts to 'a thread, a sheet of glass'.[8] Orwell may well have added that all it takes to shatter things, sometimes, is a snarl.

VII

Walking

ORWELL ONCE TRIED A THOUGHT EXPERIMENT IN which he ran through the months of the year to test the associations they call up. He started with March, which for him evoked cold wind and hares boxing in cornfields. April suggested showers, cuckoos, swallows and sand martins, whereas May held the fragrance of stewed rhubarb and the 'pleasure of not wearing underclothes'. June was all about smelling hay and going for after-supper walks, just as July brought up an 'endless pop-pop-pop of cherry stones as one treads the London pavements'. One of the things he missed about England when he was in Morocco in 1939 was the sight of flowering cherry trees and apple trees coming into leaf. A decade later he would find a great deal of peace tending cherries on the Isle of Jura, where he ensconced himself to finish writing *Nineteen Eighty-Four*, just as the thought of walking through orchards sustained him when he found himself marooned on the Spanish front. As he put it in *Homage to Catalonia*:

WALKING

> Sentry-go, patrols, digging; mud, rain, shrieking winds, and occasional snow. [...] Up here on the plateau the March days were mostly like an English March, with bright blue skies and nagging winds. The winter barley was a foot high, crimson buds were forming on the cherry trees (the line here ran through deserted orchards and vegetable gardens), and if you searched the ditches you could find violets and a kind of wild hyacinth like a poor specimen of a bluebell.

Walking was a constant in Orwell's life. Going places on foot gave him the time and the leisure to spot flowers, and it also gave him the opportunity to be mysterious. The writer Paul Potts reminisced that in his company 'a walk down the street became an adventure into the unknown', almost as if you could never be sure that he was not about to gallop off into the world in search of another experience and another story to tell.[1] The restlessness in Orwell's character was intellectual, as his hopping from subject to subject in book after book makes clear. Yet there was a literal restlessness in him too, a need to keep busy and to occupy himself in the world: through writing, of course, and through weeding, planting, bicycling, roaming. It was the restlessness of someone who had goals he wanted to achieve and the anxiety of a modern age that made it hard to stay still for too long. Orwell lived out that unsettledness in his global travels, to Burma and beyond. But walking appears to have been a way to cope with unsettledness as much as it could have been a symptom of it – a means with which to resist the restlessness of modern life and not merely its stamp. Walking gave him time to think and to be slowed down in the

thinking: to embrace the attentive noticing of the world that an unhurried pace entails.

The research for *The Road to Wigan Pier* began with a long sequence of journeys: by train, bus and on foot. Orwell set out on 31 January 1936 by train from London to Coventry, where he stayed at a smelly bed and breakfast. The scent seems to have awakened his prejudice. 'Smell as in common lodging houses,' he wrote in his diary. A 'servant girl' caught his attention for the wrong reason – all he jotted down about her was her 'huge body' and 'tiny head', the 'rolls' on her neck 'curiously recalling ham-fat'. Similar observations appear in *Down and Out in Paris and London*, where he dwells on the 'very pink' features of a young shopkeeper, whose skin makes him seem 'like a slice of ham', and in *Keep the Aspidistra Flying*, in which a 'horribly eupeptic family' with 'grinning ham-pink faces' adorn an advertising poster. He couldn't help but recoil slightly at the sight of fatness. Nor could he refrain from associating fat people with stupidity – the servant girl in the Coventry bed and breakfast is 'half witted', just as Comrade Parsons, in *Nineteen Eighty-Four*, is a portly blockhead. A journey to England's industrial north entailed a parallel journey into Orwell's considerable reserves of disgust.

The next day Orwell walked to the outskirts of Birmingham, hopped on a bus to Stourbridge and then strolled a further five miles to a hostel. The total distance walked, he recorded, was sixteen miles, and he had had to walk through spells of rain. He walked another sixteen miles the day after this, going back to Stourbridge on foot and then by bus to Wolverhampton, where he wandered through its slum areas. After lunch he

walked the ten miles to Penkridge. Here he stopped for a cuppa in a tea parlour, where he encountered a 'wizened oldish man and an enormous woman' (another recoil from fatness), who 'thought [him] a hero to be walking on such a day'. A further walk was followed by a bus ride to Stafford, where he checked into a hotel. More bad pongs: 'the usual dreadful room and twill sheets greyish and smelly as usual.' His diary entry concludes with an absurd vignette: 'Went to bathroom and found commercial traveller developing snapshots in bath. Persuaded him to remove them and had bath, after which I find myself very footsore.'

These journeys in and through the north of England – through Hanley and Burslem in Stoke-on-Trent, on to Rudyard Lake, and from there to Macclesfield, Wigan, Liverpool, Sheffield, Leeds and Barnsley – continued Orwell's pattern: buses, trains, paths. Working on *The Road to Wigan Pier* took him through the countryside, into urban centres and people's homes and down mines, where he braved the fearful conditions of a pit worker's day-to-day life. He wanted to know what it was like to walk home through smoke-blackened streets to a grimy, cramped house, passing inadequately stocked shops and miserable people on the way. He wanted to stay in dusty lodgings with filth-strewn floors. He made sure he put himself in the narrow darkness of the subterranean roads running to and from the seams of coal that kept local communities and the nation, and its empire, going. He wanted to stoop and crawl underground, to exhaust himself and to observe miners moving 'with extraordinary agility' through the darkness in which they spent so much of their time. Being dirty, having

weary feet and a crooked back, meant being informed. After one trip into the depths, Orwell sank into a hot bath. Getting the dirt off was nigh-on impossible, and he acknowledged that he was already at an advantage because he had the option of immersing himself in water.

Orwell seems to have enjoyed walking very much indeed, and, in spite of his frequent bouts of ill health, also to have been good at it. After all, anyone who has a favourite brand of walking boot, as he did, probably knows a thing or two about putting one foot in front of the other. Writing in January 1942, he noted that the war had made people 'simplify' their lives, forcing them to 'fall back more and more on the resources of [their] own minds instead of on synthetic pleasures manufactured […] in Hollywood or by the makers of silk stockings, alcohol and chocolates'. An unexpected benefit of the 'pressure of that necessity' was the rediscovery of 'simple pleasures – reading, walking, gardening, swimming, dancing, singing', enjoyments that had been 'half forgotten in the wasteful years' before 1939. There's something of this in *Nineteen Eighty-Four* in the lingering description of Winston Smith picking his way up a sun-kissed lane to his fateful tryst with Julia in the 'golden countryside', pools of light forming in between parted boughs. Winston's slow movement through the countryside shows how he takes pleasure from the simple act of walking, just as Orwell's unhurried description of it underlines the act's importance.

Though increasing ill health meant he couldn't always go as far as he'd like to, Orwell often set himself on long walks. Several of his early letters home to his mother, sent while he was a student at St Cyprian's, mention happy excursions on foot

across the Sussex Downs, and there are repeated references to enjoyable walks of varying lengths and purposes throughout his letters and diaries. True to form, many of his fictional characters are peripatetic, walking through their environments often with purpose and sometimes in circles. How often they're victims of *peripeteia*, an unexpected, sudden reversal of fortune, is a moot point. But as novels like *Burmese Days* and *Nineteen Eighty-Four* demonstrate, he was clearly invested in the leg sensations and foot feels of walking, describing the act itself, especially when it was punishing, in affecting detail. In *Homage to Catalonia* there are walks through greasy, shit-smeared trenches with disintegrating boots, whereas in *The Road to Wigan Pier* he records the near-impossible demands of walking (or trying to walk) underground towards coal seams. Even the animals in *Animal Farm* 'walk', although this is a narrative convenience – and when it's interrupted, it's interrupted for good reason. The animals on Animal Farm surely know the game's up when they watch Squealer the pig 'walking on his hind legs', not least because a piggish tottering is all it takes for the sheep to break into their sycophantic chorus of 'Four legs good, two legs *better*!' and walk the line.

The time Orwell spent in Burma meant walking a line, too. Emma Larkin puts the point well when she writes that for five years, between 1922 and 1927, he 'dressed in khaki jodhpurs and shining black boots. Armed with guns and a sense of moral superiority, the Imperial Police Force patrolled the countryside and kept this far-flung corner of the British Empire in line.'[2] *Burmese Days* shows how everyday colonial life for a British functionary in Burma would have been taken up in

duties performed on foot. In that sense it gives a crucial set of insights into the physicality of the author's daily experiences as an imperial police officer. There are no sure ways to map the experiences of the novel's protagonist, John Flory, onto Orwell's (and it's surely unwise to try), but it's nevertheless tempting to speculate that when Flory walks 'to Dr Veraswami's house, with his shoes squelching and periodical jets of water flowing down his neck' from the brim of his hat, he's not far behind his author's steps and strides. There's the same sense of closeness between author and character in how Flory tries to sweat himself 'into a better mood' by walking for miles into the jungle, drenching his shirt and stinging his eyes. *Burmese Days* records the repellent impact of unbearable heat on the human body, the air in Burma being 'so hot' for European interlopers 'that to walk in it [is] like wading through a torrid sea'. Walking fast under the 'savage' sun quickly leads to an inundation of sweat, but it also sets the stage for poetic digression. When Flory and Elizabeth Lackersteen come to the end of a long walk and feel the sun 'striking into their faces with a yellow, gentle beam', they're touched by an 'inordinate happiness that comes of exhaustion and achievement, and with which nothing else in life – no joy of either the body or the mind – is even able to be compared'.

Orwell states in his essay 'Why I Write' (1946) that when he was sixteen he knew he wanted to compose 'enormous naturalistic novels with unhappy endings, full of detailed descriptions and arresting similes, and also full of purple passages in which words were used partly for the sake of their sound'. He instanced *Burmese Days* as one such book, and it's easy to

see why. This is a novel in which arresting similes and purple passages strain to convey the other-worldliness, as the young Orwell would have perceived it, of a culture half a world away. So much of the local interest of the novel is rendered in these terms, with extravagant analogies figuring Burmese faces that recall 'coffee blancmange', a 'lukewarm sea that foam[s] like Coca-Cola' and a cadaver 'swathed in cloths, like a mummy'. At one point in the novel, Elizabeth shoots a pigeon in the jungle. This prompts a beater (a person employed to flush birds from cover) to run up a 'great creeper' to retrieve the dead animal. The vine curls up a tree 'thick as a man's thigh and twisted' (in another arresting simile) 'like a stick of barley sugar'. Walking 'upright along the broad bough' of the tree, the beater enacts a form of expertise – the ability to manoeuvre himself effortlessly through the branches – that the colonial intruders can't hope to acquire. The narrator resorts to simile, comparing the creeper to a stick of boiled sugar, the sort found in any parochial village shop, to get his head round the sight of something he can't fathom.

In *Burmese Days*, in other words, walking marks an important difference between those who have come to Burma uninvited and those who were already there. For characters like Flory and Elizabeth, and indeed for all the colonial arrivals, walking is often a necessary trial undertaken in the boiling sun to get from place to place. For the Burmese locals, it reveals their fluency in the physical demands of their environment. Yet walking is not always benign in *Burmese Days*, and Orwell seems to have known that the degradation of local populations under colonial rule was discernible in the sapped gait of its

near-disregarded subjects. There is a passage in the novel when Flory sees a disturbing sight:

> Flory went outside and loitered down the compound, poking weeds into the ground with his stick. At that hour there were beautiful faint colours in everything – tender green of leaves, pinkish brown of earth and tree-trunks – like aquarelle washes that would vanish in the later glare. Down on the maidan flights of small, low-flying brown doves chased one another to and fro, and bee-eaters, emerald-green, curvetted like slow swallows. A file of sweepers, each with his load half hidden beneath his garment, were marching to some dreadful dumping-hole that existed on the edge of the jungle. Starveling wretches, with stick-like limbs and knees too feeble to be straightened, draped in earth-coloured rags, they were like a procession of shrouded skeletons walking.

Here, walking speaks the pain of a group of people on the verge of dying. There's a trace of the 'grove of death' from Joseph Conrad's *Heart of Darkness* (1902), in which his narrator, Marlow, recalls seeing a gathering of exhausted African workers who have been reduced to 'moribund shapes' and quasi-mathematical abstractions: 'bundles of acute angles' sitting 'with their legs drawn up' and staring 'at nothing, in an intolerable and appalling manner'.[3] The similarity across these texts indicates an influence (and we know Orwell knew his Conrad), but it also demonstrates an alertness to the dehumanising possibilities of imposed footfalls.

Long walks appear repeatedly in Orwell's books, from the early-morning two-mile jaunts taken by Mr Macgregor in *Burmese Days*; to Dorothy Hale's 'long solitary walks' of ten to fifteen miles in *A Clergyman's Daughter*; to the 'five or seven miles' walked by Gordon Comstock in *Keep the Aspidistra Flying*, a distance that leaves his feet 'hot and swollen from the pavements'. The same idea is given a dystopian twist in *Nineteen Eighty-Four* when Winston Smith chooses not to spend an evening at the state-provided Community Centre, preferring instead to walk 'several kilometres over pavements', his varicose ulcer throbbing. The numerical particularity – a given amount of miles here, a certain number of kilometres there – comes from an author who knows what it's like to walk long distances, and what the walker gains or loses in the walking. Long journeys give characters time and space to have self-realisations. Dorothy's walks in *A Clergyman's Daughter* help her realise that what she really wants, and needs, is 'human companionship'. In *Coming Up for Air*, George Bowling takes an arrogant satisfaction from walking down suburban streets and imagining them as prisons 'with the cells all in a row. A line of semidetached torture-chambers where the poor little five-to-ten-pound-a-weekers quake and shiver,' even though he himself is just as trapped in the 'prison' of nostalgia from within which he makes sense of the modern world.

Keep the Aspidistra Flying's Gordon Comstock habitually walks round London with the self-deluding 'pride' of a poet who isn't as good as he thinks he is. Winston Smith, by contrast, dreams about a voice saying to him that he'll meet the voice's unknown owner in the place where there is no darkness – a

foretaste of his torture in the unceasing brightness of the Ministry of Love. The voice comes into Winston's consciousness as he walks through a pitch-dark room, and he walks on without pausing, almost as if the walking is a defence against the thought of a rebellion that will be his undoing (as it proves). Later on in *Nineteen Eighty-Four*, Winston yearns simply to walk 'through the streets' with Julia 'openly and without fear, talking of trivialities and buying odds and ends for the household', for the unfeigned domesticity that they know, deep down, they can never have. And right at the end of the novel Winston sits in a dream state imagining himself back in the Ministry of Love, 'walking down [a] white-tiled corridor, with the feeling of walking in sunlight, and an armed guard at his back'. Here, walking means death. A bullet will soon enter his brain as he ambles away from his capitulation to power.

In other contexts, walking could be freighted with moral insight. Orwell's journeys through Marrakech inspired him to remark on the ease with which colonists could disparage faraway peoples on account of their apparent physical uniformity:

> When you walk through a town like this – two hundred thousand inhabitants, of whom at least twenty thousand own literally nothing except the rags they stand up in – when you see how the people live, and still more how easily they die, it is always difficult to believe that you are walking among human beings. All colonial empires are in reality founded upon that fact. The people have brown faces – besides, there are so many of them! Are they really the same flesh as yourself? Do they even have names? Or are they merely a kind of

undifferentiated brown stuff, about as individual as bees or coral insects? They rise out of the earth, they sweat and starve for a few years, and then they sink back into the nameless mounds of the graveyard and nobody notices that they are gone. And even the graves themselves soon fade back into the soil. Sometimes, out for a walk, as you break your way through the prickly pear, you notice that it is rather bumpy underfoot, and only a certain regularity in the bumps tells you that you are walking over skeletons.

The passage's ambiguous tone needs to be handled carefully. Although it can seem as if Orwell is endorsing the claim that the inhabitants of Marrakech are 'undifferentiated brown stuff', it's equally plausible that he is pointing out the opposite: that the experience of living under colonialism encourages the view that these people are entirely 'other', allowing the imperialist to forget that dead locals were once living souls. He uses an image of walking to suggest that no amount of forgetting can eradicate the remnants of a body, its bumpy intrusions through the soil announcing the lasting presence of the deceased in the face of colonial indifference.

There were two women in particular with whom Orwell often shared his yearning to walk: Brenda Salkeld and Eleanor Jaques, both of whom he got to know in and around Southwold in Suffolk in the 1920s. He met Salkeld – the gym mistress at a local boarding school and one of the models for Dorothy Hare, the protagonist of *A Clergyman's Daughter* – through his sister, Avril. He met Jaques because her family lived next door to his parents, who had moved to Southwold in the early

1920s. Both women were to be important figures in his life. He made no secret of his affection for Salkeld, though he never had a romantic relationship with her. Things were different with Jaques, with whom he had a brief liaison in 1932–3. The letters he sent to them cover the gamut of his interests. In a July 1931 letter to Salkeld he teases her for what he took to be her 'exaggerated fear' of muck and grime, before intoning solemnly: 'It is a great mistake to be too afraid of dirt.' Salkeld made fun of his attempts on his tramping expeditions to blend in with the dispossessed, and he evidently wanted to return the jibe. Other letters sent to Salkeld include lengthy reflections on the state of the modern novel, including a fascinating account of Joyce's *Ulysses*.[4] Orwell's letters to Jaques are no less enthralling in their range, taking in discussions of gardening, literature, birdwatching, the weather and much else besides, hinting in some instances at their intimacies. In one letter in particular, from September 1932, he remembers the impress of Jaques's 'nice white body in the dark green moss' in a wood near Southwold. It was a memory that stayed with him: Winston has much the same thought about Julia in *Nineteen Eighty-Four*.

Orwell certainly thought that walking could be much more than a matter of getting from here to there. There's a famous photo of him pushing his adopted and only son, Richard, along a pavement in a pram, whose handlebar seems too low for his father's height. A gleam in the adult's eye speaks to the simple pleasure of pushing his child, who seems nonplussed, as children in prams often are. For a man who took so much of the world's weight onto his shoulders, it's good to know he could exit from the world's cares in moments of parental solace.

There may have been an enjoyment in the walking, too, given how often he would have been tied to a desk and typewriter: the satisfaction of stretching his legs and feeling the breeze. A character in *A Clergyman's Daughter* doubles herself up 'like a geometrid caterpillar, with many creakings', but it's tempting to imagine the opposite when Orwell stood up from his desk and got himself ready to go out, angles and elbows and knees righting themselves into gangly tallness. At any rate, the photo shows a man immersed in the present. Here, walking isn't a means to an end – it's an end in itself, something to enjoy for its own sake and on its own terms, a positive alternative to simplistic rhetorics of utility and usefulness.

What went through Orwell's mind in such moments? Was he 'in the moment', as we say, or did his mind wander? There's no equivalent scene of pram-pushing in his fiction, but there are plenty of references to the reflections walks can induce. In *A Clergyman's Daughter* we learn that Dorothy Hare takes herself on 'long solitary walks' to get away from the stifling domination of her school employer, Mrs Creevy, only to find that these excursions take her into 'colourless labyrinthine suburbs' shadowed by winter weather 'more gloomy' than 'the bleakest wilderness'. An escape from confinement, then, to a different sort of snare. When she can, Dorothy takes herself off to a nearby wood, where she walks through 'great beds of drifted beech leaves' that glow 'like copper in the still, wet air'. At times she feels sufficiently comfortable in such places to read a book: a modern version of pastoral calm. In *Coming Up for Air*, by contrast, the protagonist George Bowling walks up the Strand in central London and finds the experience stifling

and claustrophobic – the occasion for an uncanny meeting with the inanimate other: 'When you walk through a crowd of strangers it's next door to impossible not to imagine that they're all waxworks, but probably they're thinking just the same about you.' Bowling's self-awareness is deeply uncomfortable, raising the thought that he's the object to someone else's subject, the unthinking thing to someone else's vital glance. A walk has left Bowling walking a fine line between being dead and being alive.

Orwell trod that line himself on several occasions. Towards the end of his life his respiratory problems made walking difficult, a matter of slow starts and frequent rest. He ended a June 1946 letter to his friend Rayner Heppenstall, who was planning to visit him on the Scottish island of Jura, by saying that the walks there were 'wonderful'. Later, when Orwell's respiratory problems were multiplying, no doubt the beautiful surroundings would have seemed tantalisingly distant, the thought of a walk through them irritatingly beyond his means. When he was recovering in Hairmyres Hospital in Lanarkshire in May 1948 he was often held at a snail's pace despite being able to walk a fair distance, his shaky breathing defeating him. Later that same year, when he was back on Jura, he found that he had to spend much of the day in bed and then on a sofa, with even a few hundred yards of walking or light garden work giving him a temperature. These are more than offhand details; they give insights into a man who had retreated from the world, and who was taking solace, or seeking to take solace, in nature, in which he'd once so easily immersed himself. They're the torment of someone who had long enjoyed to walk and now couldn't. His remark at the start of his essay 'Boys' Weeklies'

(1940) – 'You never walk far through any poor quarter in any big town without coming upon a small newsagent's shop' – has the ring of experience. Part of that experience meant reflecting on what walking means, and more importantly on what it can be made to mean, in stories.

Walking mattered to Orwell, clearly, but maybe it mattered more to those who remembered him walking. One such individual was Richard Peters, one of the author's private tutees from Southwold in 1930 and in time Professor of Philosophy of Education at London University. He recalled Orwell as follows:

> His attitude to animals and birds was like his attitude to children. He was at home with them. He seemed to know everything about them and found them amusing and interesting. Perhaps he thought of them like children, as uncorrupted by the pursuit of power and riches, living for the moment and caring little for organised exploitation of each other. He infused interest and adventure into everything we did with him just because of his own interest in it. Walking can be just a means of getting from A to B; but with him it was like a voyage with Jules Verne beneath the ocean. He had, of course, nothing of the hearty technique of the adolescent scoutmaster or the burning mission of the enthusiast. Neither had he the attitude of the guide on a conducted tour. A walk was a mixture of energy, adventure, and matter of fact. The world, we felt, was just like this. And it would have been absurd not to notice all there was to see.[5]

Peters added that what became clear about Orwell on these walks was the unsentimentality of his attitude to nature: 'There was nothing of the romantic about him. If he had met Wordsworth's leechgatherer he would have been interested in the leeches and in how the old boy made a living.'[6]

This is not to say Orwell didn't have or couldn't employ a dreamy attitude to nature when he felt the urge. A recently discovered letter of his reveals that he appreciated 'those days when spring is just trying to appear & everything has such a beautiful fresh clean colour – sky the colour of a hedge-sparrow's egg – & you can walk & walk all day without getting either hot or cold'.[7] No wonder, then, that of all the folk passages celebrating spring, he liked best the opening of one of the Robin Hood ballads:

> When shaws be sheen and swards full fair,
> And leaves both large and long,
> It is merry walking in the fair forest
> To hear the small birds' song.

Although he lets the protagonist of *Keep the Aspidistra Flying* mock these sentiments, and although he was suspicious of what he called the 'cult of spring', Orwell nevertheless appears to have relished the turn from winter, and to have been inspired by the sight of paths to follow and new flowers to smell. The greater pleasure lay in working out how best to get it all down on paper.

VIII

Greenery

ORWELL'S NEAR-OBSESSIVE INTEREST IN ANIMALS, AND in how humans frequently seem to behave like beasts, was part of a deeper fascination with the scale and diversity of the natural world. For as long as he lived he was entranced by Ralph Waldo Emerson's 'daily food' of the natural, which sends 'wild delight' running through man.[1] It was an everyday pleasure for Orwell, and he could be surprised by those who thought that enjoying nature was a frivolous indulgence. 'Is it wicked to take a pleasure in Spring and other seasonal changes?' he asks in 'Some Thoughts on the Common Toad':

> To put it more precisely, is it politically reprehensible, while we are all groaning, or at any rate ought to be groaning, under the shackles of the capitalist system, to point out that life is frequently more worth living because of a blackbird's song, a yellow elm tree in October, or some other natural phenomenon which does not cost money and does not have what the editors of left-wing newspapers call a class angle?

The essay celebrates the humble joys of seeing time in flow: swallows migrating, daffodils appearing, snowdrops lifting themselves out of the earth. A reminder of bombs comes through in the sight of an elder tree's vivid green sprouting amid blitzed architecture, and the essay ends with the thought of atomic weapons piling up in factories. Still, the earth continues on its lonely journey round the sun, 'and neither the dictators nor the bureaucrats, deeply as they disapprove of the process, are able to prevent it.' Orwell is telling us that there's a hard limit to power. Whatever lies are told about it, and however much it's damaged, nature endures in one form or another.

Orwell's 'wild delight' in nature sometimes meant he made life difficult for himself when he didn't need to. Paul Potts recalled that the author 'carried independence to such lengths that it became sheer poetry'. The poetry, for Potts, wasn't in Orwell's work, but in how he behaved. There was a stubbornness there. When Potts visited him on Jura, Orwell needed help moving furniture from a nearby village into the house he was renting some seven miles away. There was the option to use cars: a rich family nearby had a garage with estate cars and load-bearing jeeps. Anyone else would have leaped at the chance. Orwell, being Orwell, refused. Despite his worsening health, his preference was to strap the furniture – tables and chairs – onto his back, and onto Potts's, and to walk. 'He could have borrowed the use of one of those cars almost as easily as he could have been told the time had his watch stopped,' Potts remarked.[2] But Orwell didn't want to. He wanted to smell the sea air.

When in *A Clergyman's Daughter* Dorothy rubs a fennel frond against her face and inhales a 'scent of summer days,

scent of childhood joys, scent of spice-drenched islands in the warm foam of oriental seas', I get the sense that this is *Orwell*'s experience, not hers – a remnant of the countryside walks he used to take in and around Southwold in the early 1930s, the inspiration for the novel's setting. Cycling home on a summer's day, Dorothy spots a wild rose. She dismounts so she can check if it's a sweet briar: *Rosa rubiginosa*. Caught off guard by the fennel, and by its richness of scent, she swoons:

> Her heart swelled with sudden joy. It was that mystical joy in the beauty of the earth and the very nature of things that she recognised, perhaps mistakenly, as the love of God. As she knelt there in the heat, the sweet odour and the drowsy hum of insects, it seemed to her that she could momentarily hear the mighty anthem of praise that the earth and all created things send up everlastingly to their maker. All vegetation, leaves, flowers, grass, shining, vibrating, crying out in their joy. Larks also chanting, choirs of larks, invisible, dripping music from the sky. All the riches of summer, the warmth of the earth, the song of birds, the fume of cows, the droning of countless bees, mingling and ascending like the smoke of ever-burning altars. Therefore with Angels and Archangels! She began to pray, and for a moment she prayed ardently, blissfully, forgetting herself in the joy of her worship. Then, less than a minute later, she discovered that she was kissing the frond of the fennel that was still against her face.

The joy doesn't last. Dorothy checks herself when she realises she's slipped into a 'half-pagan ecstasy' and hears the

admonishing voice of her father's strictures against 'Nature-worship': 'mere pantheism, and, what seemed to offend him even more, a disgusting modern fad'. The rose turns from sacred object to scolding punishment. Dorothy takes one of its thorns and pricks herself with it three times, reminding herself of the priority of the Holy Trinity. Yet it's the force of her short-lived joy that matters. We glimpse a world beyond the rebuking voice of patriarchy and peek into Dorothy's enraptured solidarity with nature, letting us feel her delight in its cosmic power.

This could not be more different from the feelings evoked by, and the possibilities for feeling contained in, the pleasure resorts of the future that were being planned in the mid 1940s. Uncompromisingly synthetic and Americanised, they caught Orwell's eye. He wrote in a short piece, 'Pleasure Spots' (1946), that plans were afoot to create holiday camps filled with bars and restaurants, dance halls with translucent plastic floors, bowling lanes, swimming pools with rhythmically pulsing wave generators, tanning beds and open-air drive-in cinemas, all soundtracked by incessantly transmitted music filtering through speakers playing dance or symphonic tunes and accompanied by 'glass-covered tennis courts, a bandstand, a roller-skating rink and perhaps a nine-hole golf course'. In short, 'everything that a "life-hungry" man could desire.' Think Butlin's *in excelsis*, or the setting for one of J. G. Ballard's disturbing satires. Orwell contrasted such 'pleasure-domes' with the project of Kubla Khan in Coleridge's 1816 poem of the same title, which turns on a design to make 'gardens bright with sinuous rills' and 'sunny spots of greenery'.[3] The reality of the pleasure spot of the future is much less enticing. In these resorts, holiday-goers are

never alone or self-reliant, light and temperature are artificially regulated, there is a constant hum of background music, and most damningly there is no 'wild vegetation or natural objects of any kind'. The background noise prevents thought and even conversation, shutting out birdsong and the whistling wind.

Orwell thought the artificiality of the modern pleasure spot was like trying to climb back into the womb: a way to surrender responsibility and to recover a lost but contingent safety. In 'Some Thoughts on the Common Toad' he also compares staying in a holiday camp to being 'immured in a prison'. And the endlessly babbling acoustics remind him of the radio, which – surprisingly for someone who spent so much time *on* the radio – could seriously irritate him. To him, its murmur was a clattering disturbance, an intrusion into the mind. *Coming Up for Air* aligns the radio with everything slick and shiny and streamlined, and Orwell himself depicts it occasionally as one of the modern world's 'passive, drug-like pleasures'. He was increasingly of the view that the 'function' of the radio is not to be listened to as such but to always be heard and hearable: an incessant stream of sound in the backdrop of everything, stopping conversation 'from becoming serious or even coherent' and preventing thought. How appropriate, then, that in its first draft the famous opening line of *Nineteen Eighty-Four*, 'It was a bright cold day in April, and the clocks were striking thirteen,' was about radios, not timepieces. He understood the radio as something that weakens human mindfulness, dulling curiosity and driving people 'nearer to the animals'. Decisively opposed to the natural, the radio symbolised much of what was wrong with a modern world from which, in his view, simple

pleasures were being eliminated. It all boiled down to whether there was something sentimental 'in preferring bird-song to swing music and in wanting to leave a few patches of wildness here and there instead of covering the whole surface of the earth with a network of *Autobahnen* flooded by artificial sunlight'.

Birdsong mattered. When Orwell was working in 1932 as a secondary school teacher in Hayes he often went in search of birds and their nests. Like Coleridge, did he ask what the birds say?[4] You can imagine him walking down a lane and being frustrated when he didn't find them. Hayes stirred his disgust: 'one of the most god-forsaken places' he had ever 'struck', as he put it. It wasn't the teaching that sickened him, it was the suburban location. He tried to compensate for it all by getting an allotment, a place where he could grow a marrow for the harvest festival, among other things. Rain, slugs and mice gave him trouble at first, but before too long he was getting it all in order. Digging in the earth meant he didn't have to dig too far into the locale. It kept him busy. Still, it was hard to find the time to be green-fingered. In the letters from this period he often mentions being pressed for time and having to make the most of his weekends in the garden.

The urgency found its way into Orwell's poetry, which often reveals how little time there is to survey nature's offerings, and how an indifference to nature is felt in human behaviour. One T. S. Eliot-like poem he published in *The Adelphi* in March 1933 contrasts 'middle autumn days' in which withered trees, 'sere elms', can be seen as the 'being[s]' they are, 'rapt, alone', with throngs of 'death-marked people' in streets, 'Goalless, rootless, like leaves drifting, / Blind to the earth and to the sky.' Another

poem of two months later, again published in *The Adelphi*, celebrates the dash and dance of a blue tit unaware of 'the transient light that gleams like the ghost of May', of the hawk on its way along with 'the frost-bound nights', the blue tit's death 'foredoomed'. It's all a bit forced. Ezra Pound would have taken his red pen to 'sere', at the very least.[5] But it demonstrates that Orwell found solace in writing when he wasn't rebuking suburbia, and beneath that in feeling the complex pleasures of witnessing nature in its seasonal rhythms.

Orwell's most extended character study in resentment, Gordon Comstock, finds it difficult to look at nature without aggrievedly imagining something else into it. At one point in *Keep the Aspidistra Flying*, he and his girlfriend Rosemary walk in an 'extravagantly happy' way through the woods near Farnham Common, Buckinghamshire. Orwell had once been on a similar walk with Brenda Salkeld in the same woods, Burnham Beeches, and in June 1933 he hoped to persuade Eleanor Jaques to go there too. Looking at the beech trees, Gordon and Rosemary fall into a light-hearted argument about similes and metaphors. They agree that due to their smooth bark and limb-like boughs, beech trees 'look more like sentient creatures than other trees', and this spurs Gordon to compare the lumps on their bark to 'the nipples of breasts'. Invigorated by the exchange, he teases Rosemary with 'ugly similes' for everything they pass, before going too far by kicking over some lavender-coloured toadstools because they remind him of the ethereal, pixie-strewn illustrations of Arthur Rackham. This Rackhamesqueness annoys him because he associates it with a particular kind of snobbishly 'cultured' locale: the sort of road

on which literary allusions hang heavily, and where (whisper it) Browning Societies flourish and 'ladies in art serge' sit 'talking about Swinburne and Walter Pater'. All very Bloomsbury, to Gordon. Rosemary chastises him for being 'a soulless pig', and he can't help but mock her for the pleasure she takes in wading through fallen leaves.

There's little sentimentality in Gordon's thinking about nature, but there can be a soppiness in Orwell's. At times his nature prose can seem too contrived to be genuine, particularly in his essays. In some of these pieces, even in 'Some Thoughts on the Common Toad', it can have the feel of an overstressed melancholy. But this doesn't change the fact that he was highly knowledgeable about beasts, birds and flowers, all of which he loved with an insatiable curiosity about their distinctive places in 'the order of Nature', to quote the dying Old Major in *Animal Farm*. When the narrator of *Nineteen Eighty-Four* sweeps across the vistas of bombed-out London, one of the key details is the sight of willowherb straggling over heaps of rubble, just as in 'Some Thoughts on the Common Toad' on even 'the most sordid street' the elder 'sprouting on a blitzed site' or a 'brighter blue between the chimney pots' register the approach of spring. Greenery's appearance in debris is the allure of hope. The willowherb is a meaningful part of the author's novelistic world-building: it evokes a natural sphere coinciding with and yet simultaneously beyond the reach of totalitarianism, a world growing through the wreckage of human civilisation and that will, in theory, outlast it. But it also evokes something more modest: the fact that Orwell was a gardener, and that he understood where and when, as a writer,

to use his green knowledge. The willowherb shows that he had soil under his fingernails.

Orwell's closeness to the earth in part explains why he was troubled by the machinic elements of civilisation that posed such a threat to the flora and fauna he revered. He was never persuaded by those conservatively minded thinkers who supposed that machines could simply be eliminated from modern life. As he claimed in *The Road to Wigan Pier*, 'to revert to primitive methods, to use archaic tools, to put silly little difficulties in your own way, [is] a piece of dilettantism.' Yet he was unsettled by how certain traditions within the socialist politics of his time appeared to accept mechanisation as an inevitable requirement of material progress. Part of his distrust of the machine came from a sense that people could be more easily mobilised against the democratic socialism he championed when an industrial, inhuman, 'glittering' vision of the future was taken to stand for everything at which the socialist project supposedly aimed. *Nineteen Eighty-Four* doesn't reject socialism as such, but it rejects *this* version of socialism, a socialism transformed into a centralised tyranny that runs on mass exploitation of its citizens and an industrial economy on a permanent war footing: 'a picture of aeroplanes, tractors and huge glittering factories of glass and concrete', in the words of *The Road to Wigan Pier*. This led Orwell to question reductively utopian views of the future in which things 'made of leather, wood or stone' were to be replaced by 'rubber, glass or steel; [...] no disorder, no loose ends, no wildernesses, no wild animals, no weeds, no disease, no poverty, no pain'. *Nineteen Eighty-Four* is pitched exactly against this mechanical scenario: a 'huge, terrible and glittering

[...] world of steel and concrete, of monstrous machines and terrifying weapons – a nation of warriors and fanatics, marching forward in perfect unity, all thinking the same thoughts and shouting the same slogans, perpetually working, fighting, triumphing, persecuting'.

The deceptive glitter and glamour of totalitarian society is about as far away from gardens and vegetable plots as it's possible to get. When Orwell wasn't defending liberty from the march of fascism in Spain he had a garden back in Wallington to tend, and flowers, fruits and animals to take notice of, as he made clear in this detail-laden diary entry from April 1939:

> Flowers now in bloom in the garden: polyanthus, aubretia, scilla, grape hyacinth, oxalis, a few narcissi. Many daffodils in the field. These are very double & evidently not real wild daffodil but bulbs dropped there by accident. Bullaces & plums coming into blossom. Apple trees budding but no blossom yet. Pears in full blossom. Roses sprouting fairly strongly. I note that one of the standards which died is sprouting from the root, so evidently the stock can live when the scion is dead. Peonies sprouting strongly. Crocuses are just over. A few tulips in bud. A few leeks & parsnips in the garden (the latter have survived the winter without covering up & tops are still green), otherwise no vegetables. It appears that owing to severe frosts there are no winter greens locally.
>
> Bats out everywhere. Have not found any birds' nests yet.
> Wildflowers out: violets, primroses, celandine, anemones.
>
> A little rhubarb showing. Blackcurrant bushes etc. for the most part have grown very weedy, probably for lack of

hoeing round etc. Strawberries have all run & are covered with weeds but look fairly strong.

Sowed cos lettuce.

Leaf mould (beech) put down at end of 1937 is now well rotted down.

Found two thrushes' eggs under the hedge – no nest, somewhat mysterious, but perhaps left there by a child.

Today a stack being thrashed – oats, & seemingly no rats & few mice. Tried Marx with a live baby mouse. He smelt & licked it but made no move to eat it.

Pigeons making their mating flight fly steeply up into the air then volplane down.

Four eggs.

Orwell enjoyed the noticing for its own sake, as the accumulation of detail amply proves. The record-keeping is so lavishly attentive it amounts to a song of praise. He distanced himself from the 'rapturous' prioritising of the natural over the human that he saw in the work of Richard Jefferies and W. H. Hudson – authors of the novels *After London* (1885) and *Green Mansions* (1904) respectively – who in his mind succumbed to an 'inherently antisocial', ill-advised nature-worship. All the same, he cherished nature: cataloguing its textures, remembering the names of plants, tending the earth, coaxing fruit, tallying eggs. Ordinary pleasures well enjoyed. Even the Orwells' dog, Marx, can't quite bring himself to destroy the fauna; the mouse has to be inspected rather than killed. Nature is something to be witnessed, not dominated.

Gardens entail their own conquests. As spaces they mix nature with the unnatural, the already existing with the belatedly

well ordered. Gardens are contrived, not innate; made, not found. The Christian earthly paradise, as described in Genesis, got it all under way: 'the LORD God planted a garden eastward in Eden; and there he put the man whom he had formed.'[6] All gardens have the legacy of Genesis in them, the garden a distant relative of Paradise, the gardener a minor deity. But even deities, especially minor ones, have their problems. Gardens wouldn't be gardens if they didn't continually threaten to run away from themselves, forcing the gardener to make a compromise between austere perfection and lush tangledness. Orwell understood that the distinction between 'the trim formal garden of classicism' and 'the wild romantic jungle, full of stupendous beauty, and also of morasses and sickly weeds' is a slippery one: 'the two encroach, and claim neutral ground, so that sometimes it is hard to say which is jungle and which is garden.' It takes a lot of work to get a garden into shape, and to keep it there, through a constant negotiation with nature's insistent growth and growing. Dapper lawns and well-groomed flower beds don't take care of themselves, after all. There are those who enjoy the labour, but there are also those who wonder what the effort is really for.

There's a gardener's mind at work in *Animal Farm*, which treads a fine line between taking a view of planting and weeding as good things in themselves and questioning them as tools of power. Motivating the animals' discontent is the fact that their human master, Mr Jones, doesn't pay enough attention to his wildflowers. Although once upon a time he 'had been a capable farmer', by the time *Animal Farm* begins his employees have become 'idle and dishonest', his buildings

have fallen into disrepair, the animals are underfed, the farm's hedges are 'neglected' and its fields 'full of weeds'. The pursuit of Animalism entails getting Jones's affairs in order: bringing in the hay, harvesting the corn, imagining and then building a windmill. And weeding, inevitably – a job the animals are peculiarly well placed to do 'with a thoroughness impossible to human beings'. All too quickly, though, the work of weeding becomes intermingled with the suspicions of paranoia. The traitor, Snowball the pig, is suspected to have mixed weed seeds with seed corn, thereby undoing the animals' hard graft. In the reimagined farm, in what is meant to be the animals' utopia, weeding has become something to be done under duress, an act performed by scared animals working diligently and yet 'not knowing whether to be more frightened' of the pigs they serve or the human visitors whose trust the pigs hope, against all Animalist sentiment, to gain. When Boxer the horse is carted off to the knacker's yard, most of the animals are distractedly weeding turnips in a field.

Orwell's garden at Wallington gave him ample opportunity to imagine how a society of animals might tend the land, and to get his hands into the earth. Rayner Heppenstall recalled visiting the author in Wallington at The Stores ('not a pretty cottage', in his view), where he saw 'two goats in a stinking shed at the back'.[7] Orwell made a habit of digging there, weeding and planting ramblers, roses, fruit trees and gooseberries. He returned to the garden a decade after he first started ordering it, remarking in his 1946 essay 'A Good Word for the Vicar of Bray' that the visit gave him 'a feeling of having done good unconsciously'; in planting trees and bushes he'd added to the

world's common stock of virtue. The rose bushes were to be admired simply for having bloomed, as were the fruit trees, and the idea of putting trees into the earth appealed to his deep sense of heritage. Planting an apple tree is 'a public-spirited action'; the bloom of a rose bush matters because it gives pleasure for years on end, just as an 'oak or a beech may live for hundreds of years and be a pleasure to thousands or tens of thousands of people before it is finally sawn up into timber'. Still, he regretted not having planted a walnut tree, even though he believed that planting trees wouldn't change the world. But he thought that pushing an acorn into the ground could make a small contribution to the collective well-being of society. 'The planting of a tree,' he wrote, 'especially one of the long-living hardwood trees, is a gift which you can make to posterity at almost no cost and with almost no trouble, and if the tree takes root it will far outlive the visible effect of any of your other actions, good or evil.'

In her meditation on Orwell's green-fingered worldview, Rebecca Solnit has written about how, if you 'dig into [his] work, you find a lot of sentences about flowers and pleasures and the natural world'.[8] Reading about a man who liked to dig necessitates its own burrowing, which opens out onto a life committed to the wonders of natural green space. Yet Orwell also thought that a garden isn't good simply because it's a garden – it also depends on what sort of garden it is, what surrounds it, what it's used for, where it's located, why it's there and who enjoys it. The Wallington garden was good because through it he could contribute to posterity and make his mark on a small patch of earth, and because in writing about it he

could connect the planting of trees to 'universal questions of redemption and legacies'.[9] By contrast, a garden of the kind that George Bowling looks at from his bathroom window, at the start of *Coming Up for Air*, doesn't cut the mustard:

> It was a beastly January morning, with a dirty yellowish-grey sky. Down below, out of the little square of bathroom window, I could see the ten yards by five of grass, with a privet hedge round it and a bare patch in the middle, that we call the back garden. There's the same back garden, same privets and same grass, behind every house in Ellesmere Road. Only difference – where there are no kids there's no bare patch in the middle.

It's not clear what's more troubling for Bowling: the comparatively small garden, its typicality, the worn patch in its centre or the bourgeois privet hedge with which it's framed. But these irritating elements make the garden what it is: a reminder of how little worth it has *as a garden*. Bowling's garden, unlike the garden at Wallington, has no claims on a legacy. Like every other garden in the suburbia in which the character lives – a suburbia lined with streets that 'fester' and houses akin to prison cells in their uniformity – its only bequest is to have been itself: a sign of the streamlining of modern life that Bowling dislikes.

The real problem with the gardens on Ellesmere Road is that they don't have any flowers in them. Because of this, they don't have a true claim on Englishness as Orwell understood it. A little later on that same beastly January morning, Bowling gets a train into central London. He notices a bomber flying

overhead. A sign of war, and its imminence; the dread of a conflict not yet started but inevitable. His eye wandering around the carriage, he assesses his fellow commuters: some newspaper canvassers, a couple of lawyers' clerks talking ostentatiously about their work. Bowling's gaze turns outwards and away from the carriage. Watching the backs of the houses on the line from West Bletchley, he glimpses their 'little backyards with bits of flowers stuck in boxes and the flat roofs where the women peg out the washing and the bird-cage on the wall': less suburbia and more slum, as he views it, but 'kind of peaceful' all the same. Bowling later remarks that young boys aren't interested in greenery, never looking at landscapes and not giving a damn about flowers. But he at least seems to admire them. Picking a primrose gives him a sensation of wonder: intense, satisfying and flame-like, and like all flames flickering and labile, about to disappear. He also knows that to admire a flower is to incur a cost. The leisure to do it necessitates that someone else works so that the leisure time can exist: 'It's only because chaps are coughing their lungs out in mines and girls are hammering at typewriters that anyone ever has time to pick a flower.'

Picking flowers in *Coming Up for Air* is a fragile way to hold on to something real in a modernising world of increasing sameness. It marks Bowling's nostalgia for the idealised past he fails to discover, and it indicates his normality – the normality of an Englishman who finds peace in flowers and in the reassuring solidity of the names of coarse fish: roach, rudd, dace, gudgeon, chub, carp and all the rest of them, names invented by people ignorant of machine guns and who 'didn't live in terror of the sack or spend their time eating aspirins, going to the pictures

and wondering how to keep out of the concentration camp'. Orwell wrote *Coming Up for Air* in part as a protest against the modern, against radios and car horns. Yet he was convinced that loving flowers offered no defence against the unstoppability of industrial progress. To be English is to cherish things that have long since gone out of date, to dislike philosophy and to be bad at town planning, he claimed, but it's also to have an instinct for justice and an unwillingness to be dominated. The 'minor English trait' that is their 'love of flowers' is 'one of the first things that one notices when one reaches England from abroad, especially if one is coming from southern Europe', as he did when he returned to England from Spain. In a beautifully judged passage, he lists in the concluding paragraph of *Homage to Catalonia* the sight of nature in unignorable grandeur:

> Down here it was still the England I had known in my childhood: the railway-cuttings smothered in wild flowers, the deep meadows where the great shining horses browse and meditate, the slow-moving streams bordered by willows, the green bosoms of the elms, the larkspurs in the cottage gardens; and then the huge peaceful wilderness of outer London, the barges on the miry river, the familiar streets, the posters telling of cricket matches and Royal weddings, the men in bowler hats, the pigeons in Trafalgar Square, the red buses, the blue policemen – all sleeping the deep, deep sleep of England, from which I sometimes fear that we shall never wake till we are jerked out of it by the roar of bombs.

IX

Hobbies

THE ACCUMULATING DESCRIPTIONS OF THIS BOOK amount, in their way, to a list or catalogue of Orwell's fascination with the everyday – an entirely appropriate form, given his lifelong fondness for lists, inventories, tallies and enumerations of every sort. Like Evelyn Waugh, another catalogue-minded writer, Orwell used lists repeatedly in his work. They gave him a way to capture the many-sidedness of any number of topics and problems, chief among them the question of England's national character. Although he emphasised that national characteristics 'are not easy to pin down', and that 'when pinned down they often turn out to be trivialities or seem to have no connexion with one another', this didn't stop him from seeing national character as a listable thing: 'Spaniards are cruel to animals, Italians can do nothing without making a deafening noise, the Chinese are addicted to gambling,' he wrote in *The Lion and the Unicorn*. There's a playfulness in such comments, with the author using the form of the list to suggest the ludicrousness of reducing character to a sequence of attributes.

But recognising the possibility for lists to be silly didn't stop list-making from being one of his favoured pastimes. A good list can be a surer guide than the unbridled commentary. Discussions expand, lists concentrate. Lists helped him get to the heart of the matter.

They also gave him a way to judge his contemporaries. He liked to make lists of the books he'd read and which he planned to read. His reading list for 1949, for example, includes texts by F. Scott Fitzgerald (*Tender Is the Night*), D. H. Lawrence (*Sons and Lovers*), Vita Sackville-West (*The Edwardians*), Aldous Huxley (*Ape and Essence*), Thomas Hardy (*Tess of the D'Urbervilles*), Winston Churchill (*Their Finest Hour*), Charles Dickens (*Little Dorrit*), George Gissing (*New Grub Street*), John Maynard Keynes (*Two Memoirs*), William Empson (*Seven Types of Ambiguity*), Raymond Chandler (*The Little Lady*[1]), Agatha Christie (*Sparkling Cyanide*), Oscar Wilde (*De Profundis*), Rebecca West (*The Meaning of Treason*) and several volumes by Joseph Conrad, among many others (though with only a handful by women). The list runs to some 143 entries; given his health at the time, this implies an impressive reading rate of one book every two and a half days. He was reading between five and fifteen books a month, and commenting to himself on his progress through them. Orwell dipped into several books and read 'most of' several others, including volumes by Edgar Allan Poe and Dorothy Sayers. 'Skimmed' books included Suzanne Labin's *Stalin's Russia*, David Shub's biography of Lenin and Keynes's *The Economic Consequences of the Peace*. He 'tried & failed' to read Bertrand Russell's *Human Knowledge: Its Scope and Limits*.

Orwell made similarly unguarded remarks about his fellow literary types and other figures in what is arguably the most scandalous document he ever wrote: his infamous list of crypto-Communists and fellow travellers, parts of which he shared with the Information Research Department (IRD), run out of the British Foreign Office, after it was established in 1948.[2] His list incorporates a large slice of the left-leaning, Anglo-American cultural, political and scientific intelligentsia of the time: E. H. Carr, Charlie Chaplin, Nancy Cunard, Douglas Goldring, Hugh McDiarmid, Seán O'Casey, J. B. Priestley, Stephen Spender, George Bernard Shaw, Upton Sinclair, John Steinbeck and Orson Welles are all there, as are other names less familiar today. The author's annotations for many of the figures he lists hardly paint him in the best light. Cunard, he writes, is 'silly', though she 'has money'. Arthur Calder-Marshall, the novelist, is an 'insincere person'. G. D. H. Cole appears 'shallow', likewise for Goldring. Joseph E. Davies, a former US ambassador to the USSR, seems 'very stupid'. Ralph Ingersoll, the American editor and publisher, is a 'dishonest demagogic type'. Several people are called out for what Orwell takes to be their careerism or for their propensity to be wealthier than their professions seem to allow for. The most uncomfortable passages reveal Orwell's homophobia. The journalist and politician Tom Driberg has 'independence occasionally', but is quickly positioned, in an awkwardly judgemental adjective, as 'homosexual', and the poet Spender is 'easily influenced', with a 'tendency towards homosexuality'. It's always a risk to snoop into anything written by those who'd hoped to keep their writing private. But his list shows how catalogues of character attributes are rarely fully benign.

That said, the list isn't exactly what Orwell's detractors have made it out to be. He has often been called out by his enemies on the Right and on the Left for having turned into a snitch against his own cause. In this light, the list is damning, or more precisely is able to be seen as damning, because it appears to confirm that at the end of his life he was ready to betray the socialist cause. The probable reality is less outrageous. Although he did pass on the list to his friend Celia Paget (née Kirwan), who worked at the IRD, the consequence of doing so was likely to be little more than disqualifying those on the list from being employed by the IRD as part of Cold War-era resistance against Soviet Russia.[3] There is also the thought that the list had its origins in a parlour game the author played with his friend Richard Rees, with whom he liked to speculate about the ideological propensities of public figures. 'This game,' to quote Christopher Hitchens, 'consisted of guessing [who] would, or would not, sell out in the event of an invasion or dictatorship,' and he adds that it had a pedigree in Orwell's long-standing interest in cataloguing 'the varieties of defeatist opinion to be found among British journalists and intellectuals'.[4]

At other times, Orwell's hobbyist commitment to listing involved evoking hobbies themselves as something to be listed. He was convinced that to be English is to be addicted to 'spare-time occupations', a craving that discloses the essential *'privateness* of English life'. The English are, he continued,

> a nation of flower-lovers, but also a nation of stamp-collectors, pigeon-fanciers, amateur carpenters, coupon-snippers, darts-players, crossword-puzzle fans. All the culture that is most

truly native centres round things which even when they are communal are not official – the pub, the football match, the back garden, the fireside and the 'nice cup of tea'. The liberty of the individual is still believed in, almost as in the nineteenth century. But this has nothing to do with economic liberty, the right to exploit others for profit. It is the liberty to have a home of your own, to do what you like in your spare time, to choose your own amusements instead of having them chosen for you from above.

Orwell's relaxed phrasing conveys the sentiment: English hobbies are laid-back affairs, things done for the sake of themselves, matters of neighbourly solidarity rather than imposed belonging. Listing here has a political purpose – to announce the next-to-each-other-ness of English life, its bustling sociability – even as it registers the author's list-mindedness itself. Orwell wrote lists for many different reasons: to describe national character, to announce the threats of the machine age, to catalogue rules for writing, to tell his readers key details about a given character's habits and dispositions. But he also wrote lists because at some level he appears to have found it difficult *not to write lists*.[5]

I suspect that Orwell was so partial to lists because he had a collector's mind. This is, after all, what lists do: they collect, gather, aggregate. When he writes in *Homage to Catalonia* that he 'could fill half a dozen books with quotations' evidencing the lies told in the Communist and pro-Communist press of the late 1930s if he 'chose to collect them', he isn't just saying something about a need to correct untruths. He's also

announcing his readiness to collect, the eager frame of mind with which he turned his collector's eye towards a given subject (or controversy) and the steady rate at which he noticed things becoming collectable. Many of the hobbies to which he was drawn attracted him because they allowed him to indulge a completist streak in himself. Two of his most sustaining hobbies, birdwatching and fishing, are mediums of accumulation: to spot a bird is to gain an instance of having seen it, which can then be neatly filed away in the memory or written down on paper; to catch a fish is to begin a hoard – and to release a caught fish is to indulge in the soothing fantasy of a potentially endless sequence of acquirements, which in their actual and imagined accrual become a stash. For Orwell, birdwatching and fishing satisfied a mildly obsessive need for collections, compilations and clusters.

Which is not to say that Orwell didn't appreciate the gamble that collecting entails. In a review of the journalist William Beach Thomas's *The Way of a Countryman* (1944), he pointed out that the wrong interest in nature could lead to a regrettable sentimentality:

> There is no question that a love of what is loosely called 'nature' – a kingfisher flashing down a stream, a bullfinch's mossy nest, the caddis-flies in the ditch – is very widespread in England, cutting across age-groups and even class-distinctions, and attaining in some people an almost mystical intensity.
>
> Whether it is a healthy symptom is another matter. It arises partly from the small size, equable climate, and varied

scenery of England, but it is also probably bound up with the decay of English agriculture. Real rustics are not conscious of being picturesque, they do not construct bird sanctuaries, they are uninterested in any plant or animal that does not affect them directly.

Unable to stop himself from listing the sights a nature lover (or 'nature' lover) is presumed to admire – the kingfisher, the bullfinch, the caddis flies – Orwell distinguishes between two attitudes towards the natural world: the mind drawn to the collection of 'experiences' and the mind obliged to deal with the flora and fauna at hand. 'The fact is,' he insisted, 'that those who really have to deal with nature have no cause to be in love with it.'

Orwell's hobbyist interest in nature always carried with it the risk of an amorous pretension. His poem 'Summer-like for an instant' (1933) describes the motion of a blue tit flitting over tree branches 'sure-footed and sleek like a mouse' and 'exalt[ing] in the sudden sunlight'. This is hardly the work of someone merely or casually dealing with the natural. Six years later, in Morocco in 1939, he wrote about blue tits again. He had been in Taddert in the Atlas mountains, noticing the birds:

> raven (I rather suspect that the so-called crows down here are ravens too), partridge (fairly common), hawk, some other much larger predatory bird, possibly eagle (only seen in the distance), rock dove & wood-pigeon, blue tit, other birds much as down here, but no storks or ibises. […] Tame peacocks kept at the hotel seemed to do well.

In the Moroccan context, birdwatching was a functional affair: a matter of logging and recording, with poetry kept on the back burner. When in the poem Orwell describes the blue tit as something 'joyfully labouring, proud of his strength, gay-plumed', by contrast, the sense of an exultation is intensified. This is language on the verge of excess. And there's a pleasure to be taken in its excessiveness, even as there's a balancing satisfaction to be had in noticing its contrivance.

As mentioned earlier, poems weren't Orwell's strong suit (though his prose is often poetic). He was always much more convincing when he was just getting down the words, or rather when he was giving the impression, amid much crafted restraint, that that was all he was doing. And birdwatching gave him plenty of opportunities to be restrained. Observing ostriches in their mating ritual in Marrakech prompted him to little more than the most basic of adjectival details: a red neck noticed here in the male, a grey neck there in the female. 'Height of either bird something over 7 [feet]. They would not eat bread.' Back in Wallington, on an April morning in 1939, the author recorded some starlings busily finding straw for their nests. That July there were wood pigeons still in their nests, all gorged on the few redcurrants he'd grown in the garden. A month later he was being pulled in different ornithological directions:

> 17.8.39: Hot. Some blackberries reddening. Found a few mushrooms. Most of the corn now cut, & everyone working fast to get in the remainder while the good weather lasts. Coveys of partridges are mostly large (8–12 birds) but the young birds seem rather small. Saw bird which I cannot

identify. In size colour & type by flight it resembled a waterhen, but apparently was not a waterhen, as it flew too well & took to the wing too readily, & also it was nowhere near water. It got up together with a hen pheasant, but was certainly not a pheasant at any stage of development. When Marx [Orwell's dog] put up a covey of partridges the mother did the well known trick (it is sometimes denied that this really happens) of leading M. off by flying rather slowly & squawking, while the young ones flew away in a different direction. Saw what I believe was a fieldfare, though this seems very early. Cock goldfinch calling to mate makes sound rather like 'chee-wa' (less like 'cheese' than that of greenfinch).

Diaristic prose of this kind is often restrained, but these are the words of someone objectively dealing with nature rather than falling sentimentally in love with it.

Writing about General Sir Archibald Wavell's *Allenby, a Study in Greatness* (1940), an account of Field Marshal Edmund Allenby, commander of the Egyptian Expeditionary Force during the First World War, Orwell insisted that Wavell reveals 'several unexpected sides' to Allenby's character, namely that he was 'passionately devoted to wild flowers and said, perhaps truthfully, that he was more interested in ornithology than in war'. I've no idea whether Orwell was more interested in birdwatching than he was in war, but he was certainly interested in watching birds, and his knowledgeable passion for flowers is indisputable. To those who know him only as the author of *Animal Farm* or *Nineteen Eighty-Four*, only as a critic of a world headed towards what he called the 'new religion' of

'power-worship', the fact that he could also admire how a hawk hovers in the air and the colours of primroses and bluebells may come as a surprise. As hobbies, birdwatching and flower-appreciating were in many respects all-absorbing: recurrent aspects of his daily routine rather than intermittently enjoyed distractions.

Fishing was something for which Orwell often said he 'longed'. Writing to the newspaper editor David Astor in 1948, and having been invited to go to Astor's residence in Abingdon, Oxfordshire, Orwell stressed that it would be 'lovely having the river' at his host's door: 'Probably in June or July there'd be good fishing, dace & chub.' He added that fishing in the Thames 'can be quite good', and that he 'caught some good fish at Eton'. His schooldays were never far from his mind. But then again neither was the thought of a quiet, lazy afternoon on a riverbank. The author felt so passionately about fishing that he had trouble knowing what to do with the desire to fish. One option was to sublimate the urge into analogy – see the passage in *Nineteen Eighty-Four* when a woman screaming at Goldstein during the Two Minutes Hate turns 'bright pink', her mouth 'opening and shutting like that of a landed fish'. Alternatively, the urge could be parcelled into narrative on a much larger scale. Another letter from 1948 reveals that Orwell didn't consider himself to be a 'real novelist', and that he thought he had never solved the 'difficulty' of having 'masses of experience which one passionately wants to write about [...] and no way of using them up except by disguising them as a novel'. He was raising these points with Julian Symons towards the end of his six-month stay at Hairmyres Hospital, where he

was being treated for tuberculosis, and he had his 1939 novel *Coming Up for Air* squarely in mind. He hadn't seen his son, Richard, for months, and he was not only longing to be with him but to get outside (and stay there). Although the hospital allowed him a little air each day, he had fishing on the brain. He wanted to be on the riverbank, on the shoreline, in the shallows. He wanted to feel alive.

We don't need to imagine what went through Orwell's mind when he went fishing. He lays it all out in *Coming Up for Air*, a novel full of freshwater angling: a pool whose deep water looks like dark green glass; the fish sunning themselves just under the water's surface; the characteristic movement of the line when a fish bites on the bait; the unexpectedness of an oversized catch; the promotion from fishing in cow ponds to fishing in rivers (in the Thames, no less); the endless intricacies of technique and the variety of bait; the attractions of an angling shop's window. George Bowling remembers the summer fishing expeditions of his youth as a key part of everyday experience:

> Christ, those fishing days! The hot sticky afternoons in the big schoolroom when I've sprawled across my desk, with old Blowers's voice grating away about predicates and subjunctives and relative clauses, and all that's in my mind is the backwater near Burford Weir and the green pool under the willows with the dace gliding to and fro. And then the terrific rush on bicycles after tea, up Chamford Hill and down to the river to get in an hour's fishing before dark. The still summer evening, the faint splash of the weir, the rings on the water

where the fish are rising, the midges eating you alive, the shoals of dace swarming round your hook and never biting. And the kind of passion with which you'd watch the black backs of the fish swarming round, hoping and praying (yes, literally praying) that one of them would change his mind and grab your bait before it got too dark.

Here, fishing is a dreamland: a pastime evoked in memory and dwelled on to lengthen the pleasure of remembering. Even the midges are recalled fondly. And as a dreamland, it contrasts starkly with the present in which Bowling remembers it: a time in which he's convinced that all the fishing spots near London have been emptied, the ponds drained and the streams poisoned with chemicals.

It's not hard to imagine Orwell remembering the better fishing spots and experiences of his youth, contrasting them with the degraded qualities of the modern world. But if it's not clear that Orwell and Bowling coincide entirely in their angling for angling, as it were, or in Bowling's claim that when he looks back through his life it seems that nothing ever gave him 'quite such a kick as fishing', it does seem reasonably clear that Orwell and Bowling come together in their sense that fishing not only evokes a time before the modern but also an activity of retreat within it. One of the most striking ideas in *Coming Up for Air* is the thought that when you think of fishing 'you think of things that don't belong to the modern world'. For Bowling, this signals mental repose, away from the march of boots: 'The very idea of sitting all day under a willow tree beside a quiet pool – and being able to find a quiet pool to sit

beside – belongs to a time before the war, before the radio, before aeroplanes, before Hitler.' Fishing, as Bowling understands it, and as Orwell understood it too, is the opposite of war, an activity of pure tranquillity; it is relaxed in its setting, style, sense and suppleness, though also troubling in its evocations of things sought for and waited on that may never come. The fantasy of accrual contained in the idea of fishing can also be a delay without the consolation of achievement: the fish may simply never be caught.

Coming Up for Air is a novel about the misleading consolations of nostalgia. Its premise – a trip into the past – also entails an investigation into the premise's limits. Bowling wants to leave suburban London, where he feels trapped by the repetitive sameness of the everyday and by the stale predictability of middle-class home life, and to go back to the places of his youth: to the market town of Binfield, a settlement enshrined in his memory as a place of endless summery days and golden sunshine. Bowling admits that he knows this is a delusion, and a sentimental one at that, but he can't help himself. He wants, and maybe needs, to believe in the idea, precisely because it's an alternative to a postwar world of coloured shirts and rattling machine guns: uniforms, armies on the march, aerial bombardment and the torture chamber. Recounted in the first person, *Coming Up for Air* allows its narrator to indulge in a fantasy of recuperation. He believes that he can go back to his childhood and re-experience its snugness. Yet the first-person strategy also points to the limits of Bowling's understanding. He wants the apparently endless summer of his youth to be recapturable, but a world on the march towards a Second World

War has other ideas. His repeated insistence on the illusoriness of his memories only reinforces their desirability. Like a stuffed patron saying they really shouldn't have dessert at the end of a meal, Bowling wants to ignore his conscience.

The novel's organising image of coming up for air, having a breather, is undone at the instant it's invoked. Feeling trapped inside the claustrophobic dustbin of modern life, Bowling wants to paddle up to the surface like a sea turtle and to fill his lungs. He has this thought while driving an old car that rattles 'like a tin tray full of crockery', and which is presumably belching its own clogging foulness into the very air Bowling is breathing. When he gets to Lower Binfield he finds that it's completely changed from what he remembers. Where in his memory the settlement and its surroundings were full of trees, these have all now been replaced by housing estates and, in what is surely a nod to E. M. Forster's novel *Howards End* (1910), endless acres of 'bright red roofs'.[6]

The true torment, though, lies in what has happened to the water pool in which Bowling used to fish. When he finds it, there's a split second when he doesn't understand what he's looking at, as if he can't believe the transformation it's undergone. The pool has been denuded. The trees that used to ring it have disappeared, leaving it looking uncomfortably like 'the Round Pond in Kensington Gardens'. And the fish – oh, the fish. All of them gone. It makes the narrator realise that he was being silly in thinking that he could ever recapture the golden glow of the past. 'One never does go back,' he says to himself at an earlier point in the novel. His mistake is that he doesn't listen to his own advice. He does go back, and in returning

to the hangouts of his childhood he finds that going back means learning that the place of return may never have been there at all.

As a hobby, fishing was radically double-sided for Orwell. When Bowling remarks that when he looks back, the 'whole' of his boyhood 'from eight to fifteen seems to have revolved round the days when [he] went fishing', maybe we hear something of the author's own nostalgia for a bygone youth. Yet he could also perceive an ambivalence in fishing. It was a retreat: a way to shut out the noise of modern life. Even one of the farmers in *Animal Farm* fishes. But it was irresponsible and foolish to retreat at a time when another world war seemed increasingly likely. Orwell's double-sided view of fishing may reveal something of his double-sided view of hobbies as such: how they allow people to recuperate even as they take people away from pressures they might more profitably address head-on. Bowling's efforts to go back to his past, to rediscover Lower Binfield, is a form of 'the nostalgia for distant times and places with which people,' in Orwell's words, 'delight in torturing themselves.' Nostalgia is, in its way, 'a pernicious emotion'. Hobbies console, and fishing consoled the author. But in many circumstances consolation *is* the poison it appears otherwise to detoxify. Might it be that when we embrace a certain kind of comforting nostalgia we are failing to recognise that we should in fact be running from nostalgia itself? *Coming Up for Air* certainly suggests this.

There's only the faintest hint of fishing in *Nineteen Eighty-Four*, in that passage when Winston, newly escaped from the city with Julia, looks at a close-bitten green pasture and is convinced that somewhere nearby there must be a stream

with green pools full of dace. Had Winston not had sex on the brain, he might conceivably have gone there and felt the sunshine on his face. Fishing isn't his hobby, however. In the world of *Nineteen Eighty-Four*, good, compliant citizens are not meant to have amusements as such. They're meant to go on hikes, volunteer at community centres, participate in discussion groups, attend lectures and, in one of the novel's less probable details, play table tennis. Hobbies are too private, too inward for totalitarianism. For a political system posing as a peculiarly English form of socialism, Ingsoc, hobbies are too English, too sociable to be tolerated. As a would-be revolutionary and privacy-seeker, it's appropriate that Winston has a hobby, then, because it confirms his commitment to what Ingsoc desires to eradicate: the liberty of the individual. Winston gropes after this liberty by collecting objects associated with the freedom of writing: an archaic pen with an inky nib, a diary filled with beautiful cream-coloured paper, a glass paperweight enclosing coral. These are all things that will in time be confiscated and destroyed. All of them establish Winston's enchantment with the perniciousness of a certain sort of nostalgia, a perniciousness that, in the end, will get him killed.

Is there the same perniciousness in ice skating? It's hard to say. It's a relevant question – not because when the time comes, and Winston is arrested, his entrails turn to ice, but because Orwell seemed to have liked racing across frozen lakes and streams. There are some hobbies which seem self-evidently to contain the self-deceiving, and possibly even self-harming, melancholy that the author saw in certain forms of nostalgia. Fishing, for all its innocence, has a wistfulness about it.

Ornithology takes the watcher's eyes innocently up into the sky, but it also means witnessing a form of freedom, flight, that humans can never naturally enjoy, and in that sense to apprehend an unbridgeable chasm of difference. But it's hard to spot anything other than innocence in skating, despite the risk from a twisted ankle or a skate's blade. The recently discovered letters by Orwell to Brenda Salkeld and to Eleanor Jaques, now housed at University College London, show that he was fond of the activity. Interwar England may in his view have been skating on thin ice as it sleepwalked towards war, but there was nothing sleepy about the joy he took in skating for hours on frozen water; as he did, every now and then, in Southwold.

When he was a young boy, Orwell often found himself envying those out on frozen lakes and rivers enjoying the slick scrape of metal against ice. Years later, in a BBC broadcast, 'Money and Guns' (1942), he grouped ice skating among those activities which in wartime do not use up any more usefully deployed energy:

> To make a rough division: the luxuries which have to be discarded in wartime are the more elaborate kinds of food and drink, fashionable clothes, cosmetics and scents – all of which either demand a great deal of labour or use up rare imported materials – personal service, and unnecessary journeys, which use up such precious imported things as rubber and petrol. The amusements which can be encouraged, on the other hand, are games, sports, music, the radio, dancing, literature and the arts generally. Most of these are things in which you create your amusement for yourself, rather than

paying other people to create it for you. If you have two hours to spare, and if you spend it in walking, swimming, skating, or playing football, according to the time of year, you have not used up any material or made any call on the nation's labour power.

In such asides, ice skating has become a diversion: a self-sustaining hobby that contributes to the war effort because it takes nothing away from it and incurs no shame in its enjoyment. It may even have been an effort to *outmanoeuvre* shame. Writing to Jaques in January 1936, Orwell added a PS: 'I have been skating a number of times at the Streatham ice rink. It is great fun but very shame-making, because in spite of the most desperate efforts I still can't learn to skate backwards.'[7] Maybe that was for the best. Learning to skate backwards, after all, would have deprived him of the same imagined accrual originally discoverable in fishing: the soothing thought that one day, maybe, he might figure out how to do it.

X

Walking (again)

FOR THOSE WHO CAN DICTATE HOW, WHY, WHERE AND when, walking can often be revitalising and restorative: an activity to enjoy, offering a chance of leisure, thoughtfulness, rest. For those forced to walk against their will – the beggar, the refugee, the captive, the enslaved person, the evacuee, the vagabond, the otherwise disinherited – walking is often a form of punishment. There's little of what Orwell in *Burmese Days* called the 'inordinate happiness that comes of exhaustion and achievement' in the enforced march or in the necessary but undesired journey. After all, noticing a crowd of daffodils while you wander lonely as a cloud presupposes a freedom to wander and to notice. When Orwell went to Paris in 1945 as a war correspondent for the *Observer*, the 'signs of privation' in the city presented themselves to him because he took the time to navigate the city on foot. The article he wrote about the experience was called 'Paris Puts a Gay Face on Her Miseries', and although 'in several days of wandering to and fro in all kinds of quarters' he didn't see 'a barefooted person, and not

many who were conspicuously ragged', the 'surface aspect of things' in Paris being 'less bad' than he would have expected after the war, there were indications that not all was well: infants with pale faces, trees on pavements cut down to make firewood and an almost complete lack of pigeons (because most of them had been eaten).

Walking, as Orwell experienced it in postwar Paris, led to insight. But it's not as if he didn't realise that walking can make insight or thought impossible, or at least make them difficult to enjoy. He was particularly alert to how penniless and homeless people end up spending most of their time walking. A defining characteristic of tramps, as he saw them, is that they are obliged to walk 'about twenty kilometres a day', and never have the luxury of sleeping 'two nights together in the same place'. The figure of the tramp is, in short, 'a wanderer, living on charity, roaming around on foot day after day for years, crossing England from end to end many times in his wanderings.' Tramping means constantly moving in search of generosity and in flight from authority. 'The tramp does not wander for his own amusement,' Orwell adds, 'or because he has inherited the nomadic instincts of his ancestors; he is trying first and foremost to avoid starving to death.' Stopping means becoming visible, whereas walking means staying indiscernible (albeit at the ambivalent cost of being ignored). The only permissible place to stop, the only place from which the police will not force one to move, is the workhouse, the spike, though even these places are not entirely accommodating: 'no-one can stay in any one spike more than once a month. Hence the endless pilgrimages of tramps who, if they want to eat and

sleep with a roof over their heads, must seek a new resting-place every night.'

Unlike the characters in most historical novels, who spend their time, Orwell asserts, in 'constant action' – 'plotting, fighting, flying for [their lives], hiding behind the arras, devastating provinces, going on pilgrimages or ravishing the swineherd's daughter' – tramps are obliged to move constantly partly because they're caught in the double bind of a capitalist system which expects those who aren't employed to mimic the rituals and routines of paid occupation. One of the bitterest absurdities around poverty as Orwell experienced it in Paris, and as he recorded it in *Down and Out in Paris and London*, is how it forces impoverished people to conform to codes of tolerability: to act as if they're living as usual. Impoverishment means not being able to send your clothes to the laundry, cutting down on your smoking and leaving letters unanswered. It means loafing about in public gardens watching the birds, going to a bakery and not being able to afford the bread, visiting a greengrocer's and having to leave empty-handed because you don't have the right change in your pocket, avoiding prosperous friends in the street. Moving without progressing. It means being caught in 'a net of lies'.

The web of deceit ensnaring Winston Smith isn't generated by poverty as such, though it is caused by intellectual and emotional impoverishment. We learn that the hierarchical society in which Winston lives is made possible 'on a basis of poverty and ignorance': scarcity and witlessness are two of its most essential conditions. The majority of those who live in Oceania must endure an existence characterised by unceasing

deprivation (lack of goods and basic resources, an absence of reliable knowledge about the world, the disappearance of truth and falsity as objective standards), all while behaving as if there's nothing but plenty. There are few if any escape routes from the miasma of doubt that such conditions cause. All roads away from compliance lead to death. But Winston tries at least for a time to take a different path, and literally in the sense that he finds himself walking away from his usual haunts of home and work into London's proletarian quarters. There he discovers a very different part of the city from the city he knows. Although the disorientating effects of Newspeak, doublethink and the changeability of the past make him feel as though he's 'wandering in the forests of the sea bottom, lost in a monstrous world' where he himself is the monster, a long stroll through the streets gives him a chance to gather himself together.

Going anywhere by yourself in Oceania is dangerous, but after a hard day's work Winston is tempted by the balmy April air and decides to risk it. Strolling 'into the labyrinth of London, first south, then east, then north again, losing himself among unknown streets and hardly bothering in which direction' he goes, Winston enters a maze of memory, an older world less visibly touched by the designs of Ingsoc and Big Brother. Walking a short distance away from what used to be St Pancras train station, he dodges filthy puddles and the glass from broken windows. Things seem harmless enough, despite the unfamiliarity of the brownish slums. Suddenly, the proles around him break into a commotion. A missile or 'steamer' is on its way. The novel assigns to the proles an animal awareness enabling them to anticipate the dropping of bombs on their communities.

When the explosion comes it generates an avalanche of glass that showers Winston in fragments. Standing up, he sees an object on the pavement. He moves closer. It's a hand severed from a body. On impulse he kicks it into the gutter. It's not clear whether he kicks the hand because he's disturbed by it, or because he's so disaffected that it merely irritates him. What began as a pleasant evening's walk clearly hasn't gone quite as planned.

The hand in the street anticipates the violence that awaits Winston in the Ministry of Love, where, after his traumatic 'curing', he will dream about his own execution. Sitting in the Chestnut Tree Café, the destination of all Oceanic dissidents, Winston's thoughts wander:

> The voice from the telescreen was still pouring forth its tale of prisoners and booty and slaughter, but the shouting outside had died down a little. The waiters were turning back to their work. One of them approached with the gin bottle. Winston, sitting in a blissful dream, paid no attention as his glass was filled up. He was not running or cheering any longer. He was back in the Ministry of Love, with everything forgiven, his soul white as snow. He was in the public dock, confessing everything, implicating everybody. He was walking down the white-tiled corridor, with the feeling of walking in sunlight, and an armed guard at his back. The long-hoped-for bullet was entering his brain.

The meandering mind leads to thoughts of walking along clinical passageways in the calming glare of Big Brother's

quasi-divine love. Yet the gun pressed into Winston's back reminds us that this is a forced conversion, evidence that even in this moment of ideological bliss he isn't trusted to be an authentic minion of the system. The apparently willing walk into death is, and has always been, under duress.

Orwell spent a lot of time walking through London during the Blitz, which is one reason why *Nineteen Eighty-Four*, a Blitz book by any measure, contains so many scenes of urban sauntering. Yet the novel also looks back to his wanderings around the industrial north of England, where he saw up close the destitution that informed his portrayals of the downtrodden proles. Researching *The Road to Wigan Pier* in 1936, he observed the mazes of 'tiny blackened houses' in Staffordshire, gagged at the thought of eating tripe cold with vinegar, as per the 'Lancashire method', and recorded piles of disintegrated chocolate in confectioners' windows in Wigan, whose streets were a mass of 'sticky mud criss-crossed by imprints of clogs'. Sheffield gave him the sight of a small piece of waste ground covered in litter and framed by grimy houses and 'an interminable vista of factory chimneys, chimney behind chimney, fading away into a dim blackish haze'. A railway embankment was made from furnace slag, a polluted river was 'yellow with chemicals'. He inhaled the sulphur emanating from the city's foundries. Even for the author, no stranger by this point to destitute and underprivileged people, it would have been eye-opening. It gave him the insight needed, in *The Road to Wigan Pier* and in *Nineteen Eighty-Four*, to paint a picture of industrial cities that were half bomb site and half mosaic of rotting neighbourhoods.

Something Orwell couldn't stop himself from recording in his diary is that on one of these occasions, when he was walking through Sheffield, he noticed the 'backsides of women wagging laboriously from side to side' as they shoved their 'perambulators' up a hill. The remark brings matters to a halt. It seems to have been intended to highlight the difficulty of the women's walking and to stress the arduousness of an ordinary maternal task. But the focus on their posteriors is hardly innocent. There's a puerility to it that strikes the same tone as the frequent references in his novels to 'monstrous' women with large forearms and enormous (or 'tumbling') breasts. You can hear the giggle in it, the childish snort. It's a good example of a seedier side of his mind, and of how a detail repeated often enough across his books can start to seem like a fixation. The fatuousness gets a metaphorical edge in *A Clergyman's Daughter* when the book's narrator refers to a 'huge Toby jug of a woman, with monstrous breasts', pressing through a crowd of people. *Nineteen Eighty-Four* is still more ill-advised, voyeuristic even, in referring to Julia's breasts as 'ripe yet firm' and in seeing a prole woman as a 'solid unconquerable figure, made monstrous by work and childbearing, toiling from birth to death and still singing'. It's the sort of language that gives away the male-centredness and masculine bias in his literary attitude.

It's not immediately obvious what role walking might play amid such inclinations. Yet the link comes in the guise of Orwell's inability to recognise how some of his romantic advances could seem, or simply *were*, inappropriate, ill-judged and tactless, or what some people might now call 'creepy'. In those spells of time in the 1940s when he was living on Jura,

he would often mention walking to friends. He emphasised to those about to visit his house – either to see him or, when he was in hospital being treated for tuberculosis, to see his house-sitting sister Avril – that they might have to walk part of the distance. As he put it to his publisher Fredric Warburg in July 1946:

> Do come some time in September if you can. You'll have to walk the last 8 miles (possibly only the last 5 miles), so can you make do with rucksack luggage, say a rucksack and a couple of haversacks? But it isn't really a very formidable walk, and if you manage with light luggage I can transport it on the back of a motor bike. You don't need a great amount of clothes here so long as you have a raincoat and stout boots.

All very windswept. Orwell was living a remote life, and he wanted people to know what to expect. This desire to inform could also, on occasion, spill over into some strange invitations. One such instance relates to Anne Popham, the art historian who would go on to marry Virginia Woolf's nephew, Quentin Bell. Orwell wrote to Popham in April 1946 to apologise for making a romantic advance. Wondering if he'd done wrong, he sought to clarify his intentions: 'What I am really asking you is whether you would like to be the widow of a literary man.' The author was keen to reassure Popham that although he considered himself to be sterile, it wouldn't bother him if, in entering into a relationship with him, she desired children of her own by another man, because he had 'very little physical jealousy' and because what mattered to him most was

'being faithful in an emotional and intellectual sense'. He asked Popham to come to Jura not to be his 'mistress', but simply to 'stay' and to enjoy its beauty and emptiness, with other people being present as chaperones. (In this, at least, he seems to have recognised that walking is notably a far less carefree experience for women.) He ended the letter by affirming the sentiment: 'I hope you will come and stay on Jura. It would be wonderful walking over to the west side of the island which is quite uninhabited and where there are bays of green water so clear you can see about 20 feet down, with seals swimming about. Don't think I'll make love to you against your will. You know I am civilised.' Orwell emphasised that his intentions were benign, and that he meant to pay suit to her in a restrained way. There is an awkward seeking of consent here, and he was probably testing the waters, but the 'doth protest too much' tone may have made her uncomfortable and indisposed, understandably enough, to accept. The letter is surprising in all sorts of ways, not least for how frankly he describes his sexual health and how pragmatically he depicts his intentions:

> You are young and healthy, and you deserve somebody better than me: on the other hand if you don't find such a person, and if you think of yourself as essentially a widow, then you might do worse – i.e. supposing I am not actually disgusting to you. If I can live another ten years I think I have another three worth-while books in me, besides a lot of odds and ends, but I want peace and quiet and someone to be fond of me. There is also Richard. I don't know what your feelings are about him. You might think all this over. I have

spoken plainly to you because I feel you are an exceptional person.

Clearly Orwell felt no need to hide away his circumstances from a potential partner, including the matter of becoming jointly responsible for his son, Richard. And Popham wasn't the only woman to whom he wrote so candidly. Orwell's biographer D. J. Taylor has noted that the interest in Popham is 'part of a wider pattern' of proposals that the author made in 1946 to 'a series of younger women, none of whom knew him well or, more importantly, had the least intention of becoming the second Mrs Orwell'.[1] They included Celia Paget, sister-in-law to Arthur Koestler and an editorial assistant at the journal *Polemic*, and Sonia Brownell, who in due course became Orwell's second wife. It wasn't the first time the author had been so blunt with a woman he desired and who he thought might desire him in turn.

The originating encounter was with Jacintha Buddicom, the childhood friend Orwell first got to know in 1914 in the village of Shiplake in Oxfordshire. She and her siblings were playing French cricket and noticed a boy standing on his head, like some scene out of *Alice's Adventures in Wonderland*. Asked why he was upside down, he replied: 'You are noticed more if you stand on your head than if you are right way up.'[2] The boy was the young Eric Blair, and after that they all became friends, spending many summers in each other's company. Jacintha remembered him as 'almost invariably a cheerful boy', and as someone particularly skilled at wheedling his way into good company:

The way he manoeuvred acquaintance with us proved him quite capable of ingeniously making friends with a family he liked the look of: you *are* noticed more if you ostentatiously stand on your head – incidentally not the behaviour of such a cringing, inhibited little misery as he is posthumously alleged to have been.[3]

And so it continued. Jacintha admired Orwell's sense of humour and his calm philosophical temper. Although he was especially good at helping the siblings to work out their differences when they quarrelled, he once killed a hedgehog with Jacintha's brother, Prosper, and she didn't speak to either boy for a week.

In their summers together Orwell and the Buddicom children ate sweets and drank lemonade, went on bicycle rides, occasionally went to a nearby cinema, watched birds and collected their eggs, sat by the river fishing, played in the garden, sorted stamps and challenged each other to games of Ludo and Snakes and Ladders. They were too old for tag or hide-and-seek, but they did like to hide in large houses and scare each other by jumping out of the darkness. Orwell first made it properly unsettling, Jacintha recalled, by introducing a Peter Pan-ish element, inviting the other children to wonder whether it was really him emerging from the recesses and not 'the shadow of a shadow'.[4] Jacintha was particularly fond of the time they spent reading together and discussing good books. Orwell liked ghost stories, and even theorised that most towns were half populated by wraiths and spectres. He recommended to Jacintha ghostly tales by Henry James, E. F. Benson and M. R. James, and together, as they grew up, they explored

Shakespeare, Dickens, Kipling and Wells. They also explored less forbidding material like Beatrix Potter's *Pigling Bland* (1913), which the author once read to Jacintha when she had a cold. Evidently they adored each other in the ways that intelligent young people do.

One of Orwell's poems from this period, 'The Pagan', commemorates a particularly meaningful evening he and Jacintha spent together in the September of 1918:

> So here are you, and here am I,
> Where we may thank our gods to be,
> Above the earth, beneath the sky,
> Naked souls alive and free.

They'd gone picking mushrooms near Shiplake, where the Blairs were holidaying. Lingering in the grass was a way to make time come to a stop. Orwell underlines the wind caressing their feet and the sun setting in golds and purples. It was a blissful moment that he treasured; a poem sealed it up and made it permanently theirs. He sent Jacintha a draft, and she suggested changes to it. He agreed to her recommendations, altering the text by hand and giving her a copy, eventually annihilated in the Blitz, on pale blue notepaper. The keepsake may have been destroyed, but the memory of the occasion stayed in her mind for decades: 'At the time that we saw that sunset, we both said we would never forget it. And I never have. Whenever there is a particularly beautiful sky, I am reminded of that golden evening, so long ago when we were young.'[5] They had a glimpse of Eden immersed in bluebells in a glade near water.

Things were tarnished by an incident between Orwell and Jacintha in the summer of 1921. She remembered that summer as 'gloriously, unforgettably, hot', and that she and Orwell 'were rather in the habit of going for country walks'. He was clearly in love with her, and she, more cautiously, with him. She enjoyed their friendly sparring and cultured conversation, and presented these walks uncontroversially in her memoir *Eric & Us* (1974) as innocent occasions when they picked their way along dusty lanes in the shade of cornfield hedges. There's little in the memoir to suggest that these walks were anything but innocuous moments in a shared youthful happiness. However, when *Eric & Us* was republished in 2006, Jacintha's cousin Dione Venables added a postscript to it in clarification of what she called the book's 'hidden subtext'.[6] One revelation was that on one of his walks with Jacintha Orwell tried to force himself on her in some way and held her down. She yelled at him to stop and struggled out of his grip, tearing her skirt and bruising her shoulder. The journalist Kathryn Hughes has called the encounter a 'botched seduction', though what transpired isn't clear.[7] Whatever did happen terrified Jacintha, causing a fracture in their relationship. Orwell left England for Burma, and Jacintha left Eric behind her. He sent letters to her from Burma, which were answered curtly. When he returned to England he tried to visit her again, but to no avail. What he didn't know – or, at least, didn't claim to know – is that while he'd been away Jacintha had become pregnant and had given birth to a daughter, the father abandoning both as soon as he learned of her condition.

Jacintha's memoir traces 'the shadowed reality' of how the young Eric's 'gifted mind was absorbing the seeds of all he

perceived around him, ideas, habits, beliefs, some of which would lead him along a rocky road before bursting into the tainted grandeur of George Orwell, 20th-Century Icon.[8] Part of the effort meant going deeper into the sources of the taintedness. Jacintha got the impression that Orwell had a repressed attitude towards sex, but what she writes about the subject in *Eric & Us* is oblique and evasive. Dione heard from Jacintha's sister Guiny shortly after Jacintha died that she had discovered a 'furious letter' from Jacintha to Eric, 'telling him of her disgust and shock that he should try and FORCE her to let him make love to her'.[9] Dione asked Guiny if she thought that Eric had raped Jacintha, at which she demurred: 'She shook her head, eyes cast down, frowning furiously. No, she thought that had not happened because there was a reference to Jacintha screaming at Eric to stop – and he had.'[10] There is an important difference between not doing something and ceasing to do something at someone else's distraught request, but the simple fact of the matter is that whatever occurred is now lost to history.

I've often wondered if the many scenes of outdoor roaming and lovemaking in Orwell's novels are belated attempts to atone for this encounter, to redeem it in fiction. *Keep the Aspidistra Flying*, *Coming Up for Air* and *Nineteen Eighty-Four* all feature such scenes, which are partially about class and partially a 'movement', as the critic Jamie Wood has put it, 'toward pivotal moments of sexual intercourse'. In these books, eroticism is balanced between 'strangely Arcadian imagery' and one of the central taboos of middle-class Englishness, outdoor sex.[11] The interrupted walk becomes the occasion for an intimacy and a prohibition set against the harshness of the world. To

quote Wood again: 'Outdoor sex in a countryside drawn up and marked out by romanticism, yet hidden away from preying eyes and protected by the contours of terrain or by the thorns of the bramble, is an act of transgression against the progress of modernity, a last stand for a certain type of masculinity complicit with the old order.'[12] There is also the possibility that these transgressive encounters mark a kind of shame, a guilt originating in what should have been a pleasant walk in summertime that ended – for Jacintha and for Orwell – in a way neither expected.

Walking, as Orwell wrote about it in his fiction, didn't offer any simple escape from the world's cares, nor did it compensate for sometimes wanting more from others than they were prepared to give him. His uncertainly dated poem 'My Love & I Walked in the Dark' includes a stanza picturing an ideal 'golden summer day' on which the Orwellian speaker and his love 'walked in the sun', whose rays captured them 'quite as one'. He never let go of that image. That consistency may disclose how the author never seemed to know how to make up for doing wrong to Jacintha, and through her to a more virtuous image of himself that he possibly never found again. At the very least it shows that he never stopped thinking about how walking, as an act, evokes moods and memories beyond its own footfalls. Walking across Burma, England, Spain and Morocco showed him how it can be a vector for power just as it can be a path to poetry. Orwell found in that ambiguity the stuff of story. But he never escaped the fact that some roads, paved with good intentions, lead to anguish.

Evening

XI

Pubs

ORWELL ADMIRED WRITERS WHO COULD CAPTURE THE distinctive feel of pubs on the page. Differentiating the English attitude to naming things from the brash literalism of American nomenclature, he praised 'the poetic names of [England's] wild flowers', and also the peculiarly English habit of 'giving individual names to every street, pub, field, lane, and hillock'. Pubs, as he saw them, were places that warrant the exactitude of a proper name. This may have been why he was so taken with how Joyce writes about pubs in *Ulysses*; the Irish writer manages to make the pub universal and particular all at once. He was especially impressed by how Joyce depicts pub conversations, not least because he managed to 'present life more or less as it is lived'. Orwell also tried, not as successfully as Joyce but with no less purpose, to make pubs come alive.

As Orwell conceived it, the pub is a place in which to see life happening. The pubs that play roles in his novels, most conspicuously in *Keep the Aspidistra Flying* and *Nineteen Eighty-Four*, are ambiguously characterised: enjoyable and festive

on the one hand, awkward and dispiriting on the other. And what he felt about pubs came in large part from what he felt about alcohol. When he writes about pubs he's writing as someone who drank his way through a good many of them, and who, in the drinking, studied their idiosyncrasies. He paid attention to what made them unique, and to why their pubbishness resonates in the wider culture. His attentiveness led to frustration. As the critic Ben Clarke puts it, Orwell saw drinking as 'a source of real physical and social pleasure' that 'rarely sustain[s] its own promise'.[1] As he understood things, the idea of pleasure to be found in or taken from drinking rarely lives up to the pleasure contained in the idea or prospect of drinking. Drinking inevitably disappoints, and maybe pubs do too.

Winston Smith certainly feels let down by the pub he goes to in the prole quarter in Oceanic London, and not least because he adds to the undemocratic charge sheet against him when he enters it in the first place: 'there was no definite rule against talking to proles and frequenting their pubs,' says the book's narrator, 'but it was far too unusual an action to pass unnoticed.' Immediately upon going into the pub Winston is marked as an outsider, as someone different. His blue overalls give him away – not a prole, like the regulars, but a member of the Outer Party; someone elevated, if not quite trusted. Yet the uneasiness soon dissipates. Winston talks to an old man: a 'horribly dangerous' risk. He wants to know about the past, about what life was like before Big Brother. Winston hopes to learn if the version of history he's been peddled, an exploitative capitalism superseded by the allegedly honourable politics of Ingsoc, is

true. The problem is that the old man can't remember what Winston wants him to recall; his memory is 'nothing but a rubbish-heap of details', few of them pertinent to Winston's inquiries. Winston gives up, comparing the old man to an ant who can detect the small but not the big. The tantalising thought is that what he *can* remember ('a quarrel with a work-mate, a hunt for a lost bicycle pump, the expression on a long-dead sister's face, the swirls of dust on a windy morning seventy years ago') are the kinds of apparently trivial memories that the Party despotically intends to annihilate.

Nineteen Eighty-Four imagines the pub as a site of frustration. There aren't any telescreens in the pub, which is something at least, but Winston can't relax there either. He hopes to learn from the old man about the world's past. In the end, the conversation simply makes Winston vulnerable. The scene offers a thumbed nose to his belief that if there's hope for the future it lies in the proles. If the proles are mostly like the old man, then it would seem a fool's hope. The pub has a symbolic resonance, implying that Winston's dreams of a proletarian revolution are unrealistic. But this pub is also wonderfully drawn in the details: from the burly barman with the Roman nose and huge forearms; to the group of men arguing over the differences between pints and litres; to how conversation meanders from the inconsequential to the cosmic; to how the old man drinks nearly a quarter of his beer before answering one of Winston's questions, which makes you imagine the foam on the old man's lips, the swift lick to remove it and the inevitable masculine grunt of satisfaction to follow. The use of 'wallop' as a synonym for dark beer ('pint of wallop, please') is a nice touch

too. Orwell wrote in one of his columns about how the term had sprung up all over London in 1945 and then just as quickly disappeared. 'The coming and going of words is a mysterious process whose rules we do not understand,' he added. The term evokes the novel's entanglement in the 1940s context in which it was written, even as it faintly anticipates the walloping that Winston will have to endure in the Ministry of Love.

The pub scene in *Keep the Aspidistra Flying* is also rooted in period details, right down to the venue's 'sawdusted floor' and the tables marked with rings made by 'generations of beer-pots'. In a corner Orwell places 'four monstrous women with breasts the size of melons', and a 'tall grim' landlady who resembles 'the madame of a brothel'. As a scene it stages an intriguing exchange between Gordon Comstock and his aristocratic friend Philip Ravelston (Richard Rees, Orwell's friend and ultimately literary executor, is the clear basis for this character), who takes Gordon to task for his endless bitter tirades against capitalism. In place of capitalism Ravelston argues for a version of socialism, which Gordon rejects. He thinks Ravelston wants something like the society imagined in Aldous Huxley's *Brave New World* (1932), 'only not so amusing. Four hours a day in a model factory, tightening up bolt number 6003. Rations served out in greaseproof paper at the communal kitchen. Community-hikes from Marx Hostel to Lenin Hostel and back. Free abortion-clinics on all the corners.' Ravelston disagrees, indicating that he rejects this caricature once a month in the magazine he edits, *Antichrist* (a thinly veiled representation of an actual periodical, *The Adelphi*, in which Orwell regularly published). Gordon thinks that socialism represents 'a counsel of despair', and he dismisses

socialist 'money-grabbing', as he sees it, and anyone who earns 'over five hundred a year'.

Given that Ravelston earns considerably more than 'five hundred a year', Gordon's anti-socialist tirade creates a brief awkwardness. It passes. The moment clears only because Ravelston is paying for the next round of drinks, Gordon having got the first as a 'point of honour'. It's a subtle sign of Orwell's long acquaintance with social codes, and with how they can cause resentment. Gordon buys the first round of drinks because he wants honour to be satisfied. However, the self-advertising manner in which he shoves his way to the bar and taps a shilling to catch the landlady's attention shows that he also wants Ravelston to notice what he's doing. Once the first round of drinks has been bought, Gordon can relax; Ravelston can and does buy the rest of their refreshments, though not before he's ridiculed by the landlady for trying to buy whisky in a beer house. The evening reminds him of his financial distance from everyone else in the pub, and from Gordon especially, not least because all Gordon can talk about is how little money he has. Their exchanges cause Ravelston to reflect on what he takes to be, in a self-critical way, the shame of walking around with pound notes and chequebooks in his pocket when others have so little. On leaving the pub, Gordon is reminded of his personal creed: 'One's contacts with rich people, like one's visits to high altitudes, must always be brief.'

It takes some skill to evoke in words the peculiar social rituals of pubs, or that nasal draught of tepid alcoholic fuzziness which often greets you as you enter a tavern, inn or bar. Orwell notes the 'hideous cheesy smell of sour beer' that hits

Winston Smith in the face as he goes into a prole 'drinking-shop'. The cheesiness gives away the author's familiarity with a very specific scent. This is a sketch drawn by someone who has smelled that smell and felt its reek in their guts. There may be a buried memory in there somewhere about the musty stench of the 'always-damp towels' Orwell had to use after the plunge bath at his prep school. And the sourness had a precedent in his own work, too. In *Keep the Aspidistra Flying*, Gordon notices 'sour whiffs of beer' oozing from London's pubs and the 'sour cloud[s] of beer' that seem always to hang about them, which in turn evokes Orwell's mild fixation, discoverable throughout his writing, on the sour smell of refuse and rubbish. Smelly places at the best of times, pubs drew out his sensitivity to odour. The pub Winston enters reeks of vinegary beer, yes, but mingled into that fragrance is the stink of urine. Drinking leads to toilet breaks, and the proles have their needs like anyone else.

Orwell wrote his way into situations through scent and stink. There 'seems to be interest,' writes John Sutherland, 'and on occasion relish, in [Orwell's] fascination with smell'.[2] In *Keep the Aspidistra Flying*, when Ravelston catches the smell of sour beer outside a pub he's 'revolted' by it and 'would have quickened his pace to get away from it', but Gordon has different ideas. He drags in Ravelston, who convinces himself that he wants to be dragged in there. What hits him first is the stench of the 'foul yet coldish air' that fills the pub's interior: 'a filthy, smoky room, low-ceilinged'. The pint glasses are dim and greasy. The beer has an alarming yellow scum on it. The air is thick with 'gunpowdery tobacco-smoke'. When Ravelston notices a 'well-filled spittoon near the bar' he shudders: 'It crossed his mind

that this beer had been sucked up from some beetle-ridden cellar through yards of slimy tube, and that the glasses had never been washed in their lives, only rinsed in beery water.' It's all a bit too much for him. He'd much rather have a Burgundy red or a double whisky, but the landlady is having none of it. Beer it is, with its 'nauseous taste'.

It's one thing to experience these aromas; it's another to describe them, or indeed to be *able* to describe them. Sourness elicited Orwell's descriptive finesse in locking down the exact texture of sensations. It also gave him a way to think about ideals. In 1946 he moaned about 'pubs where the beer is good but you can't get meals, others where you can get meals but which are noisy and crowded, and others which are quiet but where the beer is generally sour'. The Venn diagram of the author's pubbish preferences excluded noise and crowds. An ideal pub needed to serve good food, be quiet and have decent beer: 'draught stout, open fires, cheap meals, a garden, motherly barmaids and no radio', he wrote. He wanted a place in which it's 'always quiet enough to talk', a public house that 'possesses neither a radio nor a piano' and where 'even on Christmas Eve and such occasions the singing that happens is of a decorous kind'. He'd been working this out in his books: see George Bowling's dismissive references to 'big noisy pubs' in *Coming Up for Air* and Orwell's similarly disdainful remarks, in *The Road to Wigan Pier*, about 'sham-Tudor' pubs 'fitted out by the big brewery companies and very expensive'. It all fortified a broader set of preferences from which the din of modern life was to be excluded. As he put it in a letter of April 1940:

Outside my work the thing I care most about is gardening, especially vegetable gardening. I like English cookery and English beer, French red wines, Spanish white wines, Indian tea, strong tobacco, coal fires, candle light and comfortable chairs. I dislike big towns, noise, motor cars, the radio, tinned food, central heating and 'modern' furniture.

Buried in the calculated old-fashionedness of this characteristically Orwellian list is a pledge to a certain form of comfort. He located that comfort in an ideal, or more precisely in an illusion: the fantasy of the perfect pub.

Orwell named his illusion, in a 1946 essay of the same name, the Moon Under Water. A good, solid name for a pub that, try as you might, you'll never find. As he imagined it, the Moon Under Water is a walk away from a bus stop on a side street free from disorderly drunkards. Those who frequent it 'occupy the same chair every evening and go there for conversation as much as for the beer', mainly due to its famous 'atmosphere'. Resolutely Victorian, the pub has no mock-antique decoration. It's full of grainy wood, ornamental mirrors and cast iron fireplaces, with a ceiling stained by tobacco smoke. The middle-aged barmaids know all the customers by name; there are good fires in more than one room, and games to play. You can buy cigarettes *and* tobacco, along with aspirins and stamps. The telephone is there to be used by those who need it. The draught stout is soft and creamy, and always served in a pint glass with a handle. The lunch is good. So are the snacks. There's a garden: 'You go through a narrow passage leading out of the saloon, and find yourself in a fairly large garden with plane trees, under which

there are little green tables with iron chairs round them. Up at one end of the garden there are swings and a chute for the children.' It's a house where families are welcome all year round. Not a boozing shop but a family gathering place of the kind that pubs 'ought to be'.

Illusions console. Calling a pub the 'Moon Under Water' evokes something that is but also isn't there – the sort of uncertainty D. H. Lawrence in his novel *Women in Love* (1920) calls a 'scarce visible reflection'.[3] The Moon Under Water was meant to evoke Orwell's view of what pubs could be, when done properly, in 'the London area'. He distinguished between this kind of pub and 'drinking-shops' or 'boozing-shops', because in his mind pubs were to be anchors for community; places where you sit under trees drinking beer and hear delighted children going down slides. Rules preventing children from entering pubs got up his nose because he thought that they 'dehumanised' them as places. Orwell wanted somewhere lived-in. Taking him into pubs was the prospect of conversation, yes, but it was also the promise of beer, which he savoured. The novelist Lettice Cooper recalled that the author 'had an absolute *thing* about beer', preferring it to lager.[4] For him, pubs were more than mere places to get drunk; they were bulwarks against the creeping influences of the modern world, with its trends 'away from creative communal amusements and towards solitary mechanical ones'. He cherished the pub's 'elaborate social ritual' and 'its animated conversations'. The Moon Under Water solved all this at a stroke.

You'd be forgiven for thinking Orwell might have been difficult company in a pub. But this doesn't seem to have been

the case, or at least not all the time. In some ways he was more difficult having *left* a pub. The writer Mulk Raj Anand, a companion of Orwell's at the BBC, said that although in life the author's 'voice was restrained' and that he 'talked in furtive whispers', the 'two deep lines on his cheeks' and his 'furrowed brow' signifying 'permanent despair', he 'smiled at tea time' and was 'a good companion' in a bar. He seems to have been up for a bar crawl with Rayner Heppenstall, with whom he once lived in a flat on Lawford Road in Camden with the poet Michael Sayers. Before he and Sayers lived with Orwell, they'd dined with him at his house on Parliament Hill Road:

> He had cooked for us himself. He gave us very good steak, and we drank beer out of tree-pattern mugs, which he was collecting. I had also met him in restaurants. There he would order red wine, feeling the bottle and then sending it away to have the chill taken off, a proceeding by which I was greatly impressed. I had never seen it done in France, but then my French experience, like most of my English experience, had been provincial, while Eric had worked as a *plongeur* at restaurants in Paris.[5]

It wasn't all fun and games, though. In his reminiscence of the time they lived together, Heppenstall remembered Orwell hitting him with a shooting stick when he came home loud and drunk one evening. Heppenstall saw what he called 'a curious blend' of fear and sadism in the author's face during the confrontation, which, understandably, led to a temporary breakdown in their friendship.[6] A happier memory came from

seeing Orwell at a literary cocktail party in 1948, shortly after Orwell had written a negative review of the philosopher Jean-Paul Sartre's doorstop of a book, *Being and Nothingness*. This got up Heppenstall's nose, reminding him of how contrarian his friend could be. In a poignant aside, Heppenstall admitted that he 'had no means of knowing how little time remained either for casually not bothering to see Orwell or for deliberately electing not to'.[7] Orwell died two years later.

In 1943 Orwell reviewed *The Pub and the People*, one of the exhaustively detailed volumes produced by the Mass Observation project. Launched in 1937, Mass Observation sought to map and to describe the workings of 'real life' in the United Kingdom by studying it scientifically. Its goals were anthropological. By combining the insights of volunteers writing about everyday life and responding to questionnaires with the reflections of salaried investigators whose job it was to observe people living, Mass Observation conducted a 'wide-ranging inquiry into the habits, customs and daily routines of the nation', becoming 'one of the defining cultural phenomena of Britain in the late 1930s' in the process.[8] It was a project branded by paradoxes. Its focus on working-class life made for a stark contrast with the upper-middle-class credentials of its founders, the anthropologist Tom Harrison, the poet Charles Madge and the film-maker Humphrey Jennings. Nevertheless, Orwell thought that the methods adopted by the Mass Observers revealed important details about national morale at a time of looming war. As he put it in 1940, in a review of another Mass Observation text, *War Begins at Home*: 'Now even more than at other times it is of the most vital importance that something

of the kind should be attempted and brought to as many people's notice as possible. In war it is civilian morale, especially working-class morale, that is decisive in the long run, and there is little or no sign that the Government recognizes this.'

Obeying the maxim that 'one of the clues to development in the social sciences is the actual observation of human behaviour in everyday surroundings,' *The Pub and the People* described 'one of the most basic institutions in British work life', a place of 'everyday and everynight life, among the hundreds of thousands of people who find in it one of their principal life interests'.[9] Its focus was the pub as it existed in Worktown, the disguised version of Bolton that appeared in several Mass Observation publications. Its scope was the pub in its entirety: the physical nature of the pub as a setting, the drinks it serves, who does the serving, who does the drinking, who drinks what and why, how drunk they do or do not get, the entertainments offered, and where in Worktown pubs are located. It defined the pub as follows:

> The pub, reduced to its lowest terms, is a house where during certain hours everyone is free to buy and drink a glass of beer. It is the only kind of public building used by large numbers of ordinary people where their thoughts and actions are *not* being in some way arranged for them; in the other kinds of public buildings they are the audiences, watchers of political, religious, dramatic, cinematic, instructional or athletic spectacles. But within the four walls of the pub, once a man has bought or been bought his glass of beer, he has entered an environment in which he is participator rather than spectator.[10]

It's a paragraph Orwell might have written, though had he done so he probably would have pointed out that pubgoers have many of their thoughts and actions arranged for them by what he called the 'elaborate social ritual' and 'complex social code' of the pub as a cultural institution. Either way, *The Pub and the People* had a distinct objective: to document the workings of 'a place to which ordinary people with ordinary incomes can come without formality, swear with impunity, meet strangers and talk about anything, and maybe spit on the floor.'[11]

There's no spitting in Orwell's ideal pub, the Moon Under Water, but there is calmness, conversation and the comforting murmur of 'regulars', people 'who occupy the same chair every evening'. As a form of consolation, the comfy image that the Moon Under Water evokes lures and beguiles. At its heart is the right atmosphere. Orwell had found the wrong air in Burma, where he had encountered (if the narrator of *Burmese Days* can be trusted) a 'stifling' and 'stultifying' culture of censorship and despotic control. This is what he found among the country's English arrivals, with their 'Kipling-haunted little Clubs' and slavish adherence to 'the pukka sahibs' code'. The Moon Under Water, by contrast, was to be a place of relaxed chatter and camaraderie. The author doesn't say as much, but I suspect he also thought about the Moon Under Water as a bastion of free speech, the kind of place in which you might 'express your opinion' without hesitation. He had seen pubs in these terms in 1945, when he suggested that although the freedom of the British press was limited by the vested interests of the newspaper barons, freedom of speech was 'real': 'On a platform, or in certain recognised open air spaces like Hyde Park, you can

say almost anything, and, what is perhaps more significant, no one is frightened to utter his true opinions in pubs, on the tops of buses, and so forth.' The Moon Under Water was a place for just this sort of virtue. Its imaginary character made that virtue still more precious.

What Orwell wanted from pubs and what he found in them could be far apart. He was unequivocal in his view that the pub was a basic and highly valuable part of native English life; it could be essentially English in its tolerant open-armedness. However, its hospitality could be double-edged. He noted in 1945 that what had most struck him about the behaviour of the British people during the Second World War was their ability not to be moved by its upheavals:

> In the face of terrifying dangers and golden political opportunities, people just keep on keeping on, in a sort of twilight sleep in which they are conscious of nothing except the daily round of work, family life, darts at the pub, exercising the dog, mowing the lawn, bringing home the supper beer, etc., etc.

In this account, the pub is part of a broader coping mechanism in which war is endured not through indifference but through drowsy, samey repetition, a rhythm communicated as much via the arresting metaphor of 'twilight sleep' as it is through the typically Orwellian list, with its accretion of habits fading into (or is that snoozing into?) multiplied et ceteras. Here the pub is less a positive indication of continuity in a time of catastrophe and more an ambiguous symptom of the 'deep, deep sleep of England' – the characteristically English ability to do the same

old thing, year in, year out – at which he raises a sceptical eyebrow in the closing sentences of *Homage to Catalonia*.

When the Second World War got going, Orwell doubled down on his view that pubs were vital spaces in which to hold on to democratic difference and diversity. 'The war,' he wrote, 'is a race between the consolidation of Hitler's empire and the growth of democratic consciousness. Everywhere in England you can see a ding-dong battle ranging to and fro – in Parliament and in the Government, in the factories and the armed forces, in the pubs and the air-raid shelters, in the newspapers and on the radio.' Conversations in public houses could resist a politics that threatened to do away with free conversation altogether. They were places in which opinions for and against could be uttered. The point was not that he wanted people in pubs to speak this way or that, but simply that he wanted them *to speak*, wanted them to be *able* to speak, to express their views without fear of censorship. Pubs were, in their way, the embodiment of one of his most famous statements about liberty: that if it means anything at all, it means the right to tell people things they do not want to hear. He hoped that pubs might be places in which we tell others things they don't want to hear and in turn are told things *we* don't want to hear, on and on, in a redemptive circle of claim and counterclaim. The idea that debate can happen in pubs was a small but important part of Orwell's commitment to human freedom.

Keep the Aspidistra Flying and *Nineteen Eighty-Four* describe the unfulfilling breakdown of debate and conversation in pubs because these are books about the ending, not the protection, of liberty. In *Keep the Aspidistra Flying*, pubs are places to discuss

socialism and its problems, and also to become embroiled in those problems. In *Nineteen Eighty-Four*, the pub is a place to try to learn, unsuccessfully, about the past. But both texts cling on to the frail hope that pubs can be, in principle, places where solutions might be found for sociopolitical divisions. Orwell's point is the frustration of that hope – there's a beauty in glimpsing lost possibilities. There was also a beauty in how pubs, done like the Moon Under Water, could be places in which to resist the unrelenting march of the machine. Orwell admired the response of one woman to the Mass Observation questionnaire with which *The Pub and the People* was assembled. Asked why they drink beer, many respondents answered to say that they drank beer for their health. One woman, however, answered as follows:

> My reason is, because I always liked to see my grandmother having a drink of beer at night. She did seem to enjoy it, and she could pick up a dry crust of bread and cheese, and it seemed like a feast. She said if you have a drink of beer you will live to be one hundred, she died at ninety-two. I shall never refuse a drink of beer. There is no bad ale, so Grandma said.

Orwell described this statement as a piece of prose that impresses itself upon the memory like a poem. A beautiful thing, like the beer it commemorates. Beer could make beauty, and so could pubs, in the author's mind. They were worth the trouble.

XII

Dinner

THERE'S A PASSAGE IN *NINETEEN EIGHTY-FOUR* WHEN Winston snatches an evening meal in the Ministry of Truth before rushing to an evening of state-approved diversions at a nearby community centre. It's a throwaway detail giving us a glimpse into the hurried (and dull) quality of Oceanic life:

> He wolfed another tasteless meal in the canteen, hurried off to the Centre, took part in the solemn foolery of a 'discussion group', played two games of table tennis, swallowed several glasses of gin and sat for half an hour through a lecture entitled 'Ingsoc in relation to chess'. His soul writhed with boredom, but for once he had had no impulse to shirk his evening at the Centre.

The reason Winston doesn't get up and leave is because it hasn't been all that long since Julia has confessed, in a furtively shared, handwritten note, that she loves him. Winston stays put so he doesn't arouse suspicions, and the tastelessness of his meal

contrasts with the intensity of his emotional and sexual urges. But the near indifference with which Orwell describes Winston's dinner time points to another important fact about this story: that in the imagined future of *Nineteen Eighty-Four*, mealtimes, and dinner especially, are not occasions when people come together but rather when togetherness starts to fray.

This isn't the first time in Orwell's work that dinner doesn't go to plan. *Keep the Aspidistra Flying* includes a scene set in a swanky London restaurant: Modigliani's. Evoking the Italian expressionist of the same name, Orwell alerts us to the possibility that here Gordon Comstock will be brought up against his own inadequacies as a creator, and more specifically against his failings as a poet. Tipsy on sparkling Italian wine, and gorging himself on anchovies with bread and butter, fried sole and roasted pheasant with bread sauce and chips, Gordon rails with 'the fine scorn of the unpublished' against some of the great literary celebrities of his time. George Bernard Shaw, W. B. Yeats, T. S. Eliot, James Joyce, Aldous Huxley, Wyndham Lewis and Ernest Hemingway all fall victim to his tirade. Gordon's confidence is at an all-time high because he's just received his first real income as a poet: a cheque for fifty dollars from the *Californian Review*, which has accepted one of his poems for inclusion in a future issue. His sneering disdain is, then, more precisely described as the fine scorn of the about-to-be-published, the arrogance of someone convinced that they're about to hit the big time. But as a feeling rooted in resentfulness, the scorn points to a telling lack. Gordon's contempt is a form of jealousy.

Orwell had a good nose for this sort of stuff. He liked William Makepeace Thackeray's fiction because the older writer knew

how to describe people wishing themselves enviously into the lives of their so-called betters. Orwell instances Thackeray's short story 'A Little Dinner at Timmins's', in which the titular characters live on the Swiftian 'Lilliput Street'. The story as Orwell reproduces it is a story about small people trying to make themselves feel big, only to realise that feeling big, let along *being* big, has its problems:

> A lawyer who has received an unusually large fee decides to celebrate it by giving a dinner party. He is at once led into much greater expense than he can afford, and there follows a series of disasters which leave him heavily in debt, with his friends alienated and his mother-in-law permanently installed in his home. From start to finish no one has had anything from the dinner party except misery.

As Orwell put it elsewhere, it's 'taken for granted' in Thackeray that 'anyone who is not halfway to being a saint will ape the aristocracy if possible.' He appreciated a similar technique in the work of Charles Dickens, who could find the joke in the thought of 'a man in love with a woman who is "above" him'. His example is the Bath footmen in *The Pickwick Papers*, 'living a kind of fantasy-life, holding dinner-parties in imitation of their "betters" and deluding themselves that their young mistresses are in love with them'. As all hosts know, dinner parties can be full of distress: the gossip, the need to put on a good show, the risk of eating and drinking (and then saying) too much – it can all be a bit of a bother. 'From start to finish,' Orwell wrote, 'no one has had anything from the dinner party except misery.' The

point is not that he distrusted affection and admired those who could write about it convincingly, but that he noticed, and in noticing learned from, writers who make pomposity consequential.

In *Keep the Aspidistra Flying*, Gordon's snobbish problem is that he imagines Ravelston and Rosemary will think, and care, that he's too poor to be extravagant. They don't know about the money in his pocket, and they certainly don't know he has enough money to buy more than one bottle of wine (which he does, ignoring the thought that it's 'almost always a mistake to order a second bottle' after the first one has slipped down so well). Best to quit while you're ahead. The conversation turns to Shakespeare, soon becoming dull. Rosemary starts to yawn. The drink does its work. Thoroughly inebriated, Gordon makes sure that Ravelston and Rosemary watch him paying the bill. The decision is taken to go to another drinking spot, the Café Imperial. Travelling there in a taxi, Gordon realises that he's being stupid: he's wasted money in the restaurant, and the money he's about to spend on getting drunker should in fact go to his long-suffering sister, Julia, to whom he's in debt. Everyone gets into the Café Imperial without let or hindrance, but it becomes clear that they need to leave to stop Gordon from doing something abusive. Gordon drags Rosemary down a side alley and starts kissing her. He tries to undress her. She refuses, threatening to slap him if he continues. Mocking her, he shoves his hand with a 'curiously brutal' force into her dress. Another unwanted, violent advance, like the one Dorothy Hare endures in *A Clergyman's Daughter*. And then it's all over. Rosemary flees into the night. Gordon's attempts to recapture

the 'first fine careless rapture' of the evening – an allusion to the wise thrush who 'sings each song twice over' – culminate in offensive failure.[1]

The night ends with an arrest. Gordon wakes up the next day in a prison cell. Part of what makes the episode so fascinating is the narrative glee taken in its articulation; you get the sense from how Orwell stages the scene that he is having fun pushing Gordon so far down into shame. The dinner scene in Modigliani's is similarly handled. As a set piece, it reveals Gordon in all his self-pitying loathsomeness and condemns his irritation with the codes of civility everyone else accepts as obnoxious. A minor disagreement over ordering another bottle of wine allows Orwell, in a wonderful aside, to describe a telling form of awkwardness: the 'uncomfortable' talk of those 'who have had a little scene and are not going to admit it'. Gordon can't enjoy himself unless the enjoyment is on his own terms, and he switches off when the conversation flows towards subjects in which he isn't interested. One of those subjects is Shakespeare's *Hamlet*, a tragic work whose appearance in the novel surely reinforces the reader's justified suspicions that Gordon is about to have his own downfall.

Keep the Aspidistra Flying lingers over the dinner scene in all its embarrassment and upset because the novel is, at its heart, a morality tale. We need to see Gordon act abysmally so that the necessary censure can follow.[2] Yet *Keep the Aspidistra Flying* judges not only its protagonist but also the modern world. After Gordon's 'brutal' encounter with Rosemary, he looks out into the night:

> He stood on the kerb gazing out into the hideous midnight-noon. For a moment he felt quite deathly. His face was burning. His whole body had a dreadful, swollen, fiery feeling. His head in particular seemed on the point of bursting. Somehow the baleful light was bound up with his sensations. He watched the sky-signs flicking on and off, glaring red and blue, arrowing up and down – the awful, sinister glitter of a doomed civilisation, like the still blazing lights of a sinking ship.

This is a dissolute city on the verge of collapse that speaks to a wider decay. Gordon doesn't appear to understand how badly he's behaved, but Ravelston knows that the situation has got out of hand and that Rosemary has suffered for it. What neither Gordon nor Ravelston appears to realise, however, is that in dining so well at Modigliani's they've disclosed their complicity in another kind of indifference: the privilege of those who can dine to excess in posh restaurants, while on the streets outside, ignored under the unsympathetic sky, are 'the lost people, the underground people, tramps, beggars, criminals, prostitutes'.

Orwell had been educated in the short distance between plenty and poverty during his time as a dishwasher in Paris, where he'd seen up close how hotel patrons could sit in dining rooms in 'all their splendour – spotless table-cloths, bowls of flowers, mirrors and gilt cornices and painted cherubim' while 'just a few feet away' were the undervalued hotel staff labouring in 'disgusting filth'. Writing about such scenes in *Down and Out in Paris and London*, he focused on the transformations that occur in crossing the magical barrier between the back and

front of house. A waiter going into a hotel dining room would glide from a harried wage slave into a swanlike virtuoso: 'As he passes the door a sudden change comes over him. The set of his shoulder alters; all the dirt and hurry and irritation have dropped off in an instant.' This is a statement about a performed grace, one that quickly falls away when the ill-treated waiter returns to the kitchen and, in a gesture of annoyed defiance at rude customers, breaks wind in their general direction. It's also a comment on the *need* for the performance, a need dictated by the setting and its inseparability from huge inequalities of wealth and esteem. Orwell turns the tables on the impatient customers by reimagining the waiter as a grandee at their expense: 'you could not help thinking, as you saw him bow and smile, with that benign smile of the trained waiter, that the customer was put to shame by having such an aristocrat to serve him.' Here, writing enables a mild form of revenge.

The irony of an aristocratic waiter serving uncouth patrons in a setting where the flow of power was meant to go the other way was not lost on Orwell, who noticed comparable reversals almost everywhere in the Parisian hotel system. Elegant dining room and filth-ridden kitchen were mirror images of one another. While the high and mighty enjoyed their Médoc, the dishwashers swallowed and sweated out quarts of wine, 'one of the compensations of their life'. The 'fearful heat and stuffiness' of the labyrinthine cellars in which the hotel staff were forced to work mirrored the muggy pretentiousness of the refectories and cafeterias above. The dynamics of the one proliferated in the other. During his time as a *plongeur* at one of Paris's grand hotels, anonymised in *Down and Out in Paris and London* as

the 'Hotel X.', Orwell recalled having to work in a 'cellar below a cellar' where his job was to 'fetch meals for the higher hotel employees, who fed in a small dining-room above', thereby reproducing the master–servant hierarchy that existed in the public-facing dining room on which all the servants' labours ultimately converged. He considered the Parisian dishwasher as a kind of indentured servant:

> A *plongeur* is a slave, and wasted slave, doing stupid and largely unnecessary work. He is kept at work, ultimately, because of a vague feeling that he would be dangerous if he had leisure. And educated people, who should be on his side, acquiesce in the process, because they know nothing about him and consequently are afraid of him.

To serve them, the dishwasher doesn't need to know anything about his customers, just as the customers don't need, and in Orwell's mind wouldn't want, to know anything about the dishwashers upon whose sweaty exertions their dining relies.

'Acquiesce in the process' is a typically Orwellian sentiment, not least because it has the feel of a knowing finger pointed back at the person levelling the charge. The author had a sincere desire to learn about and to understand the plight of the dispossessed, but he was always going to be a different fish. One of the acquaintances he made in Paris, for example, a waiter called Valenti, struck him as a 'decent sort', the decency being bound up with an air of institutional familiarity: 'With his black tailcoat and white tie, fresh face and sleek brown hair, he looked just like an Eton boy; yet he had earned his living since

he was twelve, and worked his way up literally from the gutter.' Looking like 'an Eton boy' qualifies the waiter to be thought decent. Orwell's comparison is double-edged, functioning as a compliment and as a mark of insurmountable difference. Because Valenti never attended the author's alma mater, the analogy of looking like an Eton boy separates him from the very institutional privilege it seeks to confer.[3] Orwell wasn't afraid of the class echelon to which Valenti and others like him belonged, but his descriptions of socio-economic disadvantage often betray an Old Etonian privilege.

Relocating to Paris gave Orwell an opportunity to enter 'the submerged working class', putting him in the position of an educated observer of those without the means or connections required to improve their lot. It was a decision taken by a man sufficiently empowered to disempower himself on purpose, and temporarily at that.[4] To quote the feminist writer Beatrix Campbell, in slumming it the author 'tried to purge himself of privilege by becoming a tramp, descending among the down-and-outs'.[5] Campbell's 'tried to' is the operative detail. Purging himself wasn't an option. Orwell openly admitted that the accounts of poverty given in *Down and Out in Paris and London* were based on casual rather than sustained encounters with destitute and disenfranchised people, and he closed the book by saying that he felt he hadn't 'seen more than the fringe of poverty'. A complete break with his background as a public schoolboy and as an instrument of empire in Burma wasn't on the cards, and it's not clear that the author fully grasped the implications of this. Making the effort 'to understand what really goes on in the souls of *plongeurs* and tramps and Embankment

sleepers', in Orwell's words, highlighted his socio-economic distance from rather than proximity to the low-income groups he hoped, if only for a brief time, to join.

Orwell's distance from the dispossessed in Paris and London was offset by a particular complicity with large groups of disinherited people elsewhere on the colonial map. He wrote about this link in *The Road to Wigan Pier*, where he argued that the financial position of the British middle classes in the 1930s relied on an economic exploitation (or what has more recently been called 'surplus appropriation') of colonised populations who remained largely unseen:

> the high standard of life we enjoy in England depends upon our keeping a tight hold on the Empire, particularly the tropical portions of it such as India and Africa. Under the capitalist system, in order that England may live in comparative comfort, a hundred million Indians must live on the verge of starvation – an evil state of affairs, but you acquiesce in it every time you step into a taxi or eat a plate of strawberries and cream.[6]

That word again: *acquiesce*. This is a comment on global conduits of power, and on how hard it is to avoid being caught up in them. The thought that injustice inheres in something so triflingly innocuous as a classic English dessert is one of Orwell's most distinctive rhetorical moves: the discovery of the intangibly political in the sensuously material. But this is also a comment on how socio-economic groups are joined to each other. In *Down and Out in Paris and London*, the author's concern had been with the phobias attaching to a specific class

relation – educated people who fear the *plongeur* because they don't understand the hardships of a dishwasher's existence. In *The Road to Wigan Pier*, his point is that there's little chance of escaping global systems of socio-economic entanglement. Delight in your strawberries and cream, but remember that enjoying dessert means that someone, somewhere has gone or will go without.

Napoleon the pig, the self-indulgent autocrat of *Animal Farm*, is not particularly concerned that some must lose out where others gain. He's all too ready to enjoy *his* food, and couldn't care less about who suffers, elsewhere, for his enjoyment. He has created a situation in which his enjoyment depends on others being deprived, and to him this doesn't seem too high a price to secure his advantage. Taking his meals separately from the other pigs, who in turn take their meals separately from the other animals, Napoleon dines in the manner of his former human masters: he eats 'alone, with two dogs to wait upon him', and always uses 'the Crown Derby dinner service which had been in the glass cupboard in the drawing-room'.[7] Napoleon's extravagance depends on the animals having little to eat; the distribution of food supplies on the farm means that the pigs get more where the other animals get less. Napoleon deserves plenty, and thoughts to the contrary are ideologically suspicious. Any sense that the animals might be better off are quashed by Squealer's propaganda and by Napoleon's dogs. In their brave new world, the animals are 'often hungry and often cold', but think that 'doubtless it had been worse in the old days.' The animals gladly believe that somehow they're fortunate to live as they do, even though we know better. The animals are

content because they don't have the luxury of unhappiness. They must persuade themselves that things are good, because they'll die if they don't.

The same situation appears in *Nineteen Eighty-Four*, where feigned satiety, and thus feigned pleasure, is the norm for people living in a dystopian society built on convincing people to be satisfied with less. In this text the problem is not that some dine well and others don't, but that a mystique has attached itself to extravagance. About halfway through the novel, when Winston and Julia are summoned to O'Brien's apartment in the Inner Party area of London, we appreciate how insidious the charms of lavishness can be. In this strange, 'long-shaped and softly lit' space, it's not the richly dark blue carpet or the banker's lamp that impresses them, or the 'spaciousness of everything, the unfamiliar smells of good food and good tobacco, the silent and incredibly rapid lifts sliding up and down', or the fact that everything works as it's meant to, but the outlandish aura of a glass of red wine. O'Brien doesn't have to rough it with oleaginous, state-sponsored alcohol. He enjoys the finer stuff: a 'dark-red liquid' contained in a decanter that gleams 'like a ruby', and which arouses in Winston, who doesn't recognise the wine for what it is, 'dim memories of something seen long ago on a wall or a hoarding'. Winston's awe at the wine indicates that he's in the grip of a class myth. Accustomed to deprivation and to Victory Gin's dulling tang, Winston admires O'Brien's privilege because it looks like something majestic. In a parodic inversion of the rites of the Catholic Mass, when Winston sips the wine he can barely savour it. His taste buds have been destroyed by years of acidic, industrial alcohol.

Like *Animal Farm*, *Nineteen Eighty-Four* shows what happens to populations when the elites live it large and the people go hungry – what occurs when control over food supplies forms the basis for a wider structure of political power. Winston learns this lesson when he reads from Goldstein's Book (or, to give the volume its proper, formidably humourless title, *The Theory and Practice of Oligarchical Collectivism*):

> Cut off from contact with the outer world, and with the past, the citizen of Oceania is like a man in interstellar space, who has no way of knowing which direction is up and which is down. The rulers of such a state are absolute, as the Pharaohs or the Caesars could not be. They are obliged to prevent their followers from starving to death in numbers large enough to be inconvenient, and they are obliged to remain at the same low level of military technique as their rivals; but once that minimum is achieved, they can twist reality into whatever shape they choose.

O'Brien, like the rest of the Inner Party, enjoys the luxuries of a class more privileged than the Egyptian pharaohs and Roman emperors could have imagined. But he also plays a part in guaranteeing the insidiousness of a system in which ordinary citizens are made to enjoy being deprived of food in the name of love for Big Brother, while simultaneously looking with misty eyes at the luxury goods indulged in by their oppressors. In this scenario, hunger is the badge of fealty.

Orwell had had starvation on his mind for years, as *The Road to Wigan Pier* makes clear. In this text his focus had been on

the injustices of colonial rule, and on the link between comfort in the homeland and exploitation in occupied territories. Yet on the far side of the Second World War a different version of this problem presented itself, raising difficult questions about what counted as civilised behaviour in the modern age: the provocative subject of national food supplies in Europe – who had food and who didn't, which groups could afford to spare some of their stockpiles so that others wouldn't go hungry and which were prepared to starve their fellow human beings to make political and military gains. In 1946, as Europe was coming to terms with the consequences of mass human displacement and forced migration, the author wrote an article, 'The Politics of Starvation', having been sent 'a wad of literature' by the Save Europe Now movement established by his former publisher Victor Gollancz in 1945. The group's goal was to increase awareness in Britain and elsewhere of the predicament in which many dislocated German citizens found themselves after their country had been ravaged by bombs, tanks, guns and fire. As the historian Matthew Frank puts it, the issue 'generated significant discussion and public unease in Britain and triggered a far-reaching debate on European relief and reconstruction that lasted long after the expulsions and the German refugee crisis had become recent history'.[8] The impassioned calls made by Save Europe Now to 'increase the supply of food from [Britain] to Europe' had an impact on Orwell for many reasons, but above all because of the stark contrast Gollancz and his colleagues drew between the spectacle of hunger across Europe and the 'reasonably well off' conditions in Britain and the 'orgy of over-eating' discernible in the USA.

The situation in postwar Europe raised a different problem: the question of one nation giving up its 'comparative comfort' to help the famished citizens of a nation which only months before had been its political and military enemy. Orwell was concerned that the humanitarian crisis in Europe was being undermined in Britain by scaremongers making it possible 'to imagine that what was proposed was to take food from British housewives in order to give it to German war criminals'. Discussions of this problem ranged over complex questions to do with perceptions of fairness amid postwar class frictions: why, some were inclined to ask, should working-class households tolerate sending food abroad when they might have it themselves, and why shouldn't those in higher income groups, enjoying their unrationed food and meals in restaurants, not give up their surplus? He was worried that people would vindictively call for food to be used as a political weapon; that Germany should be starved and thus be chastised. 'The folly of all such calculations,' Orwell argued, 'lies in supposing that you can ever get good results from starvation.' Warning his readers against a blockade of the kind that was enacted after the 1918 Armistice ('the children we starved then were the young men who were bombing us in 1940'), he insisted on the moral criminality of hoarding resources at the expense of those who need them more. Making a 'vindictive peace', as he put it, with Britain raising its own rations 'while famine descends on Europe', would be undeniably and unquestionably evil.

Orwell rejected this vindictive option on two grounds: because it was strategically unwise, and because it was wrong. Sitting beneath everything he wrote about the politics of

food – beneath his views on global systems of socio-economic exploitation, beneath his analysis of how tyrannies weaponise food supplies to keep their subjugated citizens in line, beneath his descriptions of the envy that runs through dinner party culture, beneath his fascinated representations of the gluttonous excess of bohemian fine dining – is the simple, typically powerful point that enjoying food at the expense of those who need it but don't have it is a morally criminal act. Denying food supplies to a disintegrated nation whose displaced citizens need them, even though that nation had recently been a military enemy, was a callous act, in the author's eyes, just as he disagreed with the thought that rations might be raised in Britain while Europe went without. His characteristically forthright solution to this second possibility was to call for guarantees that in this eventuality matters should be 'plainly discussed', with 'photographs of starving children' circulated in the press so that the people of Britain would be able to 'realise just what they are doing'.

Gordon Comstock's need to dine well in Modigliani's comes from the same stock of callousness that caused some people in postwar Britain to call for the starvation of Germany's dispossessed citizens: a desire to have revenge on some unsympathetic entity out there in the world that has done you harm – in Gordon's case, to have revenge on a reality he thinks is hell-bent on limiting him at every turn; in postwar Britain's, on a vanquished nation that still needed to be punished, many thought, for all it had done under Hitler. For Orwell the problem was that revenge could seem too much like a childish daydream: 'Revenge is an act which you want to commit when you are

powerless and because you are powerless: as soon as the sense of impotence is removed, the desire evaporates also.' Those who want revenge don't, in fact, want revenge. What they want is no longer to feel disempowered.[9] Orwell wasn't immune to the temptations of revenge, as his depictions of impatient customers in *Down and Out in Paris and London* indicate. But he knew well enough when not to give in to it. The thread that connects his thinking about the rituals of dinner time and the psycho-political dynamics of postwar international relations is the possibility that eating and drinking to excess and wanting to starve one's enemies boil down to the same impulse: a want or need, a want that *is* a need, not to feel small.

Night

XIII

Sleep

WE'VE ALL DONE IT: THINKING OR SAYING WE CAN stay awake when we can't. Closing our eyes in the hope that closed eyes won't make us nod off. Getting comfortable and forgetting that this is the first step towards an irresistible slumber. Feeling your head bounce in the drift or drop towards sleep when you're on a train. There's a naughtiness in it, a surrendering of a duty. When we know that staying awake is the right call, falling asleep is the overpowering alternative to forcing our eyelids to stay open when all we want to do is to let them come down. Orwell refers to this kind of sleep in *Down and Out in Paris and London* as 'something voluptuous, a debauch more than a relief'. The deliciousness of the temptation is what makes ignoring the 'right thing to do', staying awake, *the right thing to do*. There's no better sleep than the sleep you know you mustn't relish.

It's this sort of sleep that Hermione Slater enjoys in *Keep the Aspidistra Flying*, while she's waiting for Ravelston, her lover:

[he] rode southward in a taxi, with Hermione. She had been waiting for him, asleep or half asleep in one of the monstrous armchairs in front of the sitting-room fire. Whenever there was nothing particular to do, Hermione always fell asleep as promptly as an animal, and the more she slept the healthier she became. As he came across to her she woke and stretched herself with voluptuous, sleepy writhings, half smiling, half yawning up at him, one cheek and bare arm rosy in the firelight.

The 'asleep or half asleep' lets us peek into her dozing: the drowsy in-and-out-of-a-nap that satisfies because it's taken amid other obligations. Going to sleep at night has its rhythmic pleasures, but it's the sleep that happens outside these day-by-day repetitions that offers the better thrill. And while Hermione's speed in nodding off indicates how easily she succumbs to sleep's temptations, the way others think of her as a dreamy mythological creature suggests that she's strongly defined by a beguiling sort of languor:

> She was rich, of course, or rather her people were. [Ravelston] thought of her shoulders, wide, smooth and young, that seemed to rise out of her clothes like a mermaid rising from the sea; and her skin and hair, which were somehow warm and sleepy, like a wheatfield in the sun. Hermione always yawned at the mention of Socialism[.]

Hermione isn't the only mermaid in Orwell's work: in *A Clergyman's Daughter*, a 'rough-looking woman, partially

undressed', pops up from a bed of straw in a tin-roofed hut 'like a mermaid from the [...] sea'. But she is a distinctive, sleepy woman associated with boredom, and more specifically boredom at the thought of having to listen to what she sees as a load of old codswallop about the author's style of politics.

Like Orwell, Hermione knows that socialism – to which the author would increasingly commit himself – would often battle with the indifference of those too privileged to care about socio-economic injustice. But she also registers his fear that too many people across too many slices of the social hierarchy were putting their fingers in their ears in the face of evident geopolitical dangers. As the prospect of a second world war became more and more likely, and as the threat of totalitarianism loomed ever larger, Orwell argued repeatedly against the temptations of geopolitical lethargy and fatigue, and continually enjoined others to be alert. We've already seen how *Homage to Catalonia* ends with a rousing call to arms addressed to the inward-looking, off-guard character of a particular kind of Englishness, one that seems complacently insular and parochial in the midst of an unstable, unpredictable and unsympathetic world. England's innocent ways and green spaces embodied a sleepiness that would only be broken, the author feared, by military attack. He wrote *Homage to Catalonia* partially to make that explosive awakening unnecessary: he wanted his readers in England to be shocked into alertness, to be more mindful of the threat from the European authoritarian powers – *to wake up*. He later described in 'Why I Write' that his time in Burma and his journeys into poverty in London and Paris had consolidated his

'natural hatred of authority', made him 'for the first time fully aware of the existence of the working classes' and given him 'some understanding of the nature of imperialism'. It was only by fighting in the Spanish Civil War, however, that he gained a 'political orientation', one that made him write for democratic socialism and against totalitarianism. Fighting fascists in Spain's trenches and seeing truth twisted into lies in the newspapers reporting on the conflict solidified his politics and convinced him that those hoping to safeguard freedom and liberty from authoritarian intolerance need to stay on duty.

Orwell's most quotable remark in this vein was issued after the publication of *Nineteen Eighty-Four*. Seriously unwell and deeply irritated by the view that the novel was a simple attack on socialism, he insisted that *Nineteen Eighty-Four* was meant to show the dangers in the slow creep of totalitarian thinking 'in the minds of intellectuals' of every stripe, wherever they may be, and to remind his primary readership that the book was set 'in Britain in order to emphasise that the English-speaking races are not innately better than anyone else and that totalitarianism, if not fought against, could triumph anywhere'. Like *Homage to Catalonia*, *Nineteen Eighty-Four* was a call to arms – and a more urgent one, given that the author wrote it at a time when he thought too many Anglo-American intellectuals had too rosy a view of the menace posed by Stalin's brand of power. Orwell was also alarmed by the thought of nations preparing for war with the USSR and, in their efforts to meet the challenge of its technological, economic and military hauteur, turning themselves into a mirror image of its dictatorial horrors. His publisher, Fredric Warburg, noted that the 'moral to be drawn

from this dangerous nightmare situation is a simple one: *Don't let it happen. It depends on you*'.

The author had always been alert to why people needed to stay awake, metaphorically speaking, in times of intolerance. But as the 1940s went on Orwell became more and more concerned with pointing out the dangers of falling asleep at the political wheel. The first paragraph of *Animal Farm* sets up the idea of an authority figure who is caught out by turning in for the night. Drunk as usual, the tyrannical farmer Mr Jones goes up to bed, leaving the animals free to start their journey towards self-emancipation. They listen to Old Major, who tells them of better times to come if only they can grab the chance to fight for something more than they have. Breaking into song, they throw themselves into a wild excitement. It's all a bit much – they wake Mr Jones without meaning to, and, thinking that a fox has got into the farmyard, he fires a gun into the darkness. The animals are dispelled. They retreat to their beds and quickly fall asleep. But however loudly Jones fires his gun, however angrily he raises his fist, the opportunity has passed him by. He fell asleep on the job, and the animals make him pay for it.

Animal Farm cleverly turns this scenario on its head. In waking up to the chance at freedom, the animals steadily become less and less alert to the dangers encircling them; they start to get sleepy. Old Major dies in his sleep shortly after he rouses the animals to rebellion, thereby establishing the symbolic connection between sleep and loss around which the story is constructed. The seriousness of *Animal Farm* lies in how it traces a gradual enslavement. The animals don't realise that every day a little more of their liberty slips away from them,

until finally they're confronted by the awful truth that Mr Jones has in a sense never disappeared: his spirit lives on in the pigs, who have come to resemble almost indistinguishably their former human overlords. They've not been alert to what has been going on around them. When Boxer the horse is taken away to the estate of 'Alfred Simmons, Horse Slaughterer and Glue Boiler', some of the animals do wake up – they see that the pigs, despite setting themselves up as benevolent rulers, don't have the wider community's best interests at heart. The pigs try to rewrite the past by telling the animals that Boxer has been taken to and subsequently died in a hospital, and that they've imagined otherwise. Fully taken in, the other animals accept this false version of events. The pigs celebrate their victory with a banquet travestying the night of virtuous singing with which the entire Animalist revolt began. The real salt in the wound is that the pigs get to sleep securely in their deceptions. The animals have sleepwalked into a truth-twisting version of the tyranny from which they thought, naively, their rebellion had freed them.

Orwell had had an education in a less metaphorical sleeplessness during his investigations of destitute people in the 1920s and early 1930s, which he chronicles in several essays, letters and diary entries, and at greatest length in *Down and Out in Paris and London*. He'd had a 'first adventure as an amateur tramp', as he put it in a letter to his friend Steven Runciman, in 1920. Travelling in uniform through Devon to Looe, in Cornwall, having been on an Eton Officers' Training Corps exercise, the author missed a train. He reached Plymouth, in the evening, where he learned that there were no more onward

departures. Left with enough money to pay for a night at the local YMCA or to pay for food, he chose to eat. He spent the night in a field close to a set of allotments:

> The corner had a large tree for shelter, & bushes for concealment, but it was unendurably cold; I had no covering, my cap was my pillow, I lay 'with my martial cloak (rolled cape) around me'. I only dozed & shivered till about 1 oc, when I readjusted my puttees, & managed to sleep long enough to miss the first train, at 4.20, by about an hour, & to have to wait till 7.45 for another. My teeth were still chattering when I awoke.

The author's summertime journey was taking him to his family, who often holidayed in Cornwall. Arriving in Looe, finally, he was then 'forced to walk 4 miles in the hot sun'. It was an adventure of which he was very proud. Given how often he did find himself sleeping outside in rough conditions in the late 1920s and beyond, it's not without interest that the letter ends with him saying that he wouldn't care to repeat the experience.

Orwell's time in Burma gave him a desire to be penitent, to make himself low. This desire is what took him to Paris and his work as a *plongeur*, from which he learned 'the true value of sleep, just as being hungry had taught [him] the true value of food'. It also took him to London, where he put himself among tramps, beggars and petty criminals. He went on the first of several tramping tours in London in the October of 1927, continuing in 1930 and 1931. He visited hostel wards offering short-term lodging to homeless people, dosshouses full

of fetid dormitories, and even a prison. From these expeditions emerged a new understanding of what he called the 'unfortunate inhabitants of one of the richest countries in the world'. His experiences in the hostel wards showed him that these were nigh-on indistinguishable from the ugliness and bareness of prisons, with their courtyards and bug-infested cells. What he witnessed of the dosshouses and common lodging houses convinced him that their owners had no reason to improve the conditions for which they were responsible, because their business model was immensely profitable: charging their occupants to stay in noisy, overcrowded dormitories with up to a hundred people, in which it was 'impossible to get a quiet night'. Orwell didn't miss the irony. As he put it in 1932: 'Common lodging houses are places in which one pays to sleep, and most of them fail in their essential purpose, for no one can sleep well in a rackety dormitory on a bed as hard as bricks.' The spikes were no different. The tramps who used them often had to sleep on rock-hard floors, using blankets for bedding to stave off discomfort and freezing temperatures, usually unsuccessfully: 'One spent the night in turning from side to side, falling asleep for ten minutes and waking half frozen, and watching for dawn.'

After these experiences in London's public spaces, Orwell became accustomed to the self-reinforcing injustice of hardship. One of the things he brought back with him from his time fighting in Spain half a decade later, however, was the opinion that 'distant gunfire' can act 'as a soporific provided it is distant'. And he held on to the thought, which to many other people would normally mean thinking of thunder, or the sound of rainfall, as the prelude to sleep – a sort of reassuring

repetition, far away, or far enough away not to be threatening, that lets the sleep-seeker relax into unconsciousness. For him, there was less distance between the two ideas than you might think. He once noted in his diary, after a slight frost the previous night, that 'about midday' there was a 'rumbling sound which may have been either thunder or gunfire, & soon afterwards heavy sleety rain'. The idea that gunfire can be mistaken for thunder, and thunder for gunfire, is the stock-in-trade of the war writer, and in Orwell's case it speaks to a particular adjustment: from literary journalist to soldier. Going to Spain in 1936, fighting through the first half of 1937 in its civil war, returning to England and living through the Blitz: these experiences changed the author forever. He later confessed to his diary, in an astonished manner: 'I never thought I should live to grow blasé about the sound of gunfire, but so I have.' Avoiding the deep, deep sleep of England was one thing, but staying alert to the roar of bombs was trickier than he thought.

Something else Orwell brought back with him from Spain was the memory of how hard it is to fall asleep when you're stuck in a position on the front line: what he called 'the lack of sleep which is inseparable from trench warfare.' Having joined the POUM, he went to the front at Alcubierre, in Huesca province in northern Spain. This was a week after arriving in Barcelona in December 1936. Nearby was another POUM position served by three militia women who did the cooking. In remembering this detail, yet again the author couldn't stop himself from passing judgement on their physical appearance: 'These women were not exactly beautiful, but it was found necessary to put the position out of bounds to men of other companies.' Another

characteristic mark of Orwell's account of the experience is his description of how good-naturedly soldiers of different nationalities mingled. He found himself attached to a group of English soldiers sent out to fight by the Independent Labour Party. This 'exceptionally good crowd' got a warm reception: 'It says a lot for the Spanish character that the English and the Spaniards always got on well together, in spite of the language difficulty.' This may have been down to the fact that of the two English expressions all Spaniards appeared to know, one was 'OK, baby' and the other 'a word used by the Barcelona whores in their dealings with English sailors' which was so offensive that he knew it was unprintable.

However agreeable the circumstances, disagreeableness crept in through vigilance. Or rather it crept in through the *price* of vigilance, which in this situation was discomfort and sleeplessness. Being on the front did not mean fighting. It meant scarcely fighting at all, existing 'as a sort of passive object, doing nothing in return for [...] rations except to suffer from cold and lack of sleep'. And it was a regular occurrence:

> Apart from guard-duties and patrols there were constant night-alarms and stand-to's, and in any case you can't sleep properly in a beastly hole in the ground with your feet aching with the cold. In my first three or four months in the line I do not suppose I had more than a dozen periods of twenty-four hours that were completely without sleep; on the other hand I certainly did not have a dozen nights of full sleep. Twenty or thirty hours' sleep in a week was quite a normal amount. The effects of this were not so bad as might be expected; one

grew very stupid, and the job of climbing up and down the hills grew harder instead of easier, but one felt well and one was constantly hungry – heavens, how hungry!

Leaving the front didn't necessarily make matters better, either. When Orwell found himself back in Barcelona in May 1937, guarding the POUM headquarters at the Hotel Falcón from the roof of the nearby Poliorama cinema, he was once again struck by the futility of leisure in a situation that seemed tailor-made to make things as discomfiting as possible: 'The long nightmare of the fighting, the noise, the lack of food and sleep, the mingled strain and boredom of sitting on the roof and wondering whether in another minute I should be shot myself or be obliged to shoot somebody else'.

Orwell *was* shot himself. His account of the experience is one of the most memorable things he wrote. He was in the trenches on the Aragon front and not taking enough care to stop himself from being spotted. Before he knew it, there was 'a loud bàng and a blinding flash of light'. His legs crumpled and he fell to the floor. He had been hit in the throat, a sniper's bullet (a 7 mm copper-plated Spanish Mauser bullet shot from roughly 175 yards away) narrowly missing his major arteries. Like the shot elephant in the essay of the similar name who looks 'suddenly stricken, shrunken, immensely old', he recalled that being shot entailed 'a tremendous shock – no pain, only a violent shock, such as you get from an electric terminal; with it a sense of utter weakness, a feeling of being stricken and shrivelled up to nothing.' He recorded the experience in *Homage to Catalonia* with beguiling nonchalance:

I knew immediately that I was hit, but because of the seeming bang and flash I thought it was a rifle nearby that had gone off accidentally and shot me. All this happened in a space of time much less than a second. The next moment my knees crumpled up and I was falling, my head hitting the ground with a violent bang which, to my relief, did not hurt. I had a numb, dazed feeling, a consciousness of being very badly hurt, but no pain in the ordinary sense.

The author was enormously fortunate to escape with his life (albeit with temporary severe pain in his right arm from where the bullet had grazed a nerve). The neck wound was treatable. In memory, the event took Orwell back to the terror of gunfire and to the closeness between gunfire and the sounds and sights of atmospheric violence: 'I fancy you would feel much the same if you were struck by lightning.'

It was more normal during Orwell's time in Spain, given his duties as a soldier and front-line combatant, to be struck by extreme fatigue. It may be for this reason that he went to such lengths in *Homage to Catalonia* to catalogue how variously sleep, for a soldier, was so hard to come by. After he'd been shot, he suffered from a neuralgia that caused continuous pain for a month, and especially at night. But the pain didn't take away his wryness. Confronted by those who assured him that 'a man who is hit through the neck and survives it is the luckiest creature alive,' he couldn't help but think 'that it would be even luckier not to be hit at all'. Sleep could be interrupted by a fascist attack, fear of aerial bombardment or the advancing of a line, leading to hallucinatory thoughts: 'We were sixty or

seventy hours without sleep, and my memories go down into a sort of blur, or rather a series of pictures.' Sleep deprivation could even be a punishment. Orwell wrote in a different piece on the Spanish militias about how disobedience at the front incurred certain reprimands, including double watch duty. He noted that this was particularly inadequate as a punishment, because everyone was already short of sleep anyway, and double duty made soldiers less ready to fight. It wasn't lost on him that punishing front-line soldiers is an extremely difficult thing to do, given that they're already face to face with death.

It wasn't all sleeplessness and interruption, though. When Orwell and his fellow front-liners weren't scrounging for firewood, they were 'eating, sleeping, on guard or on fatigue-duty', which shows that it was at any rate possible to sleep in the combat zone, even if the sleep wasn't of a particularly high quality. Kip, however mediocre, was better than no kip whatsoever. Catching some shut-eye by leaning against a parapet while bullets whizzed overhead was still at least some shut-eye caught. Sleeping in the sodden earth of a trench, your rifle clutched to your chest, was recuperation (ish). 'Chaff is not bad to sleep in when it is clean,' the author writes in *Homage to Catalonia*, 'not so good as hay but better than straw.' In a trench you quickly get used to sleeping in your clothes precisely because you have 'to be ready to turn out instantly in case of an attack'. Back in Barcelona, ensconced in the Hotel Falcón, he cut down a cabaret stage curtain and turned it into a makeshift blanket; a broken sofa served well enough as a bed for two poor, peacefully snoring women from the quayside; others simply slept on the floor. Orwell may have been inspired by this spectacle in

writing about the overwhelming work involved in Hate Week, in *Nineteen Eighty-Four*, which involves eighteen-hour shifts 'with two three-hour snatches of sleep' on mattresses brought up from the Records Department cellars. Having recuperated a little from his bullet wound, the author found himself sleeping in some odd places: once in a hospital bed, once in a ditch and once on a bench from which he slipped in the middle of the night. At one point he used a bullet cartridge box for a pillow, 'in a mood of deep dismay'. At another he admitted that although lumps of broken masonry make a poor bed, if the air is warm they're tolerably comfortable.

Years earlier, recollecting his time in Paris, Orwell noted that he'd become so adept at sleeping rough that he could sleep on cobblestones. He needed that expertise once more when he discovered back in Barcelona that, having been discharged from medical care, his unit, the POUM, had been suppressed. In June 1937 the leader of the POUM, Andreu Nin, was captured, and there was a general crackdown on his followers in the organisation. On the orders of the head of Spain's Republican government, Juan Negrín, the unit's headquarters at the Hotel Falcón was closed down and the members of its executive committee imprisoned. Having started out with the POUM fighting for freedom from fascism, the author now found himself associated with an outfit that had been deemed illegal. Opinions differ as to the reasons for this, though in one influential account the suppression of the POUM was orchestrated by Stalin's Secret Police, the NKVD.[1] He needed to go on the run. Parting from his wife, Eileen, who had accompanied him in Barcelona, he found a ruined church in which to sleep. It was easier to avoid

detection by day than it was by night, when he existed as a 'hunted fugitive'.

Orwell and Eileen left Spain having had a life-altering experience, narrowly managing to escape the anti-POUM purge. He returned to England having played what he deemed an 'ineffectual' part in a war that left him with 'mostly evil' memories – and yet also with no doubt that the part he had played mattered. A browbeaten, fear-laden Paris, when they reached it, seemed 'gay and prosperous' by comparison with Spain. And when they reached England, 'southern England, probably the sleekest landscape in the world', the author was struck by the contrast between what he had witnessed in Spain's civil war and an England that seemed blissfully incognisant of the threats on its doorstep. Having had an education in sleeplessness, his mind now turned to the need to make sleeplessness political – to transform it into wakeful vigilance against the threat of 'bombs, machine-guns, food-queues, propaganda, and intrigue'. Yet lack of sleep also gave him what he needed to imagine totalitarian death states in which to settle down for the night is always to run the risk of giving yourself away to those in power.

Nineteen Eighty-Four is a book about dreams, but it's also a book about how dangerous it can be to fall asleep. Like Hermione in *Keep the Aspidistra Flying*, Julia finds herself falling asleep at the thought of having to listen to some dry political theory. Hidden away in the room above Mr Charrington's shop, where eventually they'll be arrested by the Thought Police, Winston reads to Julia a long extract from Goldstein's Book. Julia snuggles down next to Winston with her eyes shut. It's six o'clock in the evening and they've just had sex. She's already

almost asleep and not in the mood to listen to an account of the history and make-up of Oceanic society. She claims to be enjoying it, but also wants Winston to 'explain' the material to her. Many a secondary school and undergraduate student has skipped over the extended passage that Winston reads to Julia, which takes in such topics as the cyclical recurrence of hierarchies in human society throughout history; the precarious standing of models of human equality; the emergence of totalitarianism; and the character of Oceanic society, with its dependence on Newspeak, ideological conformity, all-encompassing surveillance and doublethink. As Winston reaches a passage promising to reveal the 'original motive' for why his world is the way it is, he notices that Julia has fallen asleep. The sight of her, calm and beautiful in her nakedness, makes him sleepy too. He falls asleep improbably muttering that 'sanity is not statistical'.

What this all means has been argued over for a long while. As Orwell presents her, Julia falls asleep because she's blissfully entranced by the 'marvellous' material Winston reads aloud. The ambiguity is whether it's Winston's way of reading the material that's marvellous or if it's the material that's so satisfying. Fredric Warburg, however, stated in his report on the novel that it is a 'typical Orwellism that Julia falls asleep while Winston reads part of the book to her. (Women aren't intelligent, in Orwell's world.)' Contrary to Warburg, and to those inclined to agree with him, later feminist scholars have not been so sure. For some, Julia's uninterest in Goldstein's Book demonstrates that her 'resistance is rooted solely in her immediate personal concerns', whereas others argue that one of Julia's great *strengths* is that she falls asleep at Winston's reading

because she refuses to take Oceanic doctrine seriously.[2] The best retort comes in Sandra Newman's brilliant novel *Julia* (2023), which reimagines *Nineteen Eighty-Four* from Julia's perspective. In this text, Winston's reading of Goldstein's Book sends Julia to sleep not because she's too stupid to understand it, but because she understands it all too perfectly. Where Winston thinks about *The Theory and Practice of Oligarchical Collectivism* as 'a book of spells that would give him superhuman powers', Newman's Julia dislikes its jargon, arrogance, reductiveness and disillusionment: 'The futile tone of it wearied her more than anything. It tasted of the stale breath of men for whom opinions trumped life.'[3] She's heard it all before.

Julia's sleep appears to be good: she wakes from it and stretches 'luxuriously' like a cat (she is, we learn, feline in her ability 'to sleep at any hour and in any position'). It may be the best sleep anyone has in *Nineteen Eighty-Four*. It's certainly better than much of the sleep Winston gets, which is always threatened by the eye of surveillance. As Goldstein's Book explains, a Party member's 'friendships, his relaxations, his behaviour towards his wife and children, the expression of his face when he is alone, the words he mutters in sleep, even the characteristic movements of his body, are all jealously scrutinised'. In Oceania, one of the easiest ways to be discovered as a rebel is to talk in your sleep – the telescreens are always listening, with their 'never-sleeping ear[s]'. Winston's neighbour, Comrade Parsons, is arrested having given himself away in exactly this fashion. Sleep is a form of rest, yes, but only because its duration is strictly patrolled: it has to be balanced against competing demands, such as eating, working and putting in

the correct number of evening appearances at the state-run community centres. During the intense preparations for Hate Week, sleep away from work only leads to more work piling up in one's absence, rest generating unrest.

Sleep is suspect in *Nineteen Eighty-Four*, and it has large-scale implications. Goldstein's Book outlines the strategy by which the world's three superstates – Eurasia, Eastasia and Oceania – compete for dominance:

> The plan is, by a combination of fighting, bargaining and well-timed strokes of treachery, to acquire a ring of bases completely encircling one or other of the rival states, and then to sign a pact of friendship with that rival and remain on peaceful terms for so many years as to lull suspicion to sleep. During this time rockets loaded with atomic bombs can be assembled at all the strategic spots; finally they will all be fired simultaneously, with effects so devastating as to make retaliation impossible.

Geopolitical advantage depends on sleepy enemies, just as Oceania depends on lulling to sleep the qualms of its dissident citizens so they can be captured, which is precisely what happens to Winston. He's been waiting for years to be jerked out of sleep by an unfriendly hand on his shoulder. And shortly after he and Julia enjoy their final post-coital nap, they lose everything.

Whisked away to the Ministry of Love (which in Newman's *Julia* is described as an 'abattoir'[4]), Winston is subjected to the worst kind of torture. This involves sleep deprivation and

beatings interrupted by 'sleep or stupor', and also an enforced care in which he is forced through injection to sleep so that he can be better rested for further humiliation. Prior to the main phase of his torture by O'Brien, it starts to dawn on Winston that O'Brien is a puppet master who decides when he should eat and rest. Throughout this long experience of torment, Winston becomes accustomed 'to sleeping with a strong light on his face', a light that evokes a very different understanding of what the Ministry of Love is cracked up to be. Winston once dreamed of meeting O'Brien, his apparent saviour, in a place where there is no darkness. He could not imagine that the place would be the Ministry of Love, a place where there's no darkness only because its painfully glaring interior lights are never switched off. And as the torture mounts up, as Winston is broken down by O'Brien's lessons in pain, he comes to sleep less and less. In this case, the paradox of sleeplessness as torture is that the exhausted victim learns to stay awake for longer and longer periods, thereby doubling the punishment: lack of sleep is not compensated by sleep, but by a still further lack of sleep that comes to be preferable to sleep itself.

What happened *in* sleep was often on the horizon of Orwell's interest because he'd seen in so many ways how differently sleep can fail the sleeper – can take the sleepers and sleepwalkers away from the pressing questions and problems of the world. *Nineteen Eighty-Four* thinks through what sleep might mean in a society turned upside down by the nightmare of totalitarianism. And in this respect it has an eye on the ambiguous virtues of how the British had conducted themselves during the war of 1939–45. At the end of the war Orwell wrote about how 'in the

face of terrifying dangers and golden political opportunities' during the conflict, so many people at home had simply kept on keeping on, day by day. Another example of an Englishness persisting under fire. This could be a virtue: the sign of a nation able to carry on when the world was falling to pieces. It could also be a problem: the evidence of a group too used to sleeping deeply when the wolf is at the door. *Nineteen Eighty-Four*, like *Animal Farm* before it, is about what a society doesn't notice and can't resist when it has forgotten to look after itself.

XIV

Dreams

IN ONE OF ORWELL'S MOST FASCINATING AND STILL resonant essays, 'Notes on Nationalism' (1945), he differentiates between patriotism ('devotion to a particular place and a particular way of life, which one believes to be the best in the world but has no wish to force on other people') and 'the habit of assuming that human beings can be classified like insects' and that 'whole blocks of millions or tens of millions of people' can be confidently labelled 'good' or 'bad'. Where the patriot is modest, the nationalist is malicious; where the patriot is defensive, the nationalist is militaristic. Orwell understood nationalism to be a thirst for power, one that needn't be limited, counter-intuitively, by the nation as a unit. He was ready to take 'Communism, political Catholicism, Zionism, Antisemitism, Trotskyism and Pacifism' as variants of nationalism, because in all of them he discerned a tendency to think in terms of 'victories, defeats, triumphs and humiliations'. Facts matter little to those gripped by such a mindset. What counts is the willingness of the nationalist to remain unshakeably convinced

of their rightness and to be indifferent to reality. As he put it, a good many nationalists are able to live 'quite happily amid dreams of power and conquest which have no connexion with the physical world'.

The rise of totalitarianism in Europe forced Orwell to confront the difficult prospect of a politics based on fantasies hoping to lay waste to nations. More than that, totalitarianism attempted to erase distinctions between truths and untruths, to replace 'propaganda with indoctrination', in Hannah Arendt's words, and to use 'violence not so much to frighten people [...] as to realize constantly its ideological doctrines and its practical lies', so that the difference between fantasy and reality disappeared.[1] Totalitarianism turned its dreams into realities – through assaults on language and history, military power and expansion, the demonisation of institutions, a paranoia directed at ethnic and social minorities, cults of leadership, and the abolition of the very concept of the free individual in favour of the insect-like, manipulable, hate-fuelled collective. How best to warn against such a politics is the challenge *Nineteen Eighty-Four* takes up. As a citizen of this society built on dreams of power, Winston Smith lives and breathes a dreamscape in which what's true and what's false is nigh-on impossible to know. The saving gesture is the third-person form of *Nineteen Eighty-Four*. The narrative style of Orwell's resistance to totalitarianism's assaults on language and reality embodies the belief that there is a world 'out there' which can be objectively described, and whose solidity challenges the deceptions of those for whom reality is whatever they say it amounts to.[2]

Nineteen Eighty-Four took Orwell back, in a pleasing circle, to the writer whom he'd hoped as a boy to emulate: H. G. Wells. Orwell described *Nineteen Eighty-Four* as 'a Utopia written in the form of a novel', but this was really a way of saying that he'd written a dream book – or maybe that he'd written a book of bad dreams. *Nineteen Eighty-Four* adapts the world-building and descriptiveness of a text like Wells's *A Modern Utopia* to the needs of a faster-paced, doom-laden adventure story. Where *A Modern Utopia* sociologically outlines the forms of an ideal parallel world, using an idiosyncratic blend of the travelogue and philosophical rumination to do so, *Nineteen Eighty-Four* tells a story against the backdrop of a world gripped by bad utopian thinking from which vulnerable dissidents hope, naively, to escape. The young Eric Blair had hoped one day to write a book just like *A Modern Utopia*. The adult Orwell ended up writing something more like Wells's *The Sleeper Awakes*:

> In this book Wells drops all traces of optimism and forecasts a highly organised totalitarian society based quite frankly on slave labour. In some ways it comes extremely close to what is actually happening, or appears to be happening, in the modern world, and it is in any case an astonishing feat of detailed imaginative construction.

Written in 1946, these remarks apply equally as well to *Nineteen Eighty-Four* as they do to their Wellsian precursor. And it was this sense of closeness between the two authors in the 1940s that led Orwell's contemporary Wyndham Lewis to remark unsympathetically that *Nineteen Eighty-Four* 'is Wellsian in

form, Wellsian in the style of its writing, Wellsian in the colourlessness and anonymity of the personae. [...] There is, in fact, very little drama, in consequence of the extremely unelectrical quality of the human material.'[3]

Lewis didn't grasp that all this colourlessness and anonymity was precisely Orwell's point: that human material in the society depicted in *Nineteen Eighty-Four* is likely to be 'unelectrical'. But Lewis was also misjudging the novel's form, which treads a shifting line between the harshness of the 'real world' and the pain and shame of bad memories and startling dreams. The phantasmagorical hue of *Nineteen Eighty-Four* tells us something important about the role Orwell thought that a book of this kind might play in an increasingly strange, terrifying world – not only to warn against totalitarianism, but also somehow to capture totalitarianism's dread and disorientation. *Nineteen Eighty-Four* is a book about what happens to society after its bad dreamers, the totalitarians, have got their way. 'Ingsoc', the name for Oceania's ruling ideology, English socialism, is really a term that stands in for a living nightmare. Yet in describing that sociopolitical horror, the author made sure to write the novel in such a way as to make it feel disquieting at the level of style: to be full of unexpected juxtapositions, terrifying images, chronological jumps and ambivalent portrayals of what might be real and what might not. He called this mood 'the atmosphere of nightmare': the 'special world created by secret police forces, censorship of opinion, torture and frame-up trials'.

Orwell wrote in 'Arthur Koestler' (1946) that *Animal Farm* is about a 'dream of a just society' and the formation of a

community that 'turns out to be as unjust, laborious and fear-ridden' as the society it overthrows. *Nineteen Eighty-Four* is concerned with a later period, when the dream of justice has become a nightmare of oppression. But it's also a book in which the ordinary reality of the author's dreams night to night can be felt. Orwell kept his dreams and nightmares to himself, giving few details about them in his diaries and essays. When he does refer to them, however, they matter. And a stretch of dreams in and around 1940, at the start of the Blitz, matters very much indeed. By this point in time the content of his dreams and the imagined content of his fiction had started to converge. *Coming Up for Air*, a novel of imagined bombs and oppressive nostalgia, shows this, but his most dream-laden novel, *Nineteen Eighty-Four*, is where distinctions between real and imagined dreams blur completely. Usually celebrated as his most forward-looking book, *Nineteen Eighty-Four* is in certain ways his most retrospective. Its most harrowing content comes from its resistance to totalitarianism's lies and violence, to the future. There is also suffering in Winston Smith's dreams, which take us back to Orwell's visions of bombs falling from skies laden with anger and machines. It evokes a long-held fear of drowning. At the centre of it all is the frightened child in Orwell – the frightened child in all of us – for whom the world's torments are mental terrors.

Orwell wrote in his essay 'My Country Right or Left' (1940) that on the night before the announcement of the Molotov–Ribbentrop Pact (23 August 1939), which agreed terms of non-aggression between the Soviet Union and Nazi Germany, he dreamed the war had already started:

It was one of those dreams which, whatever Freudian inner meaning they may have, do sometimes reveal to you the real state of your feelings. It taught me two things, first, that I should be simply relieved when the long-dreaded war started, secondly, that I was patriotic at heart, would not sabotage or act against my own side, would support the war, would fight in it if possible.

A fear of war on its way, a dream of war already arrived, and an essay looking back on war from the other side of the war's actual beginning: a typically complex Orwellian scenario of what in this same essay he formulates as the relationship between 'real memories' and 'later accretions'. *Coming Up for Air* spins on exactly this split between accurate recollection and the bias that turns memory into desire. This is also the stuff of what eventually became *Nineteen Eighty-Four*, a novel filled with 'Freudian' meanings, war dread and hope against hope.

'Where there is dream there is trauma,' writes the critic Geoffrey Hartman.[4] Here the trauma was the fear of a worldwide war that had occupied Orwell's mind for several years. Novels like *Keep the Aspidistra Flying* and *Coming Up for Air*, along with his Spanish memoir *Homage to Catalonia*, all dread the war, and specifically the dropping of bombs. And the dream of writing in a secluded hideaway that eventually produced *Nineteen Eighty-Four* was bound up from the start with the threat of bombing. The author yearned to lock himself away on an 'uninhabited' island in the Hebrides, as he put it in his diary on 20 June 1940, where he could cultivate the land and look after the local wildlife. He didn't know it yet, but the

island would turn out to be the Scottish island of Jura. The summer of 1940 was an extended phase of tense anticipation, as German aircraft attacked Britain's airspace, landmarks and strategic positions, with the Blitz still to come. Orwell had heard already that 'a woman who rented an island in the Hebrides in order to avoid air raids was the first air raid casualty of the war, the R.A.F. dropping a bomb there by mistake.' He added, sardonically: 'Good if true.'[5]

That summer, Orwell indulged his birdwatcher's eye. He had spent a lifetime noticing the patterns and habits of birds. In his diary entry for 28 July 1940, he lingers over two ornithological encounters. The first involves an unexpected urban traveller: 'This evening I saw a heron flying over Baker Street.' An unexpected pause in the city's evening bustle; a simply stated observation that leaves things unanswered. Why was the heron there? Where was it going? It was a stone's throw from Orwell's home at the time, on Chagford Street near Regent's Park, where he'd moved with Eileen that May. Certainly the sight was far from the nostalgic idylls in *Coming Up for Air*, in which George Bowling affectionately remembers occasions when 'a heron might be standing in the shallow water fifty yards up the bank, and for three or four hours on end there wouldn't be anyone passing to scare him away.' Orwell's second encounter, more 'improbable' than the one with the heron, occurred two weeks earlier: 'a kestrel killing a sparrow in the middle of Lord's cricket ground'. The war instantly came to the author's mind: 'I suppose it is possible that the war, i.e. the diminution of traffic, tends to increase bird life in inner London.' A reasoned explanation. But the reasoning might in its way have been meant

to distract from the sense of fragility and vulnerability that the sparrow's death implied. Against the background of the Battle of Britain, which had been under way at this point for just over a fortnight, an encounter with nature – red in tooth and claw, bringing violence into the heart of genteel, cricket-obsessed England – would have been quietly unnerving.

Both encounters have their pathos. They point to a natural world indifferent to the wars of men. This is probably why Orwell wrote them down. Amid the war, and on the eve of the Blitz, description could have its consolations. And just in time, too, because the author had a worrying month ahead of him. British Somaliland was about to be lost to the Italians ('a serious defeat', as he put it in his diary entry for 20 August), and he would be vexed by sneering establishment attitudes towards the Home Guard, then called the Local Defence Volunteers, whose St John's Wood company he'd joined in mid June. Orwell and Eileen nevertheless managed a couple of days away at Wallington, where they ignored the newspapers and enjoyed the countryside. His entry for 9 August 1940, when he was mired in tensions about his income tax situation, highlighted the lack of 'real news for days past', except for 'air battles'. The war was getting closer. He wrote on 16 August about the 'enormous air battles over the Channel', entailing what was reported as 'stupendous German losses'. An irritable follow-up dwelled on how Londoners didn't know what was best for them when the alarms sounded. Rather than seeking shelter, they preferred to gaze at the sky in search of approaching bombers. Air raids are mentioned repeatedly across the ensuing pages – 'air raids are getting commoner' (20 August); 'an air-raid warning about 3

a.m.' (23 August) – as is what Orwell deemed the inadequately localised nature of the warnings accompanying them, 'costing thousands of pounds in wasted time, lost sleep, etc.' 'They will have to do something very soon about localising alarms,' he wrote on 26 August. 'At present millions of people are kept awake or kept away from work every time an aeroplane appears over any part of London.'

By 29 August 1940, the thought of bombs dropping on civilians, by design or by mistake, had become a more intimate prospect. Orwell had spent a night on duty with the Home Guard. He wanted to do his patriotic bit. And he was good at it, too, quickly being promoted to sergeant. Twice-weekly duties included stretches of guarding local strategic positions, such as the telephone exchange, and time spent training a section of ten men under his charge, in matters like street fighting, methods for attacking and defending a house, going on patrol and setting up anti-tank positions. He was a good commander: humorous, easy-going, efficient, sometimes bungling. His biographer Bernard Crick points out that although Orwell could be amusingly earnest, testimony survives pointing to 'his efficiency with weapons and to the knowledgeable and realistic training he gave his unit in street-warfare and fieldcraft'.[6] Fredric Warburg, having joined the Home Guard a year later under the author's command, remembered the author's crumpled uniform and jaunty tricorn cap, along with the 'Cromwellian' intensity of his facial expressions.[7] The work included a lot of sitting around. Orwell liked to chat with his men and have a cuppa. It was honest labour. But it probably wasn't the most tiring thing he'd ever done.

A night on duty would nevertheless have been draining. Orwell slept for two hours shortly after getting home following one long, presumably uneventful night. You can imagine him coming through the front door, tired but alert, and taking off his boots, maybe pausing for a smoke. The anxious mood worked against rest. Even when the author wasn't on duty he had duty on his mind, looking up at windows as he walked through London and trying to work out which would make for good machine-gun placements. The air raid alarms were irksome as well. Sleep was an outlet, and the outlet was getting clogged. For several nights past, Orwell wrote, the alarms had 'totalled about 16–18 hours', it being 'perfectly clear', he insisted, that the raids they announced were 'intended chiefly as a nuisance'. He later noted that bombing mattered less as bombing as such and more as an irritating interruption in the daily order:

> It is not so much that the bombing is worrying in itself as that the disorganisation of traffic, frequent difficulty of telephoning, shutting of shops whenever there is a raid on, etc., etc., combined with the necessity of getting on with one's ordinary work, wear one out and turn life into a constant scramble to catch up lost time.

Orwell may have been protesting a little too much here. His dreams told against him. The dream he had that morning was a nightmare about being bombed. 'I had a very disagreeable dream,' he wrote, 'of a bomb dropping near me and frightening me out of my wits.' Having woken up, no doubt he took an instant to compose himself. Maybe he was upset. The memory

poignantly evokes an increasingly ailing man's vulnerability: from his own ill health and from the omnipresent tension of world war as it was experienced by those on the home front. It might have been one of those dreams, so often shown in films (and used by the author in his novels), in which the dreamer is startled awake with a shudder. It also points to George Bowling's intermittent anxieties about an age of blasts and bangs. As he puts it in *Coming Up for Air*, reflecting on the nearness of another world war: 'Funny how we keep on thinking about bombs. Of course there's no question that it's coming soon. You can tell how close it is by the cheer-up stuff they're talking about it in the newspaper.' Orwell had seen his fair share of bombs falling from the sky in revolutionary Spain. The difference is that there none of the bombs had landed near him, always seeming to fall far enough away not to matter too much. In the dream, the bomb got a little close for comfort. The detail of the bomb's nearness is what counts.

Orwell wrote in *Homage to Catalonia* that he had never felt in any real danger from aerial bombs. They always seemed to be dropped elsewhere, or far enough away from him to be ignorable:

> The things that one normally thinks of as the horrors of war seldom happened to me. No aeroplane ever dropped a bomb anywhere near me, I do not think a shell ever exploded within fifty yards of me, and I was only in hand-to-hand fighting once (once is once too often, I may say). Of course I was often under heavy machine-gun fire, but usually at longish ranges.

The memory of another conflict zone is a telling symptom of Orwell's mental rootedness in Spain. It also tells of a deeper anxiety about the mechanical condition of modern warfare, the ease with which weapons of mass death and destruction could be flown over and dropped into crowded cities and streets.

At the end of his diary entry for 29 August, Orwell turns to another dreamed thought of bombs. This came from the latter stages of his time in Spain – a dream 'of being on a grass bank with no cover and mortar shells dropping round me'. His entry for 31 August works with much the same point of comparison:

> Air-raid warnings, of which there are now half a dozen or thereabouts every 24 hours, becoming a great bore. Opinion spreading rapidly that one ought simply to disregard the raids except when they are known to be big-scale ones and in one's own area. Of the people strolling in Regent's Park, I should say at least half pay no attention to a raid-warning … Last night just as we were going to bed, a pretty heavy explosion. Later in the night woken up by a tremendous crash, said to be caused by a bomb in Maida Vale. E[ileen] and I merely remarked on the loudness and fell asleep again. Falling asleep, with a vague impression of anti-aircraft guns firing, found myself mentally back in the Spanish war, on one of those nights when you had good straw to sleep on, dry feet, several hours rest ahead of you, and the sound of distant gunfire[.]

Nearness, again, and a convergence of history and dreaming. As the Battle of Britain went on and the threat of bombing raids

over London increased, Orwell's dreams put him closer and closer to the danger zone.

Sleep tells of what the mind and body feel. In Orwell's case, the bombs, this mingling of dreams and detonations, started to explode into nightmare-filled prose. *Nineteen Eighty-Four* is a novel of air raids, or more precisely a novel of their aftermath. It imagines a future London peppered with craters: the remnants of a world war that never ended. It traces the after-effects of a fear the author first articulated in *Keep the Aspidistra Flying*, with its visions of enemy aeroplanes flying over London: 'the deep threatening hum of the propellers, the shattering thunder of the bombs.' The same anxiety courses through his other works of the late 1930s, as the options for avoiding world war grew ever more scarce and fragile. An England that stayed asleep, wandering in a dream and forgetting what decency is and why it matters, is the world inherited by Winston Smith. Orwell's suspicion was that England would never wake up to the possibility of such a future until it was forced to – by necessity, by explosions or by finally recognising the totalitarian dangers lurking within itself.

Coming Up for Air ends with a scene in which a bomb is accidentally dropped on Lower Binfield by one of a fleet of bombers on exercise. A greengrocer's shop is blown to pieces. Another building is carved in two 'as neatly as if someone had done it with a knife'. A jar of marmalade is emptied over the street, making for a gruesome contrast with the trail of blood pouring from a severed leg. With another war on the horizon, and a sleeping England drifting towards it, *Coming Up for Air* scores a point about military incompetence while

implying that it may take the English bombing *themselves* to break out of the 'deep, deep sleep' Orwell lamented on his way back from Spain. The novel worries about the future as a detonative time, suggesting in that gesture the extent to which the author had bombs on his mind. In being a novel of blasts, *Coming Up for Air* anticipates and uncannily encodes a stretch of Orwell's life in which he dreamed anxiously about his own vulnerability in a world of TNT falling from the sky. Its protagonist, like its author, would much rather have been watching the birds.

In *Nineteen Eighty-Four*, architectural and infrastructural destruction of the kind feared in *Keep the Aspidistra Flying* and *Coming Up for Air* has seeped into linguistic gouging, as words are annihilated and Newspeak, a language of euphemism and intentional imprecision, takes their place. That Orwell anticipated these destructive transitions occurring in a dream book is evident from his notes for the earliest versions of the text. As early as 1943 he was writing of what became *Nineteen Eighty-Four*, then named 'The Last Man in Europe', as a text defined by 'fantasmagoric' effects, full of 'rectification' and the 'shifting of dates', with a protagonist plagued by 'doubts of [his] own sanity'. Drawing on these notes, the critic Dorian Lynskey writes: 'Pitted with dreams, hallucinations, shaky memories, falsified information, and references to mental illness, the novel is a deeply unstable narrative.'[8] As a kind of dream – a 'structured nightmare', as another critic puts it – *Nineteen Eighty-Four* reimagines Orwell's anxious visions and experiences of being bombed as an assault from a differently vertical, hierarchical menace: totalitarianism.[9] Where Orwell's dreams in August

1940 register the threat of war on its seemingly unstoppable way into the English homeland, *Nineteen Eighty-Four* encodes the looming disaster of totalitarian conquest as a dreamlike story of England lost.

Winston's daydreams take him back into his own memories of war and bombing. One of the most touching is the memory he has of going into some 'place deep in the earth, round and round a spiral staircase' – a Tube station. He's remembering a moment that might have been just after an atomic attack on Colchester; the haze of memory in a world without objective records means he can't be sure. He's with his father and mother, who follow him down the stairs, carrying a bundle that may or may not be his baby sister. They emerge into 'a noisy, crowded place':

> There were people sitting all over the stone-flagged floor, and other people, packed tightly together, were sitting on metal bunks, one above the other. Winston and his mother and father found themselves a place on the floor, and near them an old man and an old woman were sitting side by side on a bunk. The old man had on a decent dark suit and a black cloth cap pushed back from very white hair: his face was scarlet and his eyes were blue and full of tears. He reeked of gin. It seemed to breathe out of his skin in place of sweat, and one could have fancied that the tears welling from his eyes were pure gin. But though slightly drunk he was also suffering under some grief that was genuine and unbearable. In his childish way Winston grasped that some terrible thing, something that was beyond forgiveness and could never be

remedied, had just happened. It also seemed to him that he knew what it was. Someone whom the old man loved, a little granddaughter perhaps, had been killed.

Memory intensifies memory, with the idea of going down into the earth itself an image of the stratified workings of a mind. A fear of being bombed is what connects Winston, in memory, with the fear and pain of loss. It connects him with something 'beyond forgiveness' – the death of a loved granddaughter – that in turn, as we'll see, indicates his own condition of abject unforgivability.

When Winston dreams, he yearns. We know from T. S. Eliot's epic modernist poem *The Waste Land* (1922) that April, the month in which *Nineteen Eighty-Four* begins, is 'the cruellest month', the month that breeds lilacs out of the dead land and mixes memory and desire.[10] In dreaming, Winston desires a future that once might have been. He yearns for places yet to be that come from places past. His dreams of the Golden Country, for example – 'an old, rabbit-bitten pasture, with a foot-track wandering across it and a molehill here and there', with somewhere near at hand 'a clear, slow-moving stream where dace were swimming in the pools under the willow trees' – are dreams of a place to which he can escape with all the familiar hallmarks of a pastoral glade. What Winston desires, in effect, is a return into literary history. When he and Julia have their long-awaited tryst in the countryside, they wander unknowingly into the landscape of 'The Passionate Shepherd to His Love', Christopher Marlowe's poem of valleys, groves, hills and fields, in which the lyric voice asks his love to sit with

him 'upon the Rocks, / Seeing the Sheepheards feede theyr flocks, / By shallow Rivers to whose falls, / Melodious byrds sing Madrigalls.'[11] Winston and Julia see what the shepherd sees, and they hear what he hears. Poetry inflects prose. A thrush alights 'on a bough not five metres away', pouring forth a river-like 'torrent of song'. The scene is eroticised; desire is charged. As Winston and Julia make love, desire gives way to the memory of dreaming. Winston can't help but remember his dream of Julia, long before their romance, flinging aside her clothes with a 'magnificent gesture by which a whole civilisation seem[s] to be annihilated'. In sex, tyranny is destroyed. The fly in the bucolic ointment is the fear that, all the while, Winston and Julia are being spied on by the Thought Police.

Nineteen Eighty-Four subjects the dream of the Golden Country to intense pressure. Initially it seems like a utopian alternative to the bombed-out landscape of Oceanic London. A dream pitched against the nightmarish reality of the war-scarred present. A dream set in opposition to Orwell's dreams of being bombed. But as *Nineteen Eighty-Four* unfolds we learn that the dream of the Golden Country is as deceptive as Winston's similar dream of 'the place where there is no darkness', where he and O'Brien, the man who seems at first to be his benefactor, will eventually meet. The Golden Country, so fleetingly available in the pastoral landscape of Winston's and Julia's lovemaking, eventually materialises in the surreally 'glorious, golden light' of the 'mighty corridor' in which Winston imagines himself in the midst of torture. Just before he finds himself in Room 101, he dreams 'a great deal': of 'the Golden Country', of 'sitting among enormous, glorious, sunlit ruins, with his mother, with

Julia, with O'Brien – not doing anything, merely sitting in the sun, talking of peaceful things'.

Winston's mind is buckling. The torture is having its effect. Soon, in Room 101, he'll be 'cured'. The glorious, sunlit ruins are the ruins of the pastoral. The image evoked is the kind of scene depicted in images like Claude Lorrain's *Landscape with Ruins, Pastoral Figures, and Trees* (c.1650) and Adriaen van de Velde's *Pastoral Landscape with Ruins* (1664). They're also the ruins of war, taking their place alongside the 'vast and ruinous' London of Orwell's imagination, and the 'ruinous church' where Winston and Julia make love in May. For Orwell, springtime is a time of ruins, just as it was for Eliot. Winston dreams of Julia, in the Ministry of Love, because he needs to hold on to the memory of her to survive his torture. He dreams of O'Brien because he thinks O'Brien cares for him. The dream of his mother, however, is more fraught. It evokes the pain of a selfishness that can never be atoned for. He remembers her in golden light because all other memories of her are too painful to bear directly. For the old man in the Tube station the terrible thing, the something that is beyond forgiveness that can never be remedied, is the death of a granddaughter. For Winston, it's the memory of having murdered his mother – not physically or literally, but symbolically, in betrayal. Haunting Winston's dreams throughout *Nineteen Eighty-Four* is the memory of having betrayed himself to desire.

The protagonist remembers a time of bombs: a time of 'panics about air-raids' and 'sheltering in Tube stations, the piles of rubble everywhere, the unintelligible proclamations posted at street corners, the gangs of youths in shirts all the same colour,

the enormous queues outside the bakeries, the intermittent machine-gun fire in the distance – above all, the fact that there was never enough to eat'. He steals a chocolate ration from his sister and runs away while his mother scolds him. When he returns, his mother is gone. The father has already disappeared. But it's the memory of Winston's lost mother that sticks, just as the stolen chocolate sticks to his hand. The pain he feels is the pain of having lost himself *in himself*, in selfishness. It tears at his heart because she 'died loving him, when he was too young and selfish to love her in return'. And this trauma comes back to him in dreams about drowning. Whenever he dreams of his long-dead mother, and the sister whose chocolate ration he stole, he imagines them 'looking up at him through […] green water, hundreds of fathoms down and still sinking'. The dream distorts a happier memory, of playing dice with his mother as a ten-year-old on 'a pelting, drenching day when the water streamed down the window-pane and the light indoors was too dull to read by', into a *Waste Land*esque scene of death by water. Fears of being bombed become fears of watching others drown. In dreams, the vulnerable child still suffers in the adult man.

There is a fascinating parallel here with Orwell's 'Such, Such Were the Joys', which does so much to align the small cruelties of prep school education with the excesses of authoritarian power. Orwell suggests that a 'very great difficulty of knowing what a child really feels and thinks' is that children act as if nothing is wrong even when they're suffering inside:

> A child which appears reasonably happy may actually be suffering horrors which it cannot or will not reveal. It lives in

a sort of alien under-water world which we can only penetrate by memory or divination. Our chief clue is the fact that we were once children ourselves, and many people appear to forget the atmosphere of their own childhood almost entirely. Think for instance of the unnecessary torments that people will inflict by sending a child back to school with clothes of the wrong pattern, and refusing to see that this matters! Over things of this kind a child will sometimes utter a protest, but a great deal of the time its attitude is one of simple concealment.

In being unable to forget about betraying his mother, Winston Smith still lives inside the mind of a child. As the imagery of sinking into green depths implies, he's trapped underwater, living in exactly the 'sort of alien under-water world' that in Orwell's view stops children from being able to expose their true feelings to an adult even when it's in their best interests to do so.

When he's on the torture table in the Ministry of Love, Winston looks to O'Brien, his torturer, as a perversely surrogate parent. Deep into the torture sequence, unable to bear the pain, he loses consciousness. When he wakes up, he finds that he's been granted a reprieve: for a moment he clings to O'Brien 'like a baby, curiously comforted by the heavy arm round his shoulders' and feeling that his torturer is somehow 'his protector'. This turns out to be very far from the truth, except insofar as O'Brien has a nefarious desire to 'heal' Winston for his own good. But clearly Winston feels childlike, and wants the protection of a parent: a consolation that in reality he can

never have. One reason for this is that he can't quite get out from the childlike view of adults as monsters, or what in 'Such, Such Were the Joys' he called the 'veil of fear and shyness mixed up with physical distaste' that in Orwell's view marks all children's responses to grown-up bodies: from the child's point of view, their enormous size, ungainly movements, wrinkled skin, drooping eyelids, yellow teeth and strong physical smells. Amid the many things pressing in on Winston's mind in the Ministry of Love is the tiredness of O'Brien's 'worn' face, with its 'pouches under the eyes' and skin sagging from cheekbones. This is the face of a powerful man who knows that his 'weariness', as he puts it, is merely the 'vigour' of the larger ideology he serves – the face of an adult looming over someone reduced to childlike impotence. In this way, *Nineteen Eighty-Four* suggests that the nightmare of totalitarian power may uncomfortably parallel the terrors of a child's view of authority.

Orwell's nightmares of exploding metal shape *Nineteen Eighty-Four*'s preoccupation with ruined cityscapes, just as the actual bombs of the Second World War shaped his dreams of detonation-strewn Spain. Yet there's another possibility here that takes us back much further into the author's memory, and into the earlier twentieth century. When Winston dreams of his mother and sister drowning in green water, he sees them 'in some subterranean place – the bottom of a well, for instance, or a very deep grave', or, tellingly, 'the saloon of a sinking ship, looking up at him through the darkening water'. The last possibility is the significant detail. Compare it with what Orwell urged in his essay 'Writers and Leviathan' (1948):

This is a political age. War, Fascism, concentration camps, rubber truncheons, atomic bombs, etc., are what we daily think about, and therefore to a great extent what we write about, even when we do not name them openly. We cannot help this. When you are on a sinking ship, your thoughts will be about sinking ships.

The author's gambit in *Nineteen Eighty-Four* is to show how a vision of the kind dreamed by Old Major in *Animal Farm* – an idea of 'perfect unity' and 'perfect comradeship' – can be perverted into the despotism of Big Brother, the Inner Party, and the Thought Police. If *Nineteen Eighty-Four* is a book about the ship of state, it's a book about a ship of state that's sinking or already sunk. But it's also, just perhaps, about an actual and remembered ship, whose sinking affected Orwell very deeply. The ship in question, as for so many other young men of his generation, is the RMS *Titanic*.

Writing about his memory of the First World War in 'My Country Right or Left', Orwell noted that the conflict began when he was only eleven years old:

> If I honestly sort out my memories and disregard what I have learned since, I must admit that nothing in the whole war moved me so deeply as the loss of the *Titanic* had done a few years earlier. This comparatively petty disaster shocked the whole world, and the shock has not quite died away even yet. I remember the terrible, detailed accounts read out at the breakfast table (in those days it was a common habit to read the newspaper aloud), and I remember that in all the long

list of horrors the one that most impressed me was that at the last the *Titanic* suddenly up-ended and sank bow-foremost, so that the people clinging to the stern were lifted no less than three hundred feet into the air before they plunged into the abyss. It gave me a sinking sensation in the belly which I can still all but feel. Nothing in the war ever gave me quite that sensation.

No wonder sinking ships were part of Orwell's descriptive toolkit.[12] In *Nineteen Eighty-Four*, they convey nightmares. They also indicate how far this supposedly futurological novel is propelled, backwards as it goes forwards, by memories: of being bombed, of being horrified by indifferent water, of living in an alien underwater world.

A frightened child, a memory of drowning, fear of bombardment: these are the traumas that gave Orwell some of his most terrible dreams, in life and in words. *Nineteen Eighty-Four*, a novel of dreams gone wrong, builds a story out of them. The author claimed in a review of John Cromwell's 1941 film *So Ends Our Night* that dreams cannot be successfully represented 'in any other medium' than film, by which he meant that film is peculiarly suited, with its audiovisual capacities, to the depiction of non-linear, multisensory juxtapositions that make dreams what they are. This didn't stop him from writing about dreams, even if it meant that he didn't try to write dreams *as* dreams, in all their seeming violations of narrative intelligibility. *Nineteen Eighty-Four* is a novel of dreams gone wrong, of wronging others and of wronging oneself in the process. It remains the testament of a man concerned by and with machines dropping

bombs onto the earth. It also lets us peek at the frightened little boy inside the man who dreams – Winston Smith, and Orwell behind him. Eric Blair sits behind them both. *Nineteen Eighty-Four* is not a work of autobiography. But in processing Orwell's real concerns, it opens up his dreams to us.

Coda

ORWELL'S WAS A LIFE OF DREAMS: OF BECOMING A writer, fighting for democratic socialism, protecting the homeland, secluding himself on an island. He died an extremely sick man but he never lost his spirit for living, in spite of all the world's horror, and he remained fascinated to the end by the mundane. The average day is full of opportunities to find interest in ourselves and in the places through which we move. The different rhythms of monotony to which we become habituated, usually through paid employment or domestic necessity, have their dull aspects. It can be unwise, and maybe dangerous, to look for something special in the drudgery. Yet for Orwell the everyday had its enchantments. In the humdrum, he found delight.

I've tried in this book to show what the magic of the everyday looks like in Orwell's hands. He doesn't spring to mind as a writer to be read playfully, though there is good reason to read him in this way. The familiar idea of Orwell as a prophet or secular saint doesn't help, nor does the view that he wrote serious books about serious matters that should be read with

due respect if we're to grapple with the far-reaching points they raise. Topics like politics, technology, surveillance, liberty and war, all of these powerful themes in his work, are not things to be dealt with lightly, or to be sidelined by apparently less important issues (like hobbies or breakfast). Even so, there's a sense in which a focus on the seemingly trivial allows us, and allowed him, to persist: to keep concerns about politics, justice, truth and even existence itself at an approachably ordinary scale. And I suspect that we are able to read him seriously because there's enough room in his intellectual weightiness for it not to become dour. The bleakness of *Nineteen Eighty-Four* is also counter-intuitively where its humour lies. Winston Smith's predicament is nothing to laugh at. But there's a gallows wit in it all the same – a sense that things are so bad that the way out may be to laugh: at power, at hubris, in the face of hopelessness, and so to hold on to the thought of better times to come.

To quote the critic John Rodden, Orwell has long since been assimilated into 'the media's pantheon of literary figures'.[1] And there's no denying that the familiar image of a sociopolitical critic bravely positioned against the world is a beguiling one. It wouldn't have fixed itself into our collective consciousness so tenaciously if it weren't. The problem is that this version of the author is statuesque: a figure to adore, to respect; to worship, even. Orwell *is* in so many ways the figure we routinely take him to be, whatever his flaws and limitations: a morally serious, analytically impartial, decent person who repeatedly spoke truth to power. He is also at some level a version of what so many of his readers idealise: a steadfast, forthright, perceptive, witty intellectual. My purpose here has been to show that

these aspects of his character and thought are not sealed away in his political journalism or in his 'weighty' political novels, but that his deeply observant critical sensibility is discernible throughout his work and that it shapes his accounts of everyday behaviour just as significantly as it informs his insights into historic social and cultural change. There are other Orwells to enjoy, in other words, as well as human sides (and failings) to the writer who has become so mythic.

In life, Orwell mixed the extraordinary and the ordinary. The pseudonym 'George Orwell' points to these dissimilarities: the 'George' evoking the patron saint of England (the legendary), the 'Orwell' referring to the river of the same name in Suffolk where he spent so much time in the late 1920s and 1930s (the familiar). One of the most important things he did was to risk death in Spain fighting on behalf of people he didn't know but whose cause, the fight against fascism, he shared. After his death his name became increasingly synonymous with the big principles he'd put his life on the line for: freedom, decency, truth. But he lived a very down-to-earth life from which his experiences in Spain could not have been more different. The man who got a bullet through the neck on the Aragon front, and who almost died right there, is also the man who liked to go fishing, who loved birds, who had firm opinions about toasted bread, who spent time working hard in his garden and who once wrote a poem in Burma about teeth and toothpaste. Though we accept Orwell as some sort of prophet, this would have seemed unlikely to those who measured him for linen trousers in Southwold, or who remembered him as 'a man with a cough, mending a kitchen table with a piece of wood he had

cut from a dying tree'.[2] These sides of the man don't point to the 'real' Orwell so much as they reveal new aspects of the Orwell we already know but have forgotten, maybe, to wonder about.

Rebecca Solnit has said that Orwell makes room in his stories 'for the small and the subjective inside something big and historic'.[3] It seems to me that we need to go further. He didn't merely know how to make room for the small and subjective inside the big and historic; he also knew that in so many ways the one creates the other: that innumerable small happenings constitute the big processes that govern our lives. Small, subjective encounters matter because they reproduce large-scale dynamics: the thrashing doled out by an unsympathetic headmaster, the unseen mouths that snaffle food meant for everyone, a handshake offered by someone apparently trustworthy but secretly malign – all of them resonantly enact the political: these are dynamics of power that affect nations as much as they affect individuals. If we only pay attention to the 'big' Orwell, to the Orwell known for writing about international relations and wars, about the problems of honesty and truth, about the prospects of liberty and freedom, the less we notice that other Orwell who so often understood the largest existential questions in terms of small daily habits, with an eye on the seemingly trivial things that give daily life its texture; the less we see the Orwell who grasped the fact that ordinariness contains multitudes. Orwell emphasised the small, the local and the personal because he understood that these are the little worlds in which most people live and the *only* spaces in which so many can act.

In the mundane, Orwell discerned the workings of power. This is what makes his fiction feel authentic. He understood that

we live from day to day in a cycle of regularity, and that fictions reproducing that cycle and its nuances have a better shot at being believed. In *Nineteen Eighty-Four*, Mrs Parsons' kitchen sink is simply a kitchen sink, just one focal point among others that the author could have chosen (a broken door, a draughty window, uneven floorboards) for an atmospheric scenario. But it's also an opportunity to locate a larger meaning in the small happening, and a superb example of what he called an 'intimate day-to-day picture': an ordinary illustration of 'what human beings are like when they are trying to behave as human beings and not as cogs in the capitalist machine.' *Nineteen Eighty-Four* is not about capitalism per se, but when Winston does a good turn for his neighbour he is trying to live up to a standard of humane fellow feeling and solidarity that the machinic world of Oceania continually grinds out of its citizens. Behind him, Orwell is pitching to his readers that there is nowhere to escape the machine's influence even if there are beleaguered places (an unobserved alcove, a secret bedroom, a gleaming pasture) in which the vulnerable can resist it, albeit temporarily. In this sense, *Nineteen Eighty-Four* is only one instance in the author's work of a deeper impulse to show how the ordinariness of most people's lives is freighted with political meaning.

This Orwell – the one we read when we want to know about the lives of the urban destitute, the ironies of imperial rule, the cruelties of patriarchy, the vanity of bohemianism, the hopes of socialism, the deceptions of nostalgia, the hazards of revolution and the evils of authoritarian command, among so many other things – *this* Orwell will never disappear. It's precisely because a profound respect for and deep interest in ordinary human

existence was so central to his worldview that his accounts of how power flows through our lives have lasted for so many years. The Orwell who wrote about birdsong, the patterns made by crumbs on a breakfast table, the atmosphere of a corridor and the texture of a wall is no less alert to political questions than the Orwell who wrote about nations, wars, economies and all-seeing tech. The enjoyment he took in nature shows that he could appreciate the ordinary on its own terms; as he said of the novelist Samuel Butler, in words that apply equally well to his own work, 'he never lost the power [...] to be pleased by small things.' Yet Orwell also returned again and again to the social and political constraints that flow through even the most innocuously 'natural' or apparently simple facts and events. He was as fascinated by the ordinary in itself as he was by its wider implications. And that fascination is bound up with an implied plea for his readers to see and feel everything around them – to be awake to the world's detail. To be alive to how the world is continually being shaped by individuals, sometimes for the worse, but often for the better.

Acknowledgements

Spending a long time thinking about dailiness inevitably leads to reflection on one's habits and rituals. Most of this book was written in hour-long sessions: often at night, sometimes on trains, once on a plane and usually at home after putting the kids to bed and having switched off emails and social media. I found my rhythm in getting down 500 words a day – the routine for six months. It was never a chore.

Alice patiently stomached it all while having her own sizeable professional commitments. Our children, Ophelia and Hermione, have no idea who George Orwell is but have come to know his face – not least because Chris and Lucy Gee bought me GO-themed socks. The grandparents have been involved every step of the way too, babysitting, entertaining and nourishing. Writing a book about the daily amid a family's bustle reminds you to treasure the ordinary in its fleetingness.

My A-level teachers, Andrew Sinclair and Christopher Potts, introduced me to different sides of Orwell's thought, but more importantly they nurtured my curiosity about writing – its elasticity and suppleness, its contradictions and invigorating challenges. They helped me get started, as did Ian Sarginson. I'll always be grateful to them for their kindness, and for their reminders about lucidity and simplicity. Orwell would approve.

My godmother, Lynda, bought me Orwell's four-volume *Collected Essays, Journalism and Letters* back in the mid 1990s. She played a part in the origins of this book, in other words, and deserves a lot of credit for it.

Emma Smith graciously accepted a call from out of the blue to discuss the earliest version of this project. Her encouragement and inspiration gave me the confidence to keep going, as did the wise words of Chloe Currens. Similar thanks go to Michèle Mendelssohn for a supportive chat. D. J. Taylor helped me decide something at a crucial stage. Alexandra Harris and Lyndsey Stonebridge have cheered me on throughout, as have Jem Bloomfield, Sarah Davison, Ellie Dobson, Matt Hayler, Dominic Head, David James, Sebastian Mitchell, Dan Moore, Chris Mourant, Becky Roach and Emma West, among many other colleagues and former colleagues at Birmingham, Nottingham and elsewhere, including Robyn Read at the BBC.

I had the opportunity to work with my agent, Matthew Marland, after he happened to hear me speak on the radio about something unrelated to this project. So I owe a large part of all this to serendipity. Matthew has made getting to grips with trade publishing very enjoyable, and I'm indebted to him for the trust he's put in me.

My wonderful editor at Oneworld, Cecilia Stein, 'got' the project immediately and luckily for me was disposed to support it. Conversations with her have given me new ways to think about writing and reading, and not only in Orwell's case. Cecilia has always encouragingly questioned my ideas and pushed me to be more rhetorically precise. Huge thanks, likewise, to Rida

ACKNOWLEDGEMENTS

Vaquas, for her enthusiasm, and to the eagle-eyed Hannah Haseloff for her equally brilliant and perceptive input. My superb copy-editor, Sarah Terry, has been a delight to work with; *A Bright Cold Day* improved substantially on her watch. Paul Nash and my proofreader, Richard Rosenfeld, have been similarly supportive and helpful.

I'm still learning from Andrzej Gąsiorek, who read almost everything in draft form and then the full manuscript with his usual discernment – reminding me in doing so that he knows Orwell inside out and that so often the simpler ways of putting things are best. Bill Hamilton made time amid a busy schedule to read parts of the book, as did Emma Smith and Les Hurst. Darcy Moore cast his eyes over the whole thing, too, and saved me from a couple of howlers.

Finally, thanks to the large number of Orwell scholars with whom I've collaborated over the years, and especially to Richard Lance Keeble and Tim Crook, the editors of *George Orwell Studies*, for putting me on the journal's Editorial Board and for supporting my work on Orwell at every turn. At the University of Birmingham, the undergraduate students with whom I've discussed Orwell's work for almost a decade deserve special praise, chiefly among them the students who have taken the 'Orwell's Books' module and those who worked on the 'Rethinking George Orwell: New Letters by a Major Author' project funded by the College of Arts and Law: Emily Cornish, Grace Davis and Lily Sears. This book wouldn't be what it is without their questions, comments, enthusiasm, humour and indulgence, nor without the friendship and encouragement of one of my recent PhD students, Liam Knight.

Quotations from material by Orwell that remains in copyright, including the letters between Orwell and Brenda Salkeld and Eleanor Jaques recently deposited at University College London, are reproduced with the permission of the estate of the late Sonia Brownell Orwell.

Further Reading

BOOKS BY ORWELL

Orwell's work exists in many editions. The most authoritative is the one produced by the literary scholar Peter Davison, with the assistance of Ian Angus and Sheila Davison, for Secker & Warburg (1998), which provides editorial introductions, textual notes and explanatory commentaries. Penguin continues to publish the novels, books of reportage, diaries and a selection of letters and essays from this edition. Other authoritative editions of Orwell include those released in the Oxford World's Classics series (2021) and those published by Constable (2021–23), edited by D. J. Taylor.

BOOKS ABOUT ORWELL

Orwell studies is a boom area, comprising thousands of scholarly articles, essays, reviews, books and edited volumes. In suggesting further reading, I've tried to limit myself to items likely to be available in bookshops and public libraries, or easily purchasable online.

There are many biographies, the most recent being D. J. Taylor's *Orwell: The New Life* (Constable, 2023), which largely rewrites Taylor's first biography from 2003. Bernard Crick's *George Orwell: A Life* (Penguin, 1982, second edition) remains hugely useful and enjoyable, as do Gordon Bowker's *George Orwell* (Little, Brown, 2003), Robert Colls's *George Orwell: English Rebel* (Oxford University Press, 2013) and Jeffrey Meyers's *Orwell: Wintry Conscience of a Generation* (W. W. Norton, 2000). John Sutherland's *Orwell's Nose* (Reaktion, 2016), subtitled 'A Pathological Biography', reads Orwell's life through the medium of scent and smells. Sylvia Topp's biography of Orwell's first wife, *Eileen: The Making of George Orwell* (Unbound, 2020), is an important scholarly milestone, followed up, with much controversy, by Anna Funder's *Wifedom: Mrs Orwell's Invisible Life* (Viking, 2023).

Genre-defying biographical portrayals include Kristin Bluemel's *George Orwell and the Radical Eccentrics: Intermodernism in Literary London* (Palgrave Macmillan, 2004), Oliver Lewis's *The Orwell Tour: Travels through the Life and Work of George Orwell* (Icon, 2023), Jeffrey Meyers's *Orwell: Life and Art* (University of Illinois Press, 2010) and Rebecca Solnit's *Orwell's Roses* (Granta, 2021). An incomparable microhistory is given by Ronald Binns in *Orwell in Southwold* (Zoilus Press, 2018).

Unsurprisingly, most scholarly commentaries focus on Orwell's politics. Important recent studies include Philip Bounds's *Orwell and Marxism: The Political and Cultural Thinking of George Orwell* (I.B. Tauris, 2009), Glenn Burgess's *George Orwell's Perverse Humanity: Socialism and Free Speech*

(Bloomsbury, 2023), Craig L. Carr's *Orwell, Politics, and Power* (Continuum, 2010), Masha Karp's *George Orwell and Russia* (Bloomsbury, 2023), Scott Lucas's *Orwell* (Haus, 2003), John Newsinger's *Hope Lies in the Proles: George Orwell and the Left* (Pluto Press, 2018), Thomas E. Ricks's *Churchill and Orwell: The Fight for Freedom* (Duckworth, 2018), Peter Stansky's *The Socialist Patriot: George Orwell and War* (Stanford University Press, 2023), Anthony Stewart's *George Orwell, Doubleness, and the Value of Decency* (Routledge, 2003) and Kristian Williams's *Between the Bullet and the Lie: Essays on Orwell* (AK Press, 2017). An innovative account of Orwell's politics from the perspective of his journalism is given in Peter Marks's *George Orwell the Essayist: Literature, Politics and the Periodical Culture* (Continuum, 2011).

Those wishing to learn more about Orwell and the question of empire should consult Douglas Kerr's *Orwell and Empire* (Oxford University Press, 2022) and, for a more autobiographical angle, Emma Larkin's *Finding George Orwell in Burma* (Granta, 2011). Daphne Patai's study of Orwell's 'androcentrism', *The Orwell Mystique: A Study in Male Ideology* (University of Massachusetts Press, 1984), should be more widely known. Academic studies of Orwell's literary and political legacies include Laura Beers's *Orwell's Ghosts: Wisdom and Warnings for the Twenty-First Century* (Hurst & Co, 2024), Christopher Hitchens's *Why Orwell Matters* (Basic, 2002) and John Rodden's *Becoming George Orwell: Life and Letters, Legend and Legacy* (Princeton University Press, 2020).

Superb overviews of Orwell's work from a philosophical perspective are given in David Dwan's *Liberty, Equality, and*

Humbug: Orwell's Political Ideals (Oxford University Press, 2018) and Peter Brian Barry's *George Orwell and Philosophy: The Ethics of Equality* (Oxford University Press, 2023). Michael Brennan covers Orwell and religion in *George Orwell and Religion* (Bloomsbury, 2016). Thought-provoking accounts of Orwell's literary style can be found in Lynette Hunter's *George Orwell: The Search for a Voice* (Open University Press, 1984), Loraine Saunders's *The Unsung Artistry of George Orwell: The Novels from Burmese Days to Nineteen Eighty-Four* (Ashgate, 2008) and Alex Woloch's *Or Orwell: Writing and Democratic Socialism* (Harvard University Press, 2016).

For some excellent introductory guides, see Douglas Kerr's *George Orwell* (Northcote House, 2003), Valerie Meyers's *George Orwell* (Macmillan, 1991), John Rodden's and John Rossi's *The Cambridge Introduction to George Orwell* (Cambridge University Press, 2012) and D. J. Taylor's *Who is Big Brother? A Reader's Guide to George Orwell* (Yale University Press, 2024). Recommended books focusing on Orwell's most famous novel, *Nineteen Eighty-Four*, are Dorian Lynskey's *The Ministry of Truth: A Biography of George Orwell's 1984* (Picador, 2019) and D. J. Taylor's *On Nineteen Eighty-Four: A Biography* (Abrams Press, 2019). See also my edited volume, *The Cambridge Companion to Nineteen Eighty-Four* (Cambridge University Press, 2020).

A key scholarly resource is the journal *George Orwell Studies* (Abramis, 2016 to present).

Notes

All quotations from Orwell's work, along with some quotations from Georges Kopp and Fredric Warburg, are unreferenced and taken from the twenty-volume *Complete Works of George Orwell*, edited by Peter Davison with the assistance of Ian Angus and Sheila Davison, published in London by Secker & Warburg (1998) and supplemented by *The Lost Orwell*, also edited by Peter Davison (London: Timewell Press, 2006). All other quoted sources are indicated in the notes.

FOREWORD

1 Priya Satia, 'Orwell and Empire', in *The Oxford Handbook of George Orwell*, ed. by Nathan Waddell (Oxford: Oxford University Press, 2025), pp. 350–73.
2 Shoshana Zuboff, *The Age of Surveillance Capitalism: The Fight for a Human Future at the New Frontier of Power* (London: Profile, 2019), p. 372.
3 *A Bright Cold Day* can thus be considered a large-scale reinvention of Orwell in the mould of his essay 'A Day in the Life of a Tramp' (1929), but applied to the man himself.
4 Daphne Patai, *The Orwell Mystique: A Study in Male Ideology* (Amherst: University of Massachusetts Press, 1984), pp. 14, 19.

I RISING

1. See Natasha Periyan, 'Teaching and Learning in and Beyond *Nineteen Eighty-Four*', in *The Cambridge Companion to Nineteen Eighty-Four*, ed. by Nathan Waddell (Cambridge: Cambridge University Press, 2020), pp. 23–36.
2. Orwell's literary executor Richard Rees added a more colourful rationale: 'Why did [Orwell] take a pen-name? [...] On one occasion he told me that it gave him an unpleasant feeling to see his real name in print because "how can you be sure your enemy won't cut it out and work some sort of black magic on it?"' (*George Orwell: Fugitive from the Camp of Victory* (London: Secker & Warburg, 1961), p. 44).
3. To quote Douglas Kerr, 'there are indications that it was in Burma that Orwell had first started to learn about Oceania' (*George Orwell* (Tavistock: Northcote House, 2003), p. 77).
4. Richard Voorhees, *The Paradox of George Orwell* (West Lafayette, Indiana: Purdue University Press, 1961), p. 23.
5. Audrey Coppard and Bernard Crick (eds), *Orwell Remembered* (London: BBC, 1984), pp. 35–6.
6. D. J. Taylor, *Orwell: The New Life* (London: Constable, 2023), p. 115.
7. Jacintha Buddicom, *Eric & Us*, with a postscript by Dione Venables (Chichester: Finlay, 2006), p. 39.
8. Peter Davison, *George Orwell: A Literary Life* (Basingstoke: Palgrave, 1996), p. 9.
9. H. G. Wells, *A Modern Utopia* (1910), ed. by Gregory Claeys and Patrick Parrinder, introd. Francis Wheen (London: Penguin, 2005), p. 241.

NOTES

II WASHING

1 Audrey Coppard and Bernard Crick (eds), *Orwell Remembered* (London: BBC, 1984), p. 40.
2 Jacintha Buddicom, *Eric & Us*, with a postscript by Dione Venables (Chichester: Finlay, 2006), pp. 57–8.
3 Coppard and Crick, *Orwell Remembered*, p. 56.
4 Jeffrey Meyers, *Orwell: Wintry Conscience of a Generation* (New York and London: W. W. Norton, 2000), p. 48.
5 Orwell recycled the metaphor in *Coming Up for Air*, in which a stretch of woodland that once grew so thickly it resembled 'a kind of tropical jungle' has been 'shaved flat'.
6 For a philosophical discussion of the questionable links between moral values and socially constructed standards of beauty, see Heather Widdows, *Perfect Me: Beauty as an Ethical Ideal* (Princeton, NJ: Princeton University Press, 2018).
7 Martha C. Carpentier, 'Orwell's Joyce and *Coming Up for Air*', *Joyce Studies Annual*, 1 (2012), 131–53.
8 In retrospect, Orwell's tendency to associate fatness with ridiculousness – a habit that appears across his work – looks an awful lot like what in today's world is known as 'fat-shaming'.
9 David Trotter, *Cooking with Mud: The Idea of Mess in Nineteenth-Century Art and Fiction* (Oxford: Oxford University Press, 2000), p. 2.

III BREAKFAST

1 J. R. Hammond, *A George Orwell Chronology* (Basingstoke: Palgrave, 2000), pp. 10–14.
2 Alasdair Donaldson, 'With Apologies to Mr Orwell', British Council, https://www.britishcouncil.org/research-policy-insight/insight-articles/apologies-mr-orwell [accessed 10 October 2024].
3 Dorian Lynskey, *The Ministry of Truth: A Biography of George Orwell's 1984* (London: Picador, 2019), p. 7.

4 I say more about Orwell's dirt-mindedness in my essay 'Oceania's Dirt: Filth, Nausea, and Disgust in Airstrip One', in *The Cambridge Companion to Nineteen Eighty-Four*, ed. by Nathan Waddell (Cambridge: Cambridge University Press, 2020), pp. 168–80. The Brookers are a lightly fictionalised version of a real family, the Forrests.
5 Kaori O'Connor, *The English Breakfast: The Biography of a National Meal, with Recipes* (London: Bloomsbury, 2013), p. 13.
6 Britain has imported bacon from Denmark since the mid 1800s.
7 I owe this point to Samantha Wait, a former undergraduate student of mine at the University of Birmingham.

IV WORK

1 Bernard Crick, *George Orwell: A Life*, 2nd edn (London: Penguin, 1982), p. 178.
2 John J. Ross, 'Tuberculosis, Bronchiectasis, and Infertility: What Ailed George Orwell?', *Clinical Infectious Diseases*, 41: 11 (2005), 1599–603 (p. 1600).
3 Darcy Moore, 'Orwell in Paris', https://www.darcymoore.net/paris-collection/ [accessed 11 October 2024].
4 Robert Colls, *George Orwell: English Rebel* (Oxford: Oxford University Press, 2013), p. 9.
5 Beatrix Campbell, *Wigan Pier Revisited: Poverty and Politics in the 80s* (London: Virago, 1984), p. 99.
6 Peter Davison, *George Orwell: A Literary Life* (Basingstoke: Palgrave, 1996), p. 73.
7 Frank Kermode, *History and Value* (Oxford: Clarendon Press, 1989), pp. 91, 92.
8 There is a contrast to be drawn here between *The Road to Wigan Pier* and D. H. Lawrence's presentation of the bullying Walter Morel in *Sons and Lovers* (1913), a novel Orwell admired.

9 Peter Stansky and William Abrahams, *The Unknown Orwell/ Orwell: The Transformation* (Stanford, CA: Stanford University Press, 1994), pp. 151–2.

V LUNCH

1 Martha C. Carpentier, 'Orwell's Joyce and *Coming Up for Air*', *Joyce Studies Annual*, 1 (2012), 131–53 (p. 136).
2 Lynette Hunter, *George Orwell: The Search for a Voice* (Milton Keynes: Open University Press, 1984), p. 97.
3 There's an echo of *Keep the Aspidistra Flying* here, too. In this text, a man lusts after a woman's naked body because it reminds him of 'a ripe warm fruit'.
4 George Orwell, *The War Broadcasts*, ed. by W. J. West (London: Duckworth/BBC, 1985), p. 13.
5 Gill Plain, *Literature of the 1940s: War, Postwar and 'Peace'* (2013; Edinburgh: Edinburgh University Press, 2015), p. 258.
6 Plain, *Literature of the 1940s*, p. 252.

VI ANIMALS

1 Rayner Heppenstall, *Four Absentees* (1960; London: Cardinal, 1988), p. 89.
2 Margaret Drabble, 'Of Beasts and Men: Orwell on Beastliness', in *On Nineteen Eighty-Four: Orwell and Our Future*, ed. by Abbott Gleason, Jack Goldsmith and Martha C. Nussbaum (Princeton, NJ: Princeton University Press, 2005), pp. 38–48 (p. 41).
3 Sarah Gibbs, 'Orwell's Beasts', in *The Oxford Handbook of George Orwell*, ed. by Nathan Waddell (Oxford: Oxford University Press, 2025), pp. 461–74.
4 D. J. Taylor, *Orwell: The New Life* (London: Constable, 2023), pp. 201, 202.

5 George Orwell, *Animal Farm* (1945), ed. by David Dwan (Oxford: Oxford University Press, 2021), p. xi.
6 Drabble, 'Of Beasts and Men', p. 39.
7 Douglas Kerr, 'Orwell, Animals, and the East', *Essays in Criticism*, XLIX: 3 (1999), 234–55 (p. 234).
8 John Buchan, *The Power-House* (1913/1916; House of Stratus, 2003), p. 26.

VII WALKING

1 Paul Potts, *Dante Called You Beatrice* (London: Eyre & Spottiswoode, 1960), p. 86.
2 Emma Larkin, *Finding George Orwell in Burma* (London: Granta, 2011), p. 2.
3 Joseph Conrad, *Heart of Darkness and Other Tales*, ed. by Cedric Watts (Oxford: Oxford University Press, 2002), p. 118.
4 The letter in question is uncertainly dated to 10 December 1933.
5 Audrey Coppard and Bernard Crick (eds), *Orwell Remembered* (London: BBC, 1984), pp. 91–2.
6 Coppard and Crick, *Orwell Remembered*, p. 92.
7 Letter from Orwell to Eleanor Jaques (17 February 1932), George Orwell Archive, University College London Special Collections.

VIII GREENERY

1 Ralph Waldo Emerson, *Nature and Selected Essays*, ed. by Larzer Ziff (New York: Penguin, 2003), p. 38.
2 Audrey Coppard and Bernard Crick (eds), *Orwell Remembered* (London: BBC, 1984), p. 249.
3 Samuel Taylor Coleridge, *Selected Poems*, ed. by Richard Holmes (London: Penguin, 1996), p. 230.
4 Coleridge, *Selected Poems*, p. 165.

NOTES

5 'Sere' is Miltonic, as the first two lines of his 1637 poem 'Lycidas' bear out: 'Yet once more, O ye laurels, and once more / Ye myrtles brown, with ivy never sere.' John Milton, *The Complete English Poems*, ed. by Gordon Campbell (London: Everyman's Library, 1992), p. 49. Orwell nevertheless proudly announced that he was influenced by Milton, for which see his 'Why I Write' and my essay, co-written with Elizabeth Cook, 'Orwell and John Milton', in *The Oxford Handbook of George Orwell*, ed. by Nathan Waddell (Oxford: Oxford University Press, 2025), pp. 147–61.

6 The Bible: Authorised King James Version with Apocrypha, ed. by Robert Carroll and Stephen Prickett (Oxford: Oxford University Press, 1998), p. 2 (Genesis 2:8).

7 Coppard and Crick, *Orwell Remembered*, p. 114.

8 Rebecca Solnit, *Orwell's Roses* (London: Granta, 2021), p. 29.

9 Solnit, *Orwell's Roses*, p. 10.

IX HOBBIES

1 In his gloss on this, Peter Davison writes that 'The correct title is *The Little Sister* [...]. Orwell may have conflated two Raymond Chandler books, *The Lady in the Lake* and *The Little Sister*.'

2 See James Smith, *British Writers and MI5 Surveillance, 1930–1960* (Cambridge: Cambridge University Press, 2013), pp. 144–5.

3 D. J. Taylor, *Orwell: The New Life* (London: Constable, 2023), pp. 524–5.

4 Christopher Hitchens, *Why Orwell Matters* (New York: Basic, 2002), p. 157. Orwell's list, his reasons for writing it and the ensuing fallout are discussed in more detail in Ariane Bankes, *The Quality of Love: Twin Sisters at the Heart of the Century* (London: Duckworth, 2024), pp. 202–7.

5 As Ralph Pordzik puts it in a chapter called 'The Poetics of Etcetera: Orwell's Literary Lists', in many of Orwell's 'novels, essays and shorter prose pieces the enumerative, poetical or

literary list figures as a privileged means of structuring reality, of arranging distinctive words for dazzling outcome'. *The Other Orwell: Conversion, Liminality, and Abject Desire in the Writings of George Orwell* (Morrisville, NC: Lulu Press, 2023), p. 105.

6 Near the end of Forster's novel, Helen Schlegel points to the 'red rust' of houses creeping out from London into the meadows encircling the city. *Howards End* (1910), ed. by David Lodge (New York: Penguin, 2000), p. 289.

7 Letter from Orwell to Eleanor Jaques and Dennis (15 January 1936), George Orwell Archive, University College London Special Collections.

X WALKING (AGAIN)

1 D. J. Taylor, *Orwell: The New Life* (London: Constable, 2023), p. 471.
2 Jacintha Buddicom, *Eric & Us*, with a postscript by Dione Venables (Chichester: Finlay, 2006), p. 11.
3 Buddicom, *Eric & Us*, pp. 15, 19.
4 Buddicom, *Eric & Us*, p. 32.
5 Buddicom, *Eric & Us*, p. 72.
6 Buddicom, *Eric & Us*, p. 169.
7 Kathryn Hughes, 'Such Were the Joys', *The Guardian*, 17 February 2007, https://www.theguardian.com/books/2007/feb/17/georgeorwell.biography [accessed 18 October 2024].
8 Buddicom, *Eric & Us*, p. 170.
9 Buddicom, *Eric & Us*, p. 182.
10 Buddicom, *Eric & Us*, p. 182.
11 Jamie Wood, 'George Orwell, Desire, and Encounters with Rural Sex in Mid-Century England', *College Literature*, 45: 3 (2018), 399–423 (pp. 401–2).
12 Wood, 'George Orwell', p. 415.

XI PUBS

1. Ben Clarke, '"Beer and Cigarettes and a Girl to Flirt with": Orwell, Drinking and the Everyday', *English Studies*, 96: 5 (2015), 541–61 (p. 543).
2. John Sutherland, *Orwell's Nose: A Pathological Biography* (London: Reaktion, 2016), p. 25.
3. D. H. Lawrence, *Women in Love* (1920), ed. by David Bradshaw (Oxford: Oxford University Press, 1998), p. 179.
4. Stephen Wadhams (ed.), *Remembering Orwell* (Harmondsworth: Penguin, 1984), p. 117.
5. Rayner Heppenstall, *Four Absentees* (1960; London: Cardinal, 1988), p. 34.
6. Heppenstall, *Absentees*, p. 59.
7. Heppenstall, *Absentees*, pp. 123–4.
8. David Hall, *Worktown: The Astonishing Story of the Project that Launched Mass-Observation* (London: Weidenfeld & Nicolson, 2015), p. 1.
9. Mass Observation, *The Pub and the People: A Worktown Study* (London: Victor Gollancz, 1943), pp. 9, 10.
10. Mass Observation, *The Pub and the People*, p. 17.
11. Mass Observation, *The Pub and the People*, p. 338.

XII DINNER

1. Here *Keep the Aspidistra Flying* alludes to Robert Browning's poem 'Home-Thoughts, from Abroad' (1845).
2. To quote the critic Richard I. Smyer, *Keep the Aspidistra Flying* can be read as 'expressing a prudential moral, with Gordon being a sort of modern Alceste who finally comes to his senses'. See *Primal Dream and Primal Crime: Orwell's Development as a Psychological Novelist* (Columbia and London: University of Missouri Press, 1979), p. 59.

3 Later in *Down and Out in Paris and London* Orwell describes meeting a man in London, in a lodging-house dormitory, who *did* have an Etonian background, 'babbling in an educated, half-drunken voice'.
4 Orwell had the back-up option in Paris (though he seems never to have used it) of calling on his auntie, Nellie Limouzin, for financial assistance. See D. J. Taylor, *Orwell: The New Life* (London: Constable, 2023), pp. 125, 130.
5 Beatrix Campbell, *Wigan Pier Revisited: Poverty and Politics in the 80s* (London: Virago, 1984), p. 2.
6 For a discussion of 'surplus appropriation', see Aditya Mukherjee, 'Empire: How Colonial India Made Modern Britain', *Economic and Political Weekly*, 45: 50 (2010), 73–82.
7 I discuss the symmetries across animal and human behaviour at greater length on my personal website: 'Beastly Men and Humanlike Beasts in *Animal Farm*', https://drnjwaddell.co.uk/15_beastly-men-and-humanlike-beasts [accessed 20 October 2024].
8 Matthew Frank, 'The New Morality – Victor Gollancz, "Save Europe Now" and the German Refugee Crisis, 1945–46', *Twentieth Century British History*, 17: 2 (2006), 230–56, p. 232.
9 For more on the philosophical complexities and contradictions of Orwell's account of revenge, see Peter Brian Barry, 'Revenge', in *George Orwell in Context*, ed. by Nathan Waddell (Cambridge: Cambridge University Press, forthcoming).

XIII SLEEP

1 Tom Sibley, 'The Soviet Union and the Spanish Civil War', *International Brigade Memorial Trust*, https://international-brigades.org.uk/news-and-blog/content-soviet-union-and-spanish-civil-war/ [accessed 20 October 2024].

2 See Leslie Tentler, '"I'm Not Literary, Dear": George Orwell on Women and the Family', in *The Future of Nineteen Eighty-Four*, ed. by Ejner J. Jensen (Ann Arbor: University of Michigan Press, 1984), pp. 47–63, at p. 51; and Daphne Patai, *The Orwell Mystique: A Study in Male Ideology* (Amherst: University of Massachusetts Press, 1984), p. 244.
3 Sandra Newman, *Julia* (London: Granta, 2023), p. 269.
4 Newman, *Julia*, p. 240.

XIV DREAMS

1 Hannah Arendt, *The Origins of Totalitarianism* (1951; London: Penguin, 2017), p. 446.
2 The most uncompromising challenge to this aspect of Orwell's style is given by Christopher Norris in 'Language, Truth, and Ideology: Orwell and the Post-War Left', in *Inside the Myth: Orwell – Views from the Left*, ed. by Norris (London: Lawrence and Wishart, 1984), pp. 242–62.
3 Wyndham Lewis, *The Writer and the Absolute* (London: Methuen, 1952), pp. 189–90.
4 Geoffrey Hartman, 'On Traumatic Knowledge and Literary Studies', *New Literary History*, 26: 3 (1995), 537–63 (p. 546).
5 Peter Davison, *George Orwell: A Literary Life* (Basingstoke: Palgrave, 1996), p. 95.
6 Bernard Crick, *George Orwell: A Life*, 2nd edn (London: Penguin, 1982), p. 400.
7 Fredric Warburg, *All Authors are Equal* (London: Hutchinson, 1973), p. 36.
8 Dorian Lynskey, *The Ministry of Truth: A Biography of George Orwell's 1984* (London: Picador, 2019), p. 177.
9 Langdon Elsbree, 'The Structured Nightmare of *1984*', *Twentieth-Century Literature*, 5: 3 (1959), 135–41.

10 T. S. Eliot, *The Complete Poems and Plays* (London: Faber and Faber, 1969), p. 61.
11 Christopher Ricks (ed.), *The Oxford Book of English Verse* (Oxford: Oxford University Press, 1999), p. 73.
12 I provide more detail on Orwell's fascination with the *Titanic* in '"A sinking sensation": George Orwell and the RMS *Titanic*', *George Orwell Studies*, 8: 2 (2024), 33–54.

CODA

1 John Rodden, *The Politics of Literary Reputation: The Making and Claiming of 'St. George' Orwell* (New York and Oxford: Oxford University Press, 1989), p. x.
2 For the trousers, see Audrey Coppard and Bernard Crick (eds), *Orwell Remembered* (London: BBC, 1984), pp. 83–4. For the memory, see Paul Potts, *Dante Called You Beatrice* (London: Eyre & Spottiswoode, 1960), p. 86.
3 Rebecca Solnit, *Orwell's Roses* (London: Granta, 2021), p. 9.